UNEXPECTED
cables

FEMININE KNITTED GARMENTS
featuring **MODERN CABLE KNITTING**

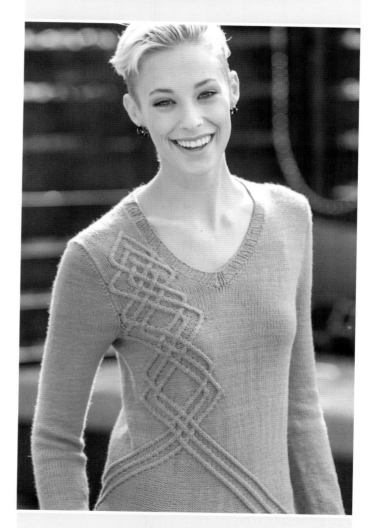

HEATHER ZOPPETTI

INTERWEAVE™

INTERWEAVE.COM

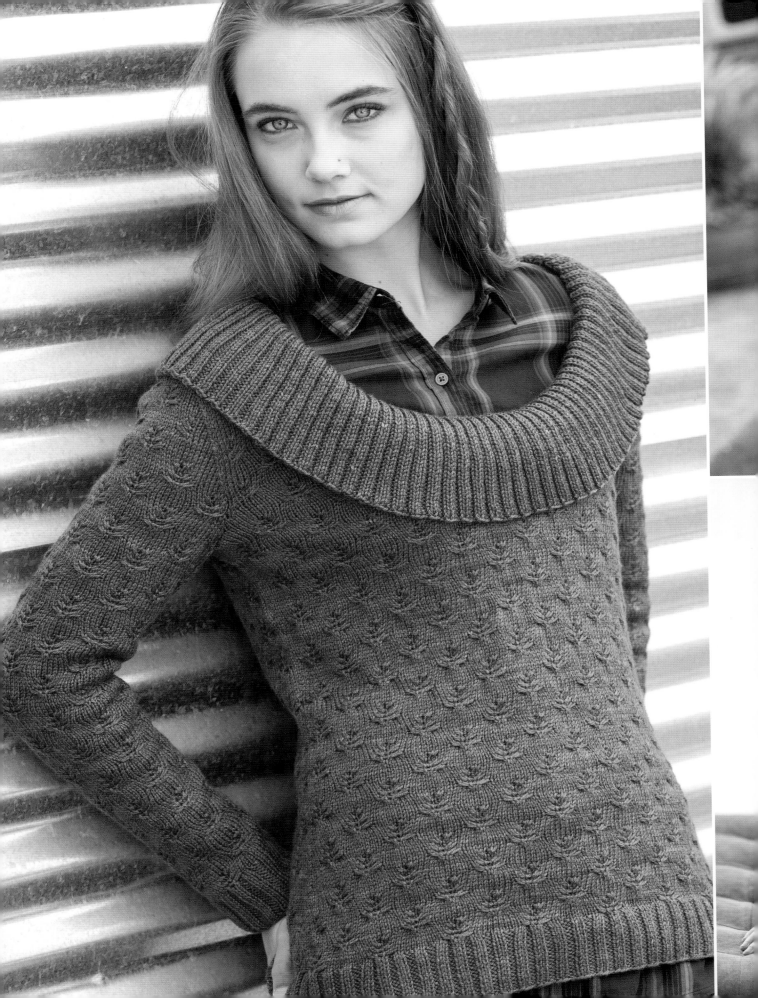

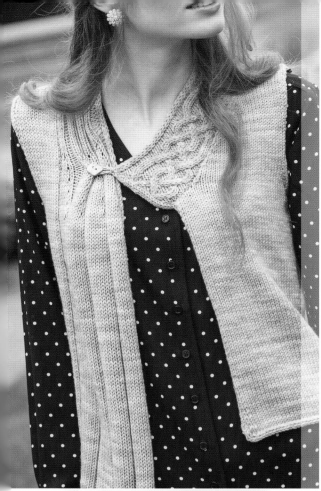

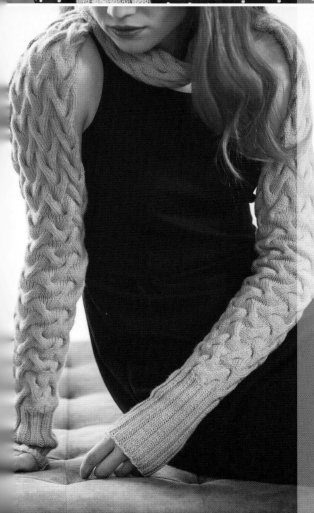

contents

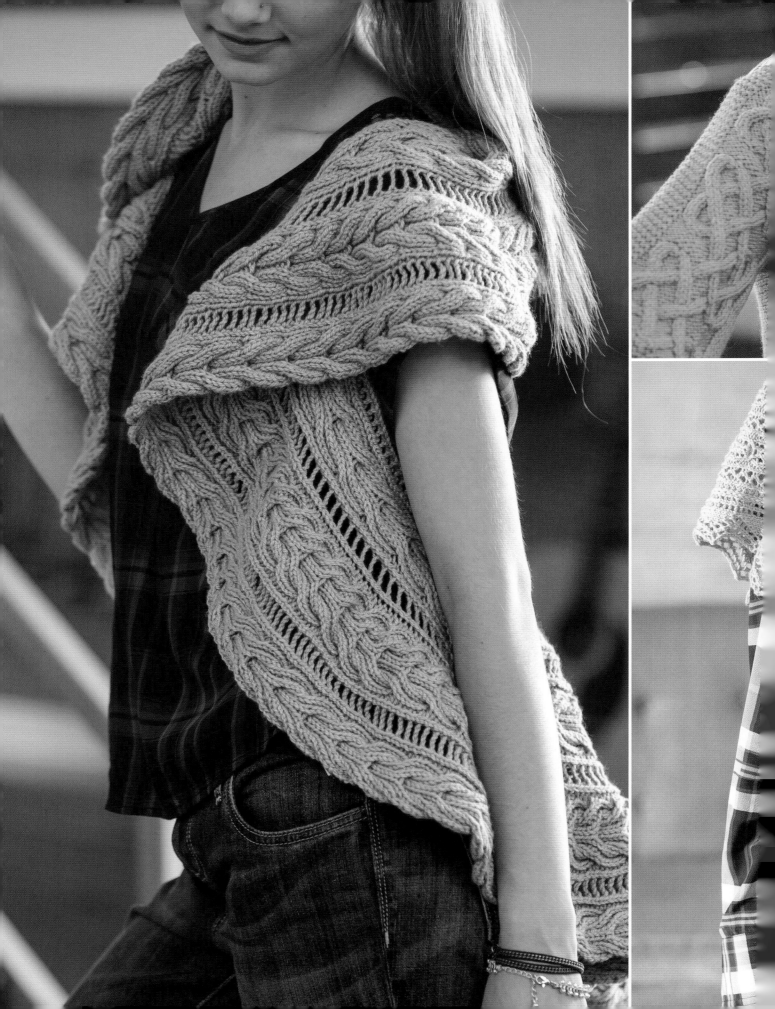

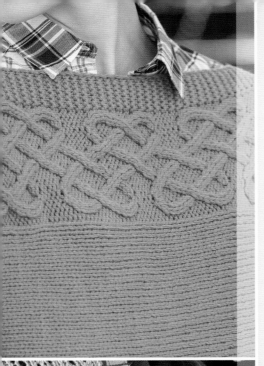

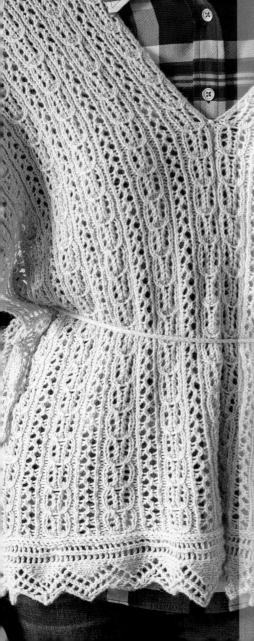

introduction

ONE OF THE THINGS I LOVE MOST ABOUT KNITTING is the endless opportunity for learning. There is always one more technique to explore, one more stitch to learn. Cable knitting, like lace, is both beautiful and somewhat magical.

When many people think of cable knitting, the first images that come to mind are big, boxy fisherman sweaters. This is exactly NOT what you will find in *Unexpected Cables*. The goal of this book is to update the cable from heirloom to modern in unexpected ways. By using sleeker garment shapes, mixing cables with lace, and constructing garments and accessories in abstract ways, I hope to motivate the knitter to explore cable knitting in unexpected ways.

Cabling looks complicated, and new knitters are often intimidated to try this technique. Essentially, a cable is created by reordering a group of stitches before knitting or purling them in the normal way. This new arrangement causes the stitches to become crossed. This crossing can appear to travel or twist to the right or to the left depending on how the stitches are rearranged. By simply changing the order in which we work stitches across the row, we are able to create the magic called cabling.

Within these pages, knitters of all skill levels will find intriguing patterns to make and wear. Projects range from adventurous beginner to intermediate in difficulty.

The projects in this book are divided into three chapters—Refined, Lace, and Abstract. Refined is the most traditional section. Projects in this chapter take the classic Aran and make it more modern by using lightweight yarns, delicate twisted stitches, and feminine shapes. The Lace chapter uses the unexpected pairing of cables and lace in delightful garments and accessories. Abstract focuses on unusual constructions, directions, and textures. Patterns in this chapter have a modern and edgy feel.

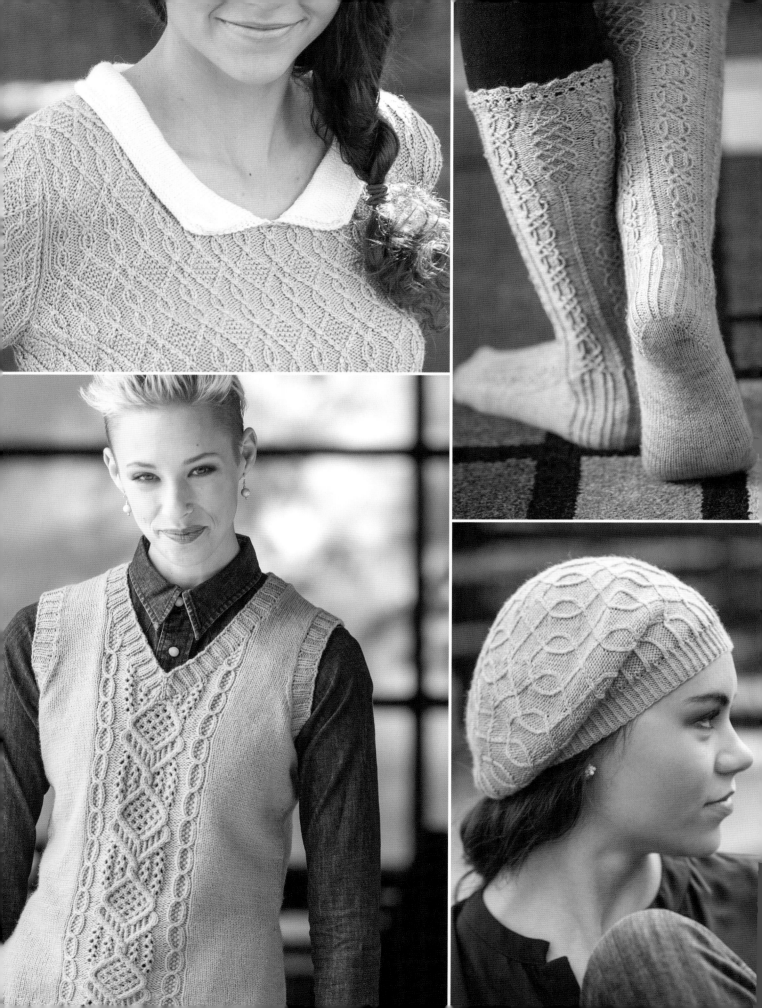

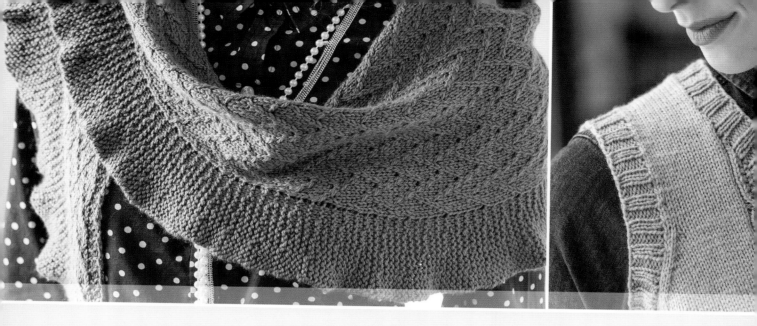

CHAPTER 1 | refined

WHEN THINKING OF CABLED SWEATERS AND ACCESSORIES, the image that comes foremost to the mind is one of overly textured bulky fabric. In this chapter, I aim to relieve that image and replace it with one of simple sophistication—a refined Aran, something delicate and beautiful. Here you will find six patterns that all employ the humble cable in a refined way. Twisted stitches and lightweight yarn update the classic Aran to something more feminine.

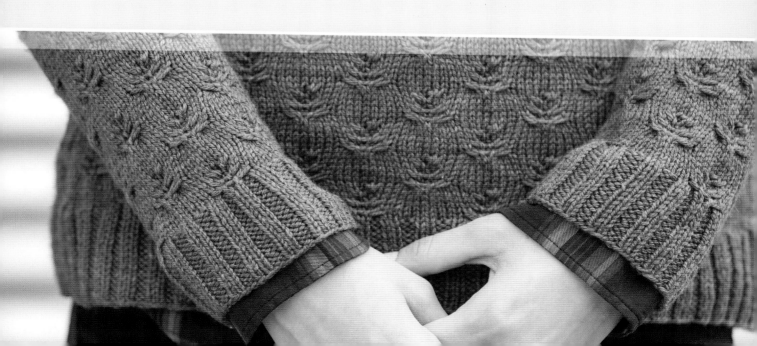

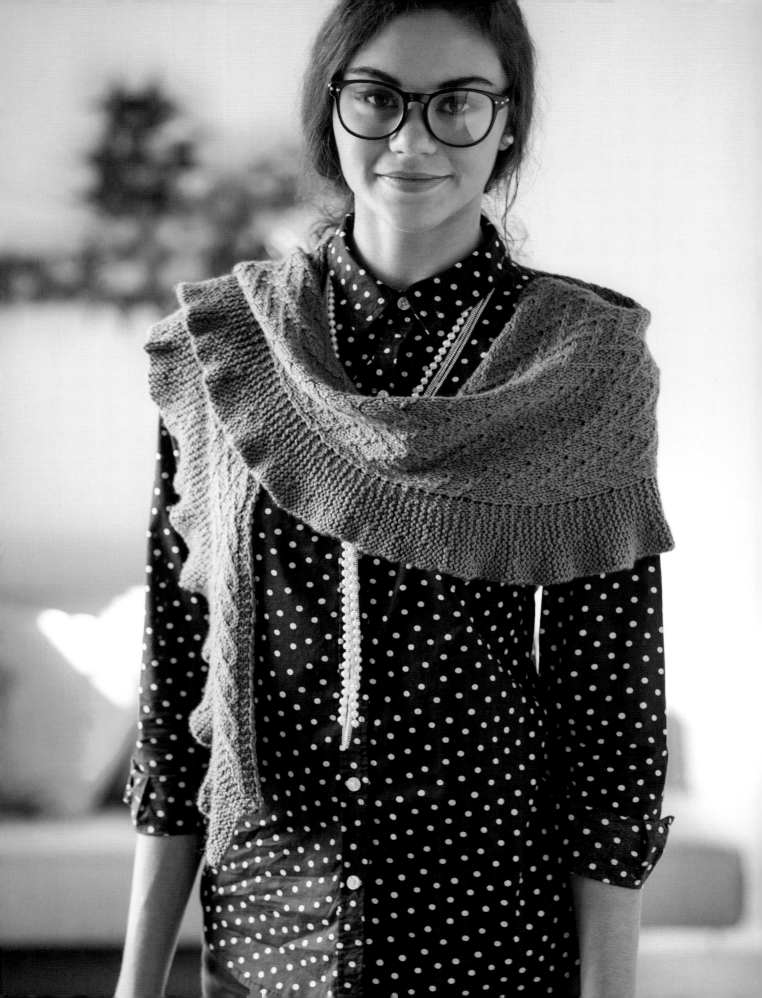

leola scarf

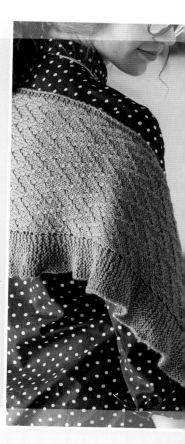

A LONG RUFFLE-EDGED SCARF, Leola will look pretty wrapped around your neck or draped over your shoulders. The delicate short-row ruffle is worked simultaneously along the edge and adds just a touch of femininity. A trellis of twisted stitches in this soft silk blend will keep your neck warm all winter.

FINISHED SIZE

Length: About 67½" (171.5 cm).

Width: About 10¾" (27.5 cm).

YARN

Sport weight (#2 Fine).

Shown here: Stitch Sprouts Yellowstone (80% wool, 20% silk; 285 yd [261 m]/100 g): reese creek, 2 skeins.

NEEDLES

Size U.S. 7 (4.5 mm): straight.

Adjust needle size if necessary to obtain the correct gauge.

NOTIONS

Markers (m); cable needle (cn); tapestry needle.

GAUGE

24 sts and 26 rows = 4" (10 cm) in Chart C.

stitch guide

1/1 RC: Sl 1 st to cn and hold in back, k1, k1 from cn.

1/1 LC: Sl 1 st to cn and hold in front, k1, k1 from cn.

Ruffle Short-Rows (panel of 13 sts)
Shape ruffle with short-rows (see Glossary) as foll:

SHORT-ROW 1: (WS) K10, wrap next st and turn so RS is facing, knit to end.

SHORT-ROW 2: K7, wrap next st and turn so RS is facing, knit to end.

SHORT-ROW 3: K4, wrap next st and turn so RS is facing, knit to end.

begin ruffle

CO 13 sts, place marker (pm), CO 2 sts—15 sts.

ROW 1: (RS) K2, sl m, k13.

Work ruffle short-rows (see Stitch Guide).

ROW 2: (WS) K13, sl m, knit to end.

ROW 3 (INC): (RS) Sl 1 st purlwise with yarn in front (pwise wyf), knit to m, m1L (see Glossary), sl m, k13—16 sts.

ROW 4: Knit.

ROW 5: Sl 1 st pwise wyf, knit to end.

Work ruffle short-rows.

ROW 6: Rep Row 2.

ROW 7: Rep Row 3—17 sts.

ROW 8: K13, sl m, p1, pm, knit to end.

body

EST CHART A AS FOLL:

ROW 1: (RS) Sl 1 st pwise wyf, knit to m, sl m, work Chart A to next m, sl m, knit to end.

Work ruffle short-rows.

ROW 2: (WS) Knit to m, sl m, work Chart A to next m, sl m, knit to end.

ROW 3: Rep Row 1.

ROW 4: Rep Row 2.

Rep Rows 1–4 and the ruffle short-rows as est until all 32 rows of Chart A have been completed—25 sts.

CHART B
Cont working as est for Chart A, but work Chart B until all 32 rows have been completed 5 times—65 sts.

CHART C
Cont working as est for Chart A, but work Chart C until all 8 rows have been worked 5 times.

CHART D
Cont working as est for Chart A, but work Chart D until all 32 rows have been worked 5 times—25 sts rem.

CHART E
Cont working as est for Chart A, but work Chart E until all 32 rows have been completed—17 sts rem.

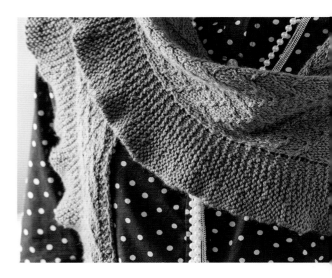

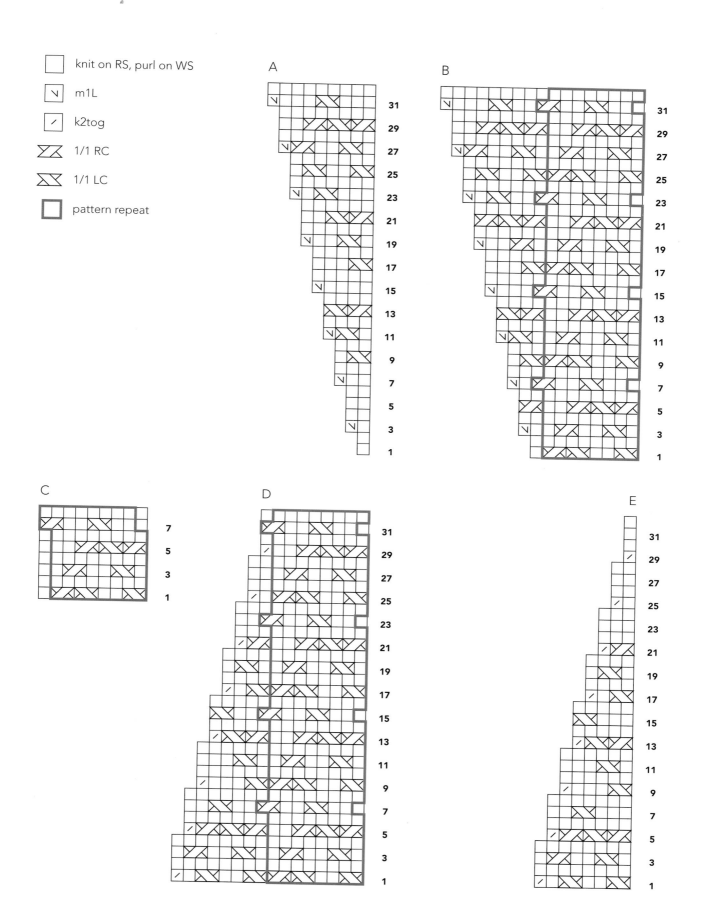

knit on RS, purl on WS

m1L

k2tog

1/1 RC

1/1 LC

pattern repeat

A

B

C

D

E

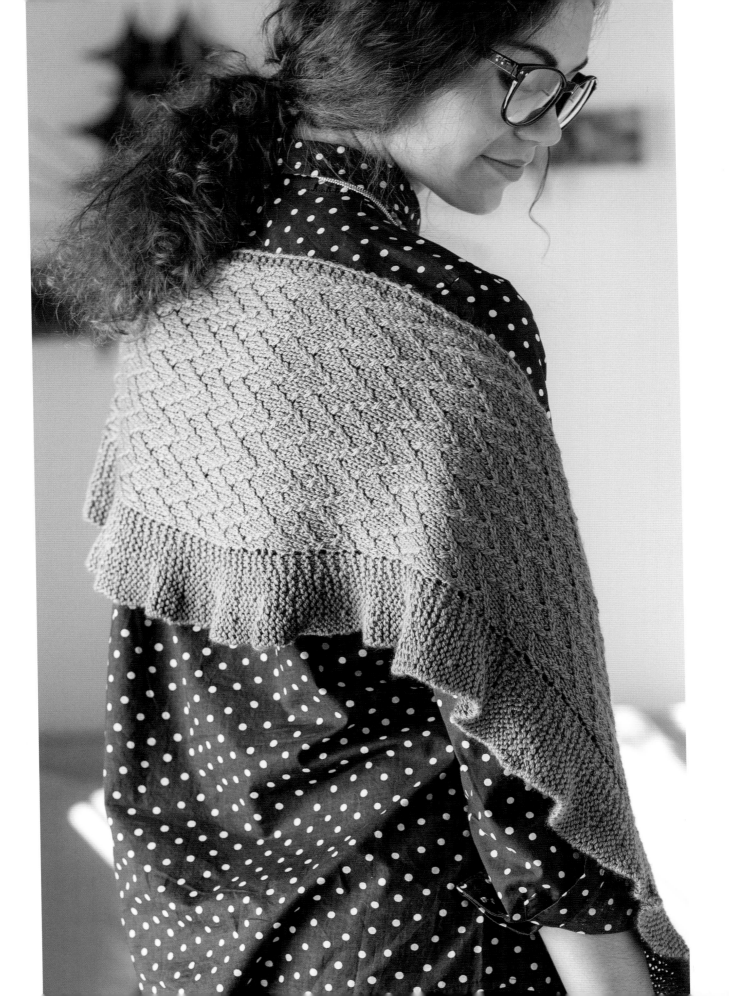

working cables and twisted stitches without a cable needle

For cabling, the most essential tool is the cable needle. Every pattern in this book calls for this notion, yet many can be made without it. Cabling without the cable needle can make your knitting progress faster.

STEP 1: Slip the stitches to be worked to the right needle.

STEP 2: Identify the stitches needed to cross to the left.

STEP 3: Insert the left-hand needle purlwise into these stitches, either in front or back of the right needle (Figure 1).

STEP 4: Carefully remove the right needle from the remaining stitches (Figure 2).

STEP 5: Re-insert the right needle into the loose stitches (Figure 3).

STEP 6: Slip all stitches to the left needle and knit as prescribed (Figure 4).

This technique works best with wooly yarns as the stitches will be more stable when off the needle. A slippery yarn may make this method more frustrating than helpful.

Figure 1.

Figure 2.

Figure 3.

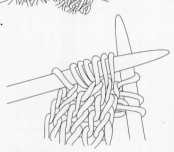

Figure 4.

end ruffle

ROW 1 (DEC): (RS) Sl 1 st pwise wyf, k1, k2tog removing m, sl m, knit to end—16 sts rem.

Work ruffle short-rows.

ROW 2: (WS) K13, sl m, knit to end.

ROW 3: Sl 1 pwise wyf, knit to end.

ROW 4: Rep Row 2.

ROW 5 (DEC): Sl 1 st pwise wyf, k2tog, sl m, knit to end—15 sts rem.

Work ruffle short-rows.

ROW 6: Rep Row 2.

BO all sts.

finishing

Block to measurements. Weave in ends.

maytown vest

THIS VEST IS A MODERN CLASSIC featuring a wide central cable with smaller flanking cables. Worked in the round from the bottom up, this lightweight vest is edged with ribbing for a timeless sporty look. The back and sides are left plain for ease of shaping.

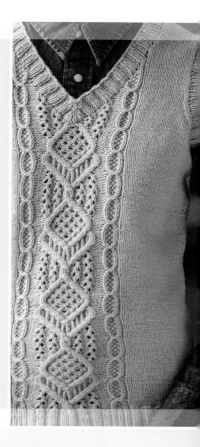

FINISHED SIZE

Bust Circumference: About 29¾ (32¾, 37¼, 40½, 44¼, 47½)" (75.5 [83, 94.5, 103, 112.5, 120.5] cm).

Length: About 22¼ (22¾, 23¼, 24, 24¼, 25)" (56.5 [58, 59, 61, 61.5, 63.5] cm).

Sweater shown measures 32¾" (83 cm).

YARN

Sport weight (#2 Fine).

Shown here: Imperial Yarns Tracie Too Sport (100% wool; 395 yd [361 m]/113 g): honeydew, 2 (2, 3, 3, 3, 3) skeins.

NEEDLES

Size U.S. 5 (3.75 mm): 16" (40 cm) and 24" (60 cm) circular (cir).

Adjust needle size if necessary to obtain the correct gauge.

NOTIONS

Markers (m); 2 cable needles (cn); st holders or waste yarn; tapestry needle.

GAUGE

25 sts and 35 rnds = 4" (10 cm) in St st.

29 sts = 3½" (9 cm) in Center chart.

6 sts = ¾" (2 cm) in Left and Right charts.

stitch guide

2/2 RC: Sl 2 sts to cn and hold in back, k2, k2 from cn.

2/2 LC: Sl 2 sts to cn and hold in front, k2, k2 from cn.

2/2 RCP: Sl 2 sts to cn and hold in back, k2, p2 from cn.

2/2 LCP: Sl 2 sts to cn and hold in front, p2, k2 from cn.

2/1/1 RCP: Sl 2 sts to cn and hold in back, k2; p1, k1 from cn.

2/1/1 LCP: Sl 2 sts to cn and hold in front, k1, p1; k2 from cn.

2/1/2 LCP: Sl 2 sts to cn and hold in front, sl 1 st to a second cn and hold in back, k2, p1 from second cn, k2 from first cn.

2/2/1 LCP: Sl 2 sts to cn and hold in front, k2, p1; k2 from cn.

1/3/1 RCP: Sl 1 st to cn and hold in back, sl 3 sts to a second cn and hold in back, k1, move first cn to front, p1, k1, p1 from second cn; k1 from first cn.

1/3/1 LCP: Sl 1 st to cn and hold in front, sl 3 sts to a second cn and hold in back, k1; p1, k1, p1 from second cn; k1 from first cn.

PSO-K-YO-K: Pass the third st on the left needle over the first 2 sts, then k1, yo, k1.

Note: The front and back sections of this vest have different stitch counts throughout based on the tighter gauge of the cable panels.

body

With longer needle, CO 195 (215, 243, 263, 287, 307) sts, place marker (pm) for beg of rnd and join for working in the rnd, being careful not to twist sts.

EST RIBBING: [K2, p2] 7 (8, 10, 11, 13, 14) times, k2, pm for beg front panel, [p1, k1] 3 times, [p1, k2] twice, [p2, k2] twice, p1, [k2, p2] twice, [k2, p1] twice, [k1, p1] 3 times, pm for end front panel, [k2, p2] 7 (8, 10, 11, 13, 14) times, k2, pm for side, [p2, k2] to last 2 sts, p2—101 (109, 125, 133, 149, 157) sts for front and 94 (106, 118, 130, 138, 150) sts for back.

Work even as est for 1" (2.5 cm).

EST PATT: Knit to front panel m, sl m, work 6 sts in Right chart, 29 sts in Center chart then 6 sts in Left chart, sl m, knit to end.

SHAPE WAIST

Work 9 (11, 9, 9, 9, 11) rnds even as est.

DEC RND: *K1, k2tog, work as est to 2 sts before side m, sl m, ssk; rep from *—4 sts dec'd.

Rep last 10 (12, 10, 10, 10, 12) rnds 3 (3, 0, 4, 0, 0) times—179 (199, 239, 243, 283, 303) sts rem; 93 (101, 123, 123, 147, 155) sts for front, 86 (98, 116, 120, 136, 148) sts for back.

Sizes 29¾ (37¼, 44¼, 47½)" only:
[Work 7 (7, 7, 9) rnds even, then rep dec rnd] 1 (5, 5, 4) time(s)—175 (219, 263, 287) sts rem; 91 (113, 137, 147) sts for front, 84 (106, 126, 140) sts for back.

All Sizes:
Work even as est until piece meas 7½ (7½, 7¾, 7¾, 7¾, 8)" (19 [19, 19.5, 19.5, 19.5, 20.5] cm) from CO edge.

INC RND: *K1, m1L (see Glossary), work as est to side m, m1R (see Glossary), sl m; rep from *—4 sts inc'd.

[Work 13 (17, 9, 13, 9, 13) rnds even, then rep inc rnd] 3 (1, 2, 3, 1, 3) time(s)—191 (207, 231, 259, 271, 303) sts; 99 (105, 119, 131, 141, 155) sts for front, 92 (102, 112, 128, 130, 148) sts for back.

[Work 15 (19, 11, 15, 11, 15) rnds even, then rep inc rnd] 1 (2, 3, 1, 4, 1) time(s)—195 (215, 243, 263, 287, 307) sts; 101 (109, 125, 133, 149, 157) sts for front, 94 (106, 118, 130, 138, 150) sts for back.

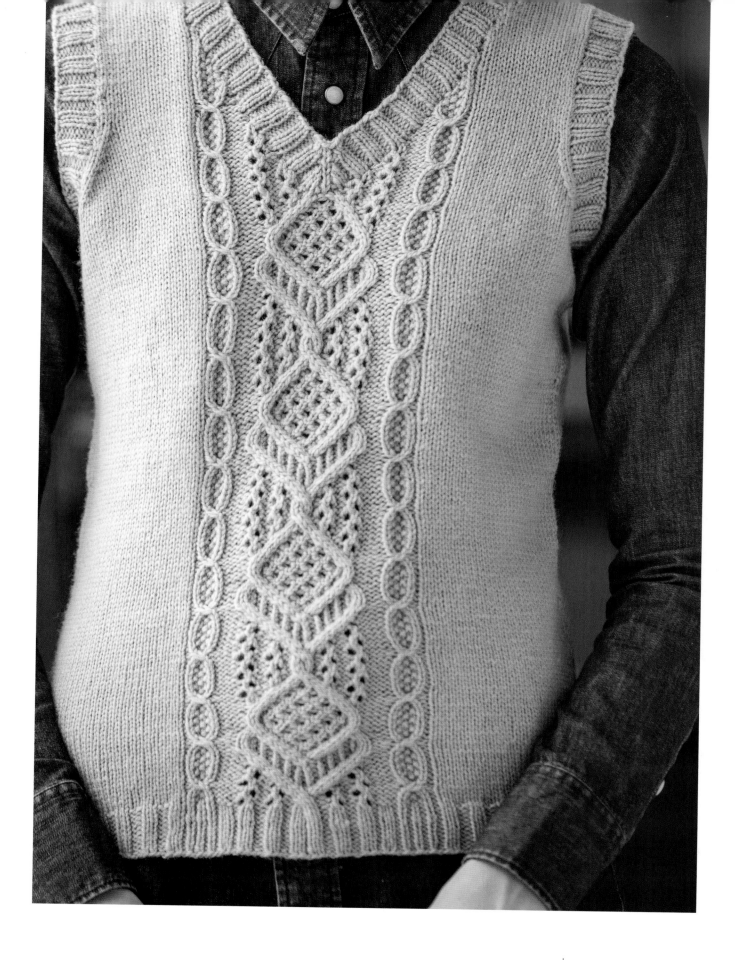

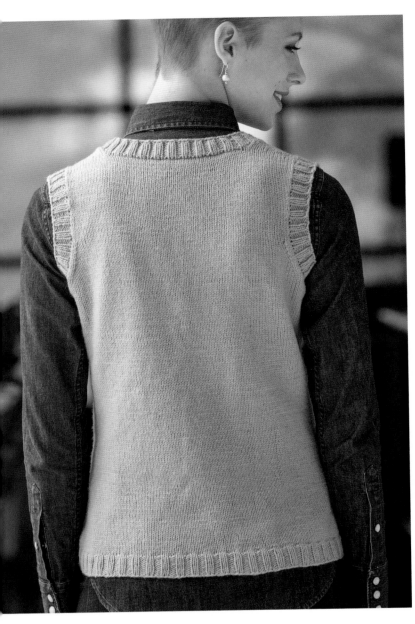

Work even as est until piece meas 15¼ (15¼, 15¼, 15½, 15½, 15¾)" (38.5 [38.5, 38.5, 39.5, 39.5, 40] cm) from CO edge, ending last rnd 5 (5, 6, 6, 7, 8) sts before end of rnd.

SEPARATE FRONT AND BACK

SET-UP RND: BO 10 (10, 12, 12, 14, 16) sts, work across front as est to 5 (5, 6, 6, 7, 8) sts before side m, BO 10 (10, 12, 12, 14, 16) sts, work across back as est to end—91 (99, 113, 121, 135, 141) front sts rem and 84 (96, 106, 118, 124, 134) back sts rem.

Cont working back and forth in rows on back sts only. Place front sts on waste yarn or st holder.

back

SHAPE ARMHOLES

BO 3 sts at the beg of the next 2 rows, then BO 2 sts at the beg of the next 2 (4, 4, 6, 6, 8) rows—74 (82, 92, 100, 106, 112) sts rem.

Purl 1 WS row.

DEC ROW: (RS) K2, ssk, knit to last 4 sts, k2tog, k2—2 sts dec'd.

Rep the last 2 rows 3 (6, 11, 14, 16, 19) more times—66 (68, 68, 70, 72, 72) sts.

Work even until armholes meas 7 (7½, 8, 8½, 8¾, 9¼)" (18 [19, 20.5, 21.5, 22, 23.5] cm), ending after a WS row.

SEPARATE SHOULDERS

NEXT ROW: (RS) K15 (15, 15, 15, 16, 17) sts, then place them onto a st holder or waste yarn for right shoulder, BO 36 (38, 38, 40, 40, 38) sts, knit to end—15 (15, 15, 15, 16, 17) sts rem for left shoulder.

Shape Left Shoulder

Shape left shoulder using short-rows (see Glossary) as foll:

NEXT ROW: (WS) Purl to neck edge, turn.

SHORT-ROW 1: (RS) K12, wrap next st and turn so WS is facing; purl to end of row.

SHORT-ROW 2: K9, wrap next st and turn so WS is facing; purl to end of row.

SHORT-ROW 3: K6, wrap next st and turn so WS is facing; purl to end of row.

NEXT ROW: (RS) Knit, working wraps as you come to them.

Place left shoulder sts onto st holder or waste yarn. Break yarn.

Shape Right Shoulder

Return 15 (15, 15, 15, 16, 17) held right shoulder sts to needle and join yarn preparing to work a WS row.

SHORT-ROW 1: (WS) P12, wrap next st and turn so RS is facing; knit to end of row.

SHORT-ROW 2: P9, wrap next st and turn so RS is facing; knit to end of row.

Center

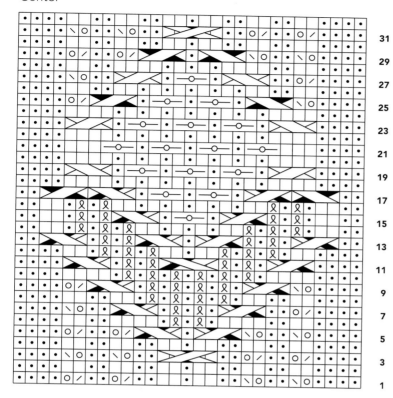

31
29
27
25
23
21
19
17
15
13
11
9
7
5
3
1

Left

9
7
5
3
1

Right

9
7
5
3
1

	knit on RS, purl on WS
•	purl on RS, knit on WS
᚜	k1tbl
o	yo
╱	k2tog
╲	ssk
⨝	2/2 RC
⨝	2/2 LC
◤⨝	2/2 RCP
⨝◣	2/2 LCP
◤⨝	2/1/1 RCP
⨝◣	2/1/1 LCP
⨝	2/1/2 LCP
◤⨝	2/2/1 LCP
⨝	1/3/1 RCP
⨝	1/3/1 LCP
─o─	pso-k-yo-k

SHORT-ROW 3: P6, wrap next st and turn so RS is facing; knit to end of row.

NEXT ROW: (WS) Purl, working wraps as you come to them.
Place sts onto st holder or waste yarn. Break yarn.

front

Return 91 (99, 113, 121, 135, 141) held front sts to needle and join yarn preparing to work a WS row.

(*Note:* Armhole and neck shaping happen at the same time. Read the next sections all the way through before beg.)

SHAPE ARMHOLES
BO 3 sts at the beg of the next 2 rows, then BO 2 sts at the beg of the next 2 (4, 4, 6, 6, 8) rows.

Work 1 WS row even as est.

ARMHOLE DEC ROW: (RS) K2, ssk, knit to last 4 sts, k2tog, k2—2 sts dec'd.

Rep the last 2 rows 3 (6, 11, 14, 16, 19) more times.

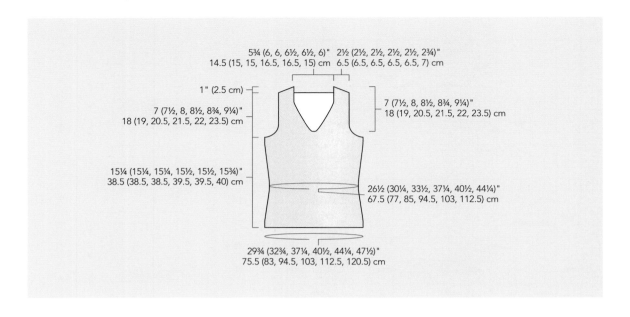

5¾ (6, 6, 6½, 6½, 6)" 2½ (2½, 2½, 2½, 2½, 2¾)"
14.5 (15, 15, 16.5, 16.5, 15) cm 6.5 (6.5, 6.5, 6.5, 6.5, 7) cm

1" (2.5 cm)

7 (7½, 8, 8½, 8¾, 9¼)"
18 (19, 20.5, 21.5, 22, 23.5) cm

7 (7½, 8, 8½, 8¾, 9¼)"
18 (19, 20.5, 21.5, 22, 23.5) cm

15¼ (15¼, 15¼, 15½, 15½, 15¾)"
38.5 (38.5, 38.5, 39.5, 39.5, 40) cm

26½ (30¼, 33½, 37¼, 40½, 44¼)"
67.5 (77, 85, 94.5, 103, 112.5) cm

29¾ (32¾, 37¼, 40½, 44¼, 47½)"
75.5 (83, 94.5, 103, 112.5, 120.5) cm

At the same time, when armhole meas 1" (2.5 cm), end after a WS row.

Pm on each side of center 3 sts for neck.

SHAPE NECK
NEXT ROW: (RS) Work as est to m, join a second ball of yarn, BO 3 sts, work as est to end of row.

Cont working each side at the same time with separate balls of yarn.

Work 1 WS row as est.

NECK DEC ROW: (RS) Work as est to 3 sts before neck edge, k2tog or ssp keeping in patt, p1; on other side, p1, ssk or p2tog keeping in patt, work as est to end—1 st dec'd on each side.

Rep the last 2 rows 19 (15, 17, 13, 20, 12) times.

[Work 3 rows as est, then rep dec row] 0 (3, 3, 6, 3, 8) times—15 (15, 15, 15, 16, 17) sts rem after all shaping is completed.

Work even until armholes meas 7 (7½, 8, 8½, 8¾, 9¼)" (18 [19, 20.5, 21.5, 22, 23.5] cm), ending after a WS row.

Shape Left Shoulder
Shape left shoulder using short-rows as foll:

NEXT ROW: (RS) Knit to neck edge, turn.

SHORT-ROW 1: (WS) P12, wrap next st and turn so RS is facing; knit to end of row.

SHORT-ROW 2: P9, wrap next st and turn so RS is facing; knit to end of row.

SHORT-ROW 3: P6, wrap next st and turn so RS is facing; knit to end of row.

NEXT ROW: (WS) Purl, working wraps as you come to them.

Place left shoulder sts onto st holder or waste yarn. Break yarn.

Shape Right Shoulder
Shape right shoulder using short-rows as foll:

SHORT-ROW 1: (RS) K12, wrap next st and turn so WS is facing; purl to end of row.

SHORT-ROW 2: K9, wrap next st and turn so WS is facing; purl to end of row.

SHORT-ROW 3: K6, wrap next st and turn so WS is facing; purl to end of row.

NEXT ROW: (RS) Knit, working wraps as you come to them.

Place sts onto st holder or waste yarn. Break yarn.

finishing

Block to measurements. Weave in ends.

With back and front RS's facing each other, use the three-needle method (see Glossary) to join shoulder seams together.

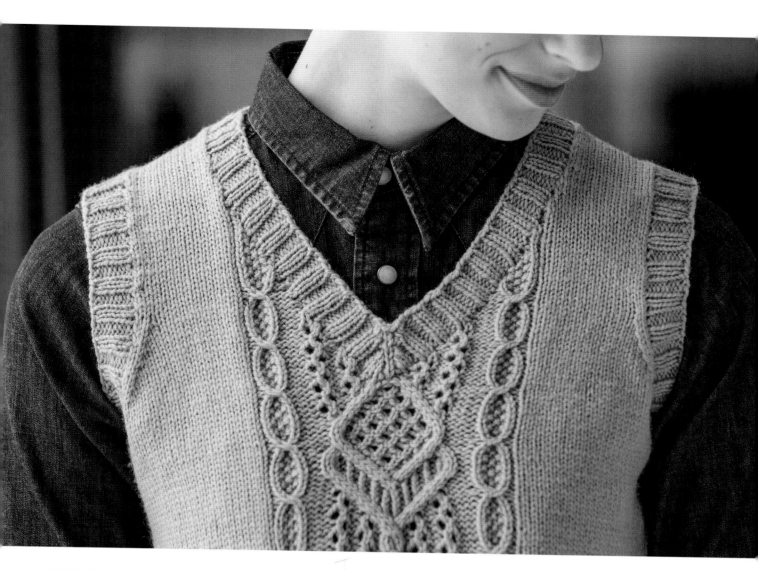

COLLAR

With RS facing, shorter needle, and starting in the center front, pick up and knit 141 (149, 149, 157, 161, 161) sts evenly around neck edge. Pm and join for working in the rnd.

EST RIBBING: K1, *p1, k2, p1; rep from *.

DEC RND 1: K1, k2tog, work in patt to last 2 sts, ssk—2 sts dec'd.

Rep dec rnd 1 once more—137 (145, 145, 153, 157, 157) sts rem.

DEC RND 2: K1, ssp, work in patt to last 2 sts, p2tog—2 sts dec'd.

Rep dec rnd 2 once, then rep dec rnd 1 twice—129 (137, 137, 145, 149, 149) sts rem.

BO all sts in patt.

ARMBANDS

With RS facing, shorter needle, and starting in the center of the underarm, pick up and knit 100 (108, 116, 128, 132, 144) sts evenly around one armhole edge. Pm and join for working in the rnd.

NEXT RND: *K2, p2; rep from * to end of rnd.

Rep last rnd until armband meas 1" (2.5 cm) from pick-up rnd.

BO all sts in patt.

Rep for second armhole.

Block again if desired.

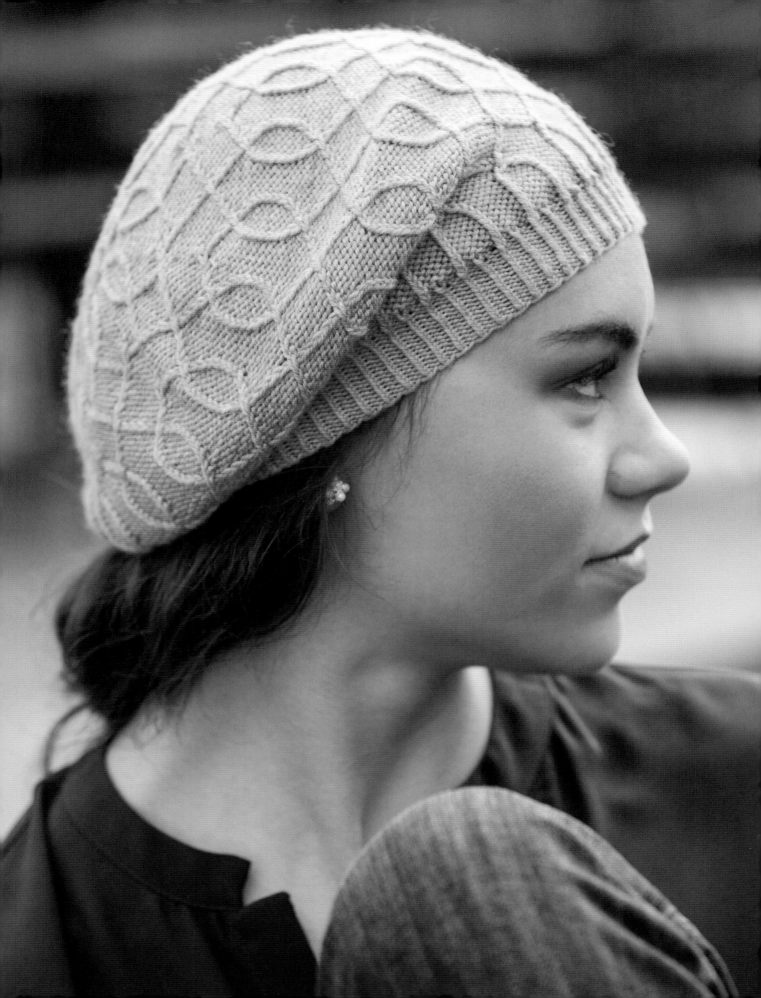

warwick tam

THIS REFINED TAM IS BOTH COZY AND STYLISH. A bright orange color warms up the winter months. Worked in a supersoft cashmere blend and featuring tiny twisted cables, this hat is as fun to knit as it is to wear.

FINISHED SIZE

Circumference: About 14" (35.5 cm), relaxed.

Length: About 9" (23 cm).

Brim will stretch to about 20" (51 cm) circumference.

YARN

Fingering weight (#1 Super Fine).

Shown here: Tanis Fiber Arts Purple Label (70% merino, 20% cashmere, 10% nylon; 400 yd [366 m]/115 g): orange blossom, 1 skein.

NEEDLES

Brim: Size U.S. 1½ (2.5 mm): double-pointed (dpn).

Body: Size U.S. 3 (3.25 mm): 16" (40 cm) circular (cir) and set of dpn.

Adjust needle size if necessary to obtain the correct gauge.

NOTIONS

Marker (m); cable needle (cn); tapestry needle.

GAUGE

41 sts and 56 rnds = 4" (10 cm) in twisted rib, relaxed with smaller needle.

33 sts and 44 rnds = 4" (10 cm) in Body chart with larger needle.

stitch guide

RT: Sl 1 st to cn and hold in back, k1tbl, k1tbl from cn.

ENDRT: Work RT on all reps except the last; sl 1 st to cn and hold in back, remove beg of rnd m, k1tbl, replace beg of rnd m, sl st from cn to left needle.

LTP: Sl 1 st to cn and hold in front, p1, k1tbl from cn.

RTP: Sl 1 st to cn and hold in back, k1tbl, p1 from cn.

Twisted Rib (multiple of 2 sts)

RND 1: *K1tbl, p1tbl; rep from *.

Rep Rnd 1 for patt.

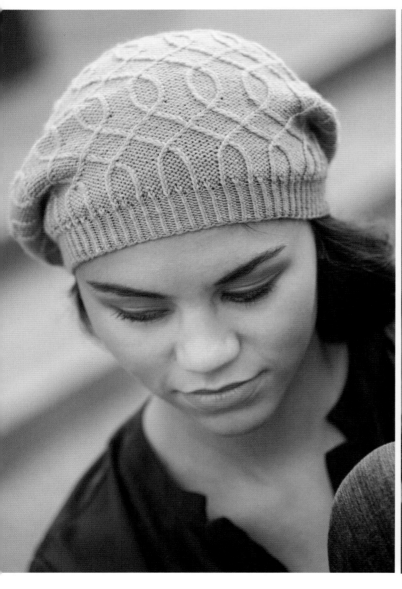

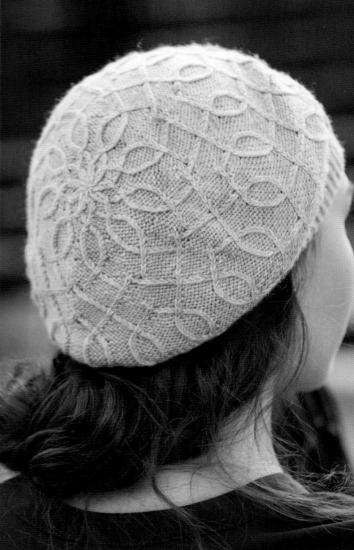

Body　　　　　Crown

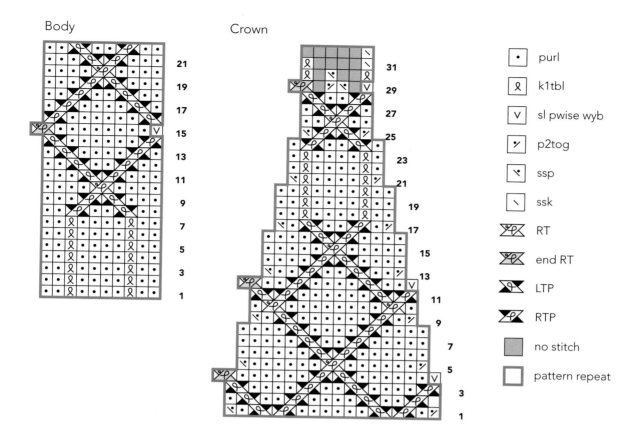

·	purl
ℓ	k1tbl
V	sl pwise wyb
⟋	p2tog
⟍	ssp
\	ssk
⤬	RT
⤬	end RT
◣	LTP
◢	RTP
▓	no stitch
▢	pattern repeat

brim

With smaller needle, CO 144 sts. Divide sts evenly over dpn, place marker (pm) and join for working in the rnd, being careful not to twist sts.

Work twisted rib for 1¼" (3.2 cm).

Change to larger cir needle.

INC RND: *K1tbl, p1, k1tbl, m1p (see Glossary), p1; rep from * to end of rnd—180 sts.

body

Work Rnds 1–22 of Body chart 2 times, then work Rnds 1–10 once more.

crown

(*Note:* Change to larger dpn when sts no longer fit comfortably on cir.)

Work Rnds 1–32 of Crown chart—9 sts rem.

Break yarn leaving a 7" (18 cm) tail. With tail threaded onto tapestry needle, draw through rem sts.

finishing

Block over a dinner plate. Weave in ends.

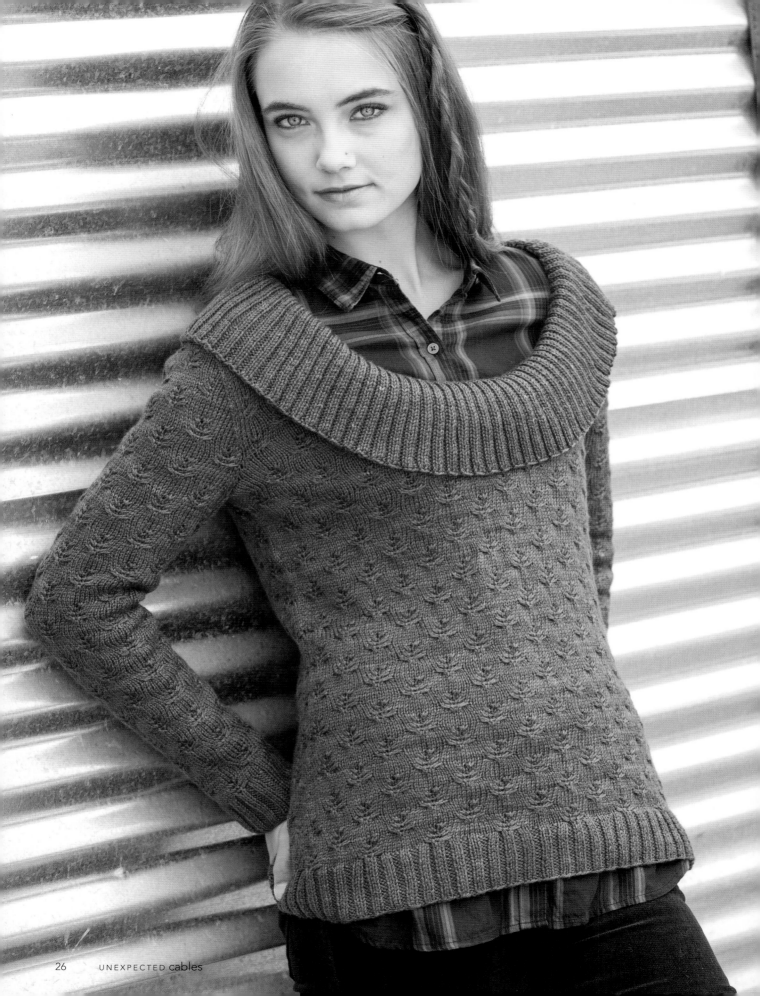

rheems pullover

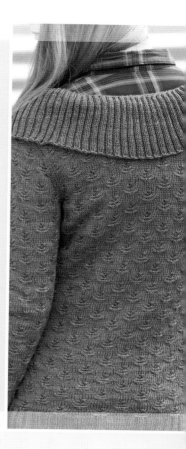

A GENEROUS COWL NECK tops this long-sleeve pullover. Knit in a yarn specifically formulated to regulate temperature, this sweater will keep you cool. A subtle allover cable pattern is delicate and feminine without being bulky. Worked from the bottom up, and featuring classic set-in sleeves, this sweater will become a wardrobe favorite that you reach for again and again.

FINISHED SIZE
Bust Circumference: About 30½ (34, 38, 41½, 45½, 49)" (77.5 [86.5, 96.5, 105.5, 115.5, 124.5] cm).

Length: About 23½ (24¼, 24¾, 25¼, 26¼, 27)" (59.5 [61.5, 63, 64, 66.5, 68.5] cm).

Sweater shown measures 34" (86.5 cm).

YARN
Sport weight (#2 Fine).

Shown here: Lorna's Laces Sportmate (70% wool, 30% outlast viscose; 270 yd [247 m]/100 g): manzanita, 6 (7, 8, 8, 9, 10) skeins.

NEEDLES
Size U.S. 5 (3.75 mm): 24" (60 cm) circular (cir) and spare needle.

Adjust needle size if necessary to obtain the correct gauge.

NOTIONS
Markers (m); cable needle (cn); waste yarn or st holders; tapestry needle.

GAUGE
30 sts and 35 rows = 4" (10 cm) in Cable chart.

stitch guide

RT: Sl 1 st to cn and hold in back, k1, k1 from cn.

LT: Sl 1 st to cn and hold in front, k1, k1 from cn.

1/2 RC: Sl 2 sts to cn and hold in back, k1, k2 from cn.

1/2 LC: Sl 1 st to cn and hold in front, k2, k1 from cn.

1/3 RC: Sl 3 sts to cn and hold in back, k1, k3 from cn.

1/3 LC: Sl 1 st to cn and hold in front, k3, k1 from cn.

Ribbing (multiple of 4 + 2 sts)
ROW 1: (WS) *P2, k2; rep from * to last 2 sts, p2.

ROW 2: (RS) *K2, p2; rep from * to last 2 sts, k2.

Rep Rows 1 and 2 for patt.

Notes: Circular needle is used to accommodate large number of sts. Do not join; work back and forth in rows.

When working shaping, work cables as established unless you are unable to complete a cross with all sts. If this is not possible because of the current st count, work in St st (knit on RS, purl on WS) instead.

back

CO 122 (138, 154, 170, 186, 202) sts. Do not join; work back and forth in rows.

Work ribbing until piece meas 2" (5 cm) from CO edge, ending after a WS row.

EST PATT: (RS) Sl 1 purlwise with yarn in back (pwise wyb), work Cable chart to last st, k1.

NEXT ROW: (WS) Sl 1 pwise with yarn in front (wyf), work Cable chart to last st, p1.

Cont working even as est until piece meas 2½" (6.5 cm) from CO edge, ending after a WS row.

SHAPE WAIST
DEC ROW: (RS) Sl 1 pwise wyb, ssk, work in patt to last 3 sts, k2tog, k1—2 sts dec'd.

[Work 5 rows even in patt, then rep dec row] 3 (4, 2, 1, 0, 0) time(s)—114 (128, 148, 166, 184, 200) sts rem.

[Work 3 rows even in patt, then rep dec row] 5 (4, 7, 9, 11, 12) times—104 (120, 134, 148, 162, 176) sts rem.

Work even as est until piece meas 8 (8¼, 8¼, 8½, 8¾, 9)" (20.5 [21, 21, 21.5, 22, 23] cm) from CO edge, ending after a WS row.

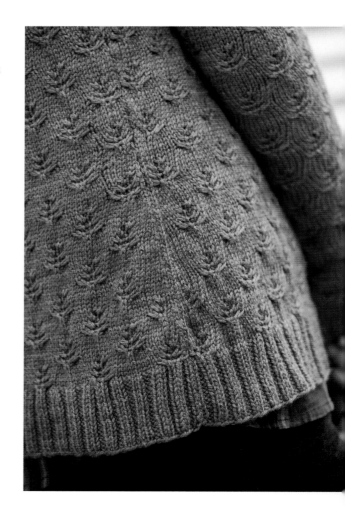

INC ROW: (RS) Sl 1 pwise wyb, m1L (see Glossary), work in patt to last st, m1R (see Glossary), k1—2 sts inc'd.

[Work 15 (21, 21, 21, 21, 21) rows even in patt, then rep inc row] 2 (2, 2, 3, 2, 3) times—110 (126, 140, 156, 168, 184) sts.

[Work 17 (23, 23, 23, 23, 23) rows even in patt, then rep inc row] 2 (1, 1, 0, 1, 0) time(s)—114 (128, 142, 156, 170, 184) sts.

Work even in patt until piece meas 16¾ (17, 17, 17, 17½, 17¾)" (42.5 [43, 43, 43, 44.5, 45] cm) from CO edge, ending after a WS row.

SHAPE ARMHOLES

BO 3 (3, 4, 4, 5, 5) sts at beg of next 2 rows—108 (122, 134, 148, 160, 174) sts rem.

BO 3 sts at beg of next 2 (4, 4, 6, 8, 8) rows—102 (110, 122, 130, 136, 150) sts rem.

BO 2 sts at beg of next 2 (2, 4, 4, 6, 8) rows—98 (106, 114, 122, 124, 134) sts rem.

DEC ROW: (RS) K1, ssk, work in patt to last 3 sts, k2tog, k1—2 sts dec'd.

Work 1 row even as est.

Rep the last 2 rows 0 (1, 3, 5, 5, 9) time(s)—96 (102, 106, 110, 112, 114) sts rem.

Cont working even in patt until armholes meas 6¾ (7¼, 7¾, 8¼, 8¾, 9¼)" (17 [18.5, 19.5, 21, 22, 23.5] cm), ending after a WS row.

Place markers (pm) each side of center 42 (48, 52, 54, 56, 58) sts for neck.

SEPARATE SHOULDERS

NEXT ROW: (RS) Work 27 (27, 27, 28, 28, 28) sts in patt, then place them onto a st holder or waste yarn for right shoulder, BO 42 (48, 52, 54, 56, 58) sts removing markers, then work in patt to end—27 (27, 27, 28, 28, 28) sts rem for left shoulder.

Shape Left Shoulder

Shape left shoulder using short-rows (see Glossary) as foll:

NEXT ROW: (WS) Purl to neck edge, turn.

SHORT-ROW 1: (RS) Work 24 sts in patt, wrap next st and turn so WS is facing; work in patt to end of row.

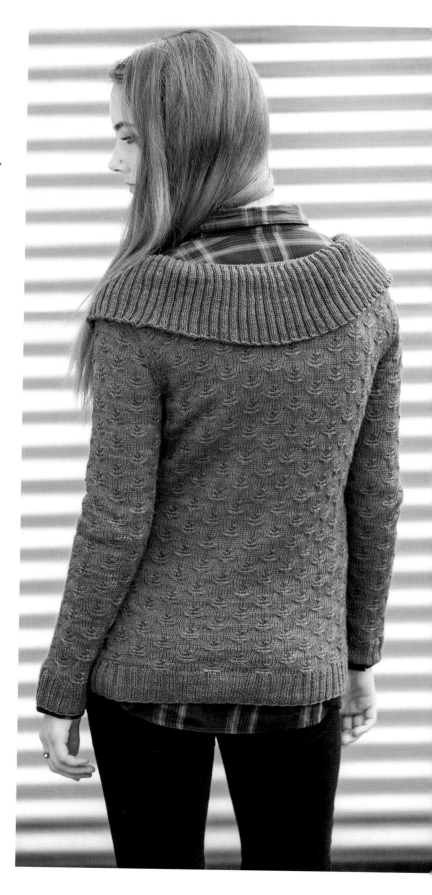

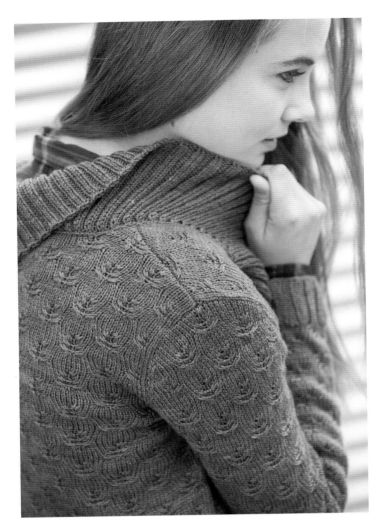

SHORT-ROW 2: Work 18 sts in patt, wrap next st and turn so WS is facing; work in patt to end of row.

SHORT-ROW 3: Work 12 sts in patt, wrap next st and turn so WS is facing; work in patt to end of row.

SHORT-ROW 4: Work 6 sts in patt, wrap next st and turn so WS is facing; work in patt to end of row.

NEXT ROW: (RS) Knit, working wraps as you come to them.

Place left shoulder sts onto st holder or waste yarn. Break yarn.

Shape Right Shoulder

Return 27 (27, 27, 28, 28, 28) held right shoulder sts to needle and join yarn preparing to work a WS row.

SHORT-ROW 1: (WS) Work 24 sts in patt, wrap next st and turn so RS is facing; work in patt to end of row.

SHORT-ROW 2: Work 18 sts in patt, wrap next st and turn so RS is facing; work in patt to end of row.

SHORT-ROW 3: Work 12 sts in patt, wrap next st and turn so RS is facing; work in patt to end of row.

SHORT-ROW 4: Work 6 sts in patt, wrap next st and turn so RS is facing; work in patt to end of row.

NEXT ROW: (WS) Purl, working wraps as you come to them.

Place sts onto st holder or waste yarn. Break yarn.

Cable

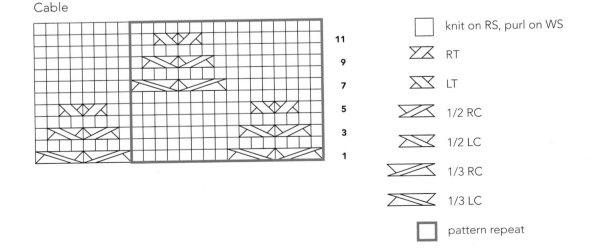

☐	knit on RS, purl on WS
⧖	RT
⧗	LT
	1/2 RC
	1/2 LC
	1/3 RC
	1/3 LC
☐	pattern repeat

front

Work as for back to armhole shaping—114 (128, 142, 156, 170, 184) sts.

Pm each side of center 14 (16, 18, 18, 20, 20) sts for neck.

(*Note:* Neck and armhole shaping begin at the same time. Read the next sections all the way through before proceeding.)

SHAPE ARMHOLES

Same as for back.

At the same time, on first row of armhole shaping, beg neck shaping as foll:

SHAPE NECK

NEXT ROW: (RS) Work in patt to neck m, join a second ball of yarn to work across both fronts at the same time, BO 14 (16, 18, 18, 20, 20) marked neck sts removing m, then work in patt to end.

Working each side at the same time with separate balls of yarn, BO 3 sts at each neck edge 2 (2, 3, 3, 3, 3) times, BO 2 sts at each neck edge 3 times.

NECK DEC ROW: (RS) Work in patt to 3 sts before neck edge, k2tog, k1; on other side, k1, ssk, work in patt to end—1 st dec'd each side.

Work 1 row even.

Rep the last 2 rows 1 (3, 1, 2, 2, 3) more time(s)—27 (27, 27, 28, 28, 28) sts rem after all shaping is complete.

Work even in patt until armholes meas 6¾ (7¼, 7¾, 8¼, 8¾, 9¼)" (17 [18.5, 19.5, 21, 22, 23.5] cm), ending after a WS row.

Shape Left Shoulder

Shape left shoulder using short-rows as foll:

NEXT ROW: (RS) Work in patt to neck edge, turn.

SHORT-ROW 1: (WS) Work 24 sts in patt, wrap next st and turn so RS is facing; work in patt to end of row.

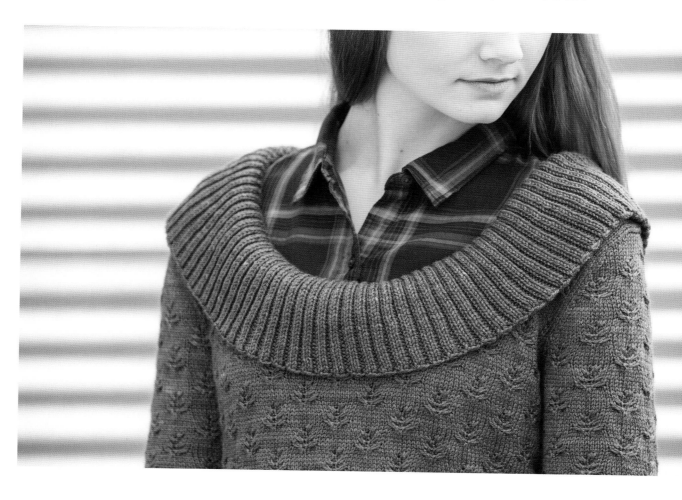

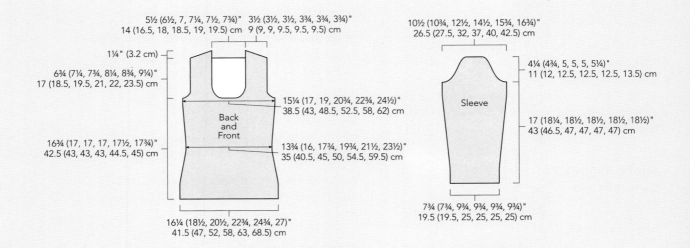

SHORT-ROW 2: Work 18 sts in patt, wrap next st and turn so RS is facing; work in patt to end of row.

SHORT-ROW 3: Work 12 sts in patt, wrap next st and turn so RS is facing; work in patt to end of row.

SHORT-ROW 4: Work 6 sts in patt, wrap next st and turn so RS is facing; work in patt to end of row.

NEXT ROW: (WS) Purl, working wraps as you come to them.

Place left shoulder sts onto st holder or waste yarn. Break yarn.

Shape Right Shoulder
Shape right shoulder using short-rows as foll:

SHORT-ROW 1: (RS) Work 24 sts in patt, wrap next st and turn so WS is facing; work in patt to end of row.

SHORT-ROW 2: Work 18 sts in patt, wrap next st and turn so WS is facing; work in patt to end of row.

SHORT-ROW 3: Work 12 sts in patt, wrap next st and turn so WS is facing; work in patt to end of row.

SHORT-ROW 4: Work 6 sts in patt, wrap next st and turn so WS is facing; work in patt to end of row.

NEXT ROW: (RS) Knit, working wraps as you come to them.
Place sts onto st holder or waste yarn. Break yarn.

sleeves

CO 58 (58, 74, 74, 74, 74) sts.

Work ribbing until piece meas 2" (5 cm), ending after a WS row.

EST PATT: (RS) Sl 1 pwise wyb, work Cable chart to last st, k1.

NEXT ROW: (WS) Sl 1 pwise wyf, work Cable chart to last st, p1.

SHAPE SLEEVE
INC ROW: (RS) S1 pwise wyb, m1L, work in patt to last st, m1R, k1—2 sts inc'd.

[Work 13 (13, 13, 7, 5, 5) rows even in patt, then rep inc row] 2 (1, 8, 14, 20, 12) time(s)—64 (62, 92, 104, 116, 100) sts.

[Work 11 (11, 11, 5, 3, 3) rows even in patt, then rep inc row] 7 (9, 1, 2, 1, 13) time(s)—78 (80, 94, 108, 118, 126) sts.

Work even in patt until piece meas 17 (18¼, 18½, 18½, 18½, 18½)" (43 [46.5, 47, 47, 47, 47] cm) from CO edge, ending after a WS row.

SHAPE CAP
BO 3 (3, 4, 4, 5, 5) sts at beg of next 2 rows—72 (74, 86, 100, 108, 116) sts rem.

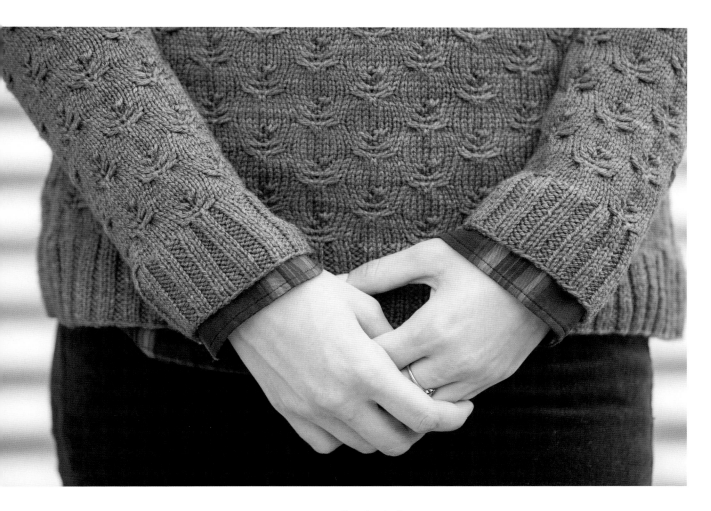

BO 3 sts at beg of next 2 (4, 4, 6, 8, 8) rows—66 (62, 74, 82, 84, 92) sts rem.

BO 2 sts at beg of next 2 (2, 4, 4, 6, 8) rows—62 (58, 66, 74, 72, 76) sts rem.

Sizes 30½ (38, 41½, 45½, 49)" only:
BO 1 st at beg of next 22 (24, 16, 12, 10) rows—40 (42, 58, 60, 66) sts rem.

Size 34" only:
Work 2 rows even.

All Sizes:
BO 2 (1, 2, 2, 2, 2) st(s) at beg of next 4 (26, 4, 10, 10, 12) rows—32 (32, 34, 38, 40, 42) sts rem.

BO 2 sts at beg of next 4 rows, then BO 3 sts at beg of next 2 rows—18 (18, 20, 24, 26, 28) sts rem.

BO all rem sts.

Make a second sleeve the same as the first.

finishing

Block to measurements. With back and front RS's facing each other, use the three-needle method (see Glossary) to join shoulder seams together. Seam sides and under sleeves. Set sleeves into armholes.

COLLAR
With WS facing, beg at the center back, pick up and knit 164 (176, 180, 178, 182, 176) sts evenly around the neck opening. Pm for beg of rnd and join to work in the rnd.

RND 1: *K1f&b; rep from *—328 (352, 360, 356, 364, 352) sts.

RND 2: *K2, p2; rep from * to end of rnd.

Rep Rnd 2 until cowl meas 4½" (11.5 cm) from pick-up rnd.

BO all sts in patt.

Weave in ends. Block again if desired.

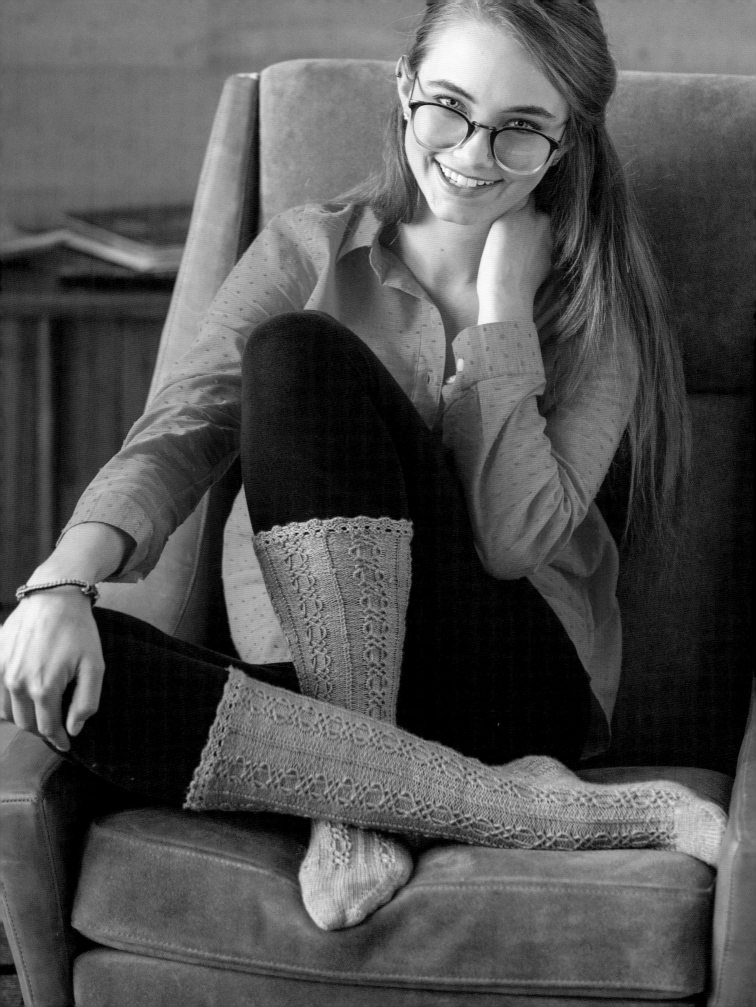

rapho socks

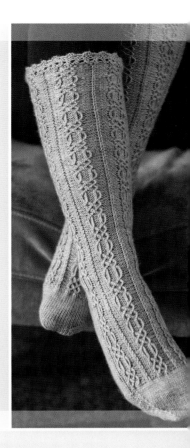

TWISTED STITCHES AND DELICATE CABLE MOTIFS add grace to your step with these knee socks. A carefully sculpted calf gusset adds room for ample calves with a twist. Worked from the top down, these socks start with an intriguing scalloped cuff and feature a traditional heel flap and wedge toe.

FINISHED SIZE

Leg Circumference: About 7 (8½, 9¾)" (18 [21.5, 25] cm), relaxed. (*Note:* Leg will stretch to fit about 9 (10¾, 12½)" (23 [27.5, 31.5] cm) circumference.)

Calf Circumference: About 8 (9½, 10¾)" (20.5 [24, 27.5] cm), relaxed. (*Note:* Calf will stretch to fit about 12 (14, 16¼)" (30.5 [35.5, 41.5] cm) circumference.)

Socks shown measure 7" (18 cm) leg circumference.

YARN

Fingering weight (#1 Super Fine).

Shown here: Crabapple Yarns Swag (80% merino, 10% cashmere, 10% nylon; 435 yd [398 m]/100 g): gloster, 2 skeins.

NEEDLES

Size U.S. 1 (2.25 mm): double-pointed (dpn).

Adjust needle size if necessary to obtain the correct gauge.

NOTIONS

Markers (m); stitch holder or waste yarn; cable needle (cn); tapestry needle.

GAUGE

32 sts and 46 rnds = 4" (10 cm) in St st.

40 sts and 46 rnds = 4" (10 cm) in Leg chart, relaxed.

stitch guide

LT: Sl 1 st to cn and hold in front, k1tbl, k1tbl from cn.

RT: Sl 1 st to cn and hold in back, k1tbl, k1tbl from cn.

LTPM: Sl 1 st to cn and hold in front, k1tbl, m1p, k1tbl from cn—1 st inc'd.

RTPM: Sl 1 st to cn and hold in back, k1tbl, m1p, k1tbl from cn—1 st inc'd.

LTP: Sl 1 st to cn and hold in front, p1, k1tbl from cn.

RTP: Sl 1 st to cn and hold in back, k1tbl, p1 from cn.

Note: If you need extra help keeping these socks from falling, you can thread a pretty ribbon through the eyelet row in the cuff.

cuff

Using the long-tail method, CO 90 (105, 125) sts. Do NOT join; work back and forth in rows.

DEC ROW: (RS) *Yo, k5, then one at a time, pass fourth, third, second, and first sts of the k5 over the fifth st of the k5; rep from *—36 (42, 50) sts rem.

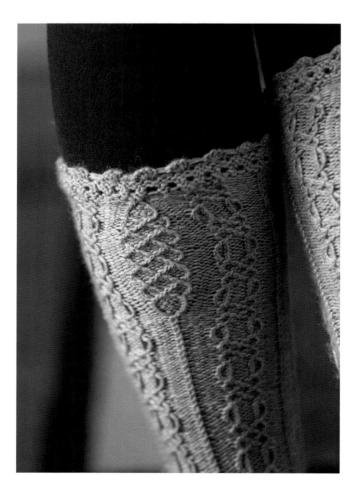

With RS still facing, place marker (pm) for beg of rnd and join for working in the rnd, being careful not to twist sts.

RND 1 (INC): *Work [k1, yo, k1tbl] all in yo of previous row, k1; rep from *—72 (84, 100) sts.

RND 2: *K1, k1tbl, k2; rep from *.

RND 3: Purl.

RND 4: Knit.

RND 5: Purl.

RND 6 (EYELET): *Yo, k2tog, rep from *.

RNDS 7–9: Rep Rnds 3–5 once.

Sizes 9 (12½)" Only:
SET-UP RND: P2tog, k2tbl, p1, *(p2, k2tbl) twice, p3, k2tbl, p1; rep from * to last 11 sts, (p2, k2tbl) twice, p2tog, p1—70 (98) sts rem.

Size 10¾" Only:
SET-UP RND: P1, k2tbl, p1, *(p2, k2tbl) twice, p3, k2tbl, p1; rep from * to last 10 sts, (p2, k2tbl) twice, p2—84 sts.

calf

All Sizes
EST PATT: Work Calf Gusset chart once, then work Leg chart to end of rnd.

Rep last rnd until Calf Gusset chart is finished, ending after Rnd 4 of Leg chart.

leg

RND 1: P1, k2tbl, p1, work Leg chart to end of rnd.

RND 2: P1, RT, p1, work Leg chart to end of rnd.

Rep last 2 rnds until leg is approximately 12¼" (31 cm) long or to your desired height from CO edge, ending after Rnd 10 of Leg chart.

NEXT RND (RND 11 ON CHART): P1, k1tbl, m1p, k1tbl, p1, work Leg chart to last 15 (19, 20) sts, leave rem sts unworked—71 (85, 99) sts.

This is the new beg of rnd; rearrange sts on needles as necessary.

heel flap

The heel flap is worked back and forth in rows over the first 35 (43, 45) sts.

Place the rem 36 (42, 54) instep sts on st holder or waste yarn.

Beg and end where indicated for your size, work Rows 1 and 2 of the Heel chart 17 (19, 21) times.

heel turn

ROW 1: (RS) Sl 1 purlwise with yarn in back (pwise wyb), k19 (23, 25), ssk, k1, turn—1 st dec'd.

ROW 2: (WS) Sl 1 pwise with yarn in front (wyf), p6 (6, 8), p2tog, p1, turn—1 st dec'd.

ROW 3: Sl 1 pwise wyb, knit to 1 st before gap, ssk, k1, turn—1 st dec'd.

ROW 4: Sl 1 pwise wyf, purl to 1 st before gap, p2tog, p1, turn—1 st dec'd.

Rep the last 2 rows 5 (7, 7) more times—21 (25, 27) sts rem.

NEXT ROW: (RS) Sl 1 pwise wyb, knit to end. Do not turn.

gusset

With RS still facing, pick up and knit 18 (20, 22) sts along the left side of the heel flap, pick up and knit 1 st in corner, pm for new beg of rnd, return 36 (42, 54)

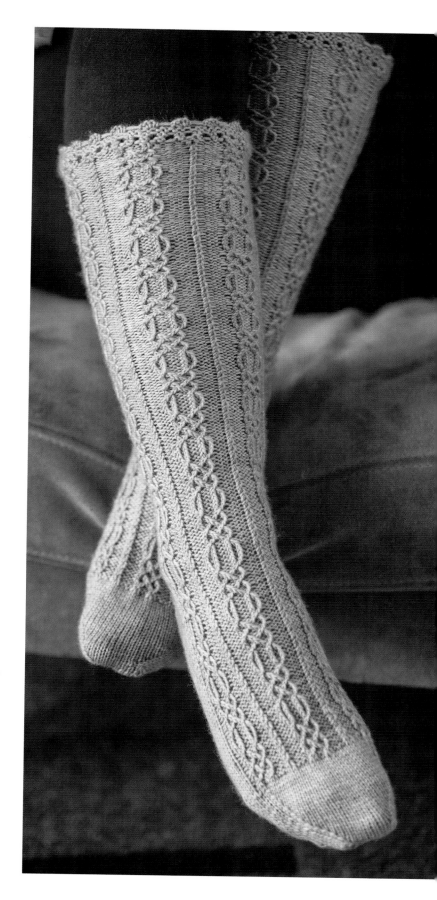

Leg

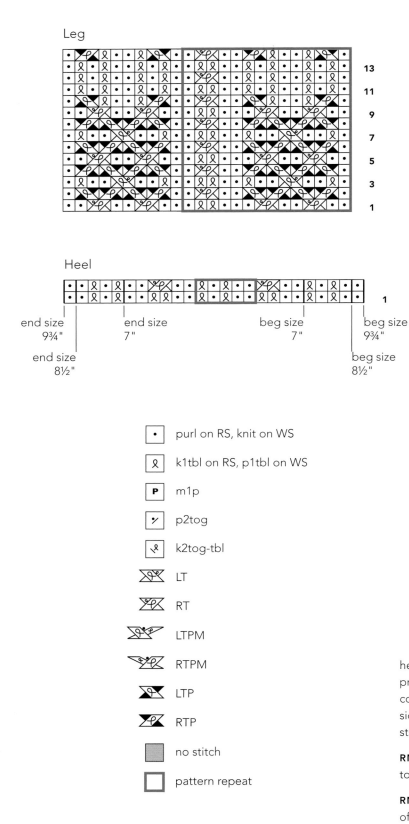

Heel

end size
9¾"

end size
7"

beg size
7"

beg size
9¾"

end size
8½"

beg size
8½"

•	purl on RS, knit on WS	
ℓ	k1tbl on RS, p1tbl on WS	
P	m1p	
⟋	p2tog	
⟍	k2tog-tbl	
LT symbol	LT	
RT symbol	RT	
LTPM symbol	LTPM	
RTPM symbol	RTPM	
LTP symbol	LTP	
RTP symbol	RTP	
(shaded box)	no stitch	
(open box)	pattern repeat	

Calf Gusset

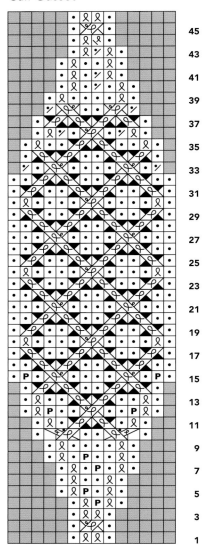

held instep sts to needle and work Leg chart as est, pm for side of foot, then pick up and knit 1 st in the corner, pick up and knit 18 (20, 22) sts along the right side of the heel flap, knit to end of rnd—95 (109, 127) sts.

RND 1: Work Leg chart as est to m, sl m, k1, ssk, knit to 3 sts before end of rnd, k2tog, k1—2 sts dec'd.

RND 2: Work Leg chart as est to m, sl m, knit to end of rnd.

Rep the last 2 rnds 11 (12, 9) times—71 (83, 107) sts rem; 35 (41, 53) sole sts and 36 (42, 54) instep sts.

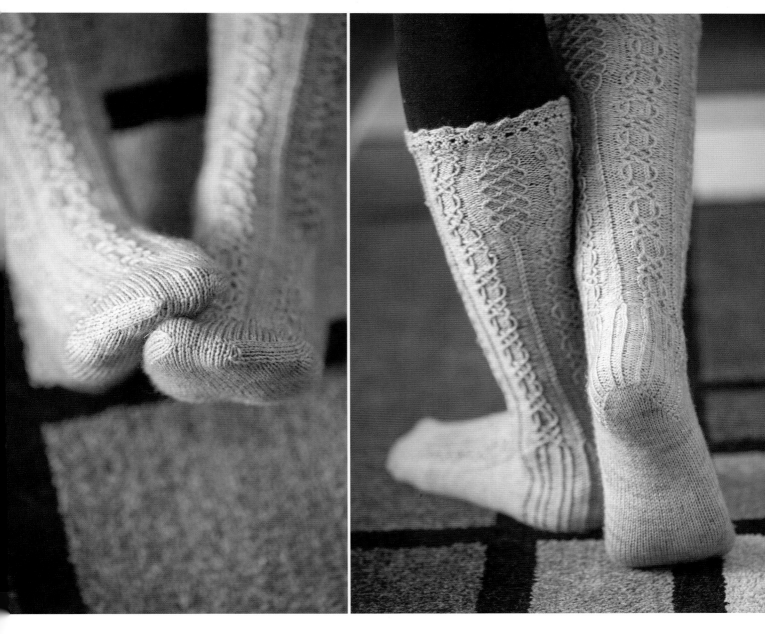

foot

Continue as established until foot meas 2 (2½, 3¼)" (5 [6.5, 8.5] cm) shorter than desired length.

DEC RND: K2tog, knit to end of rnd—70 (82, 106) sts rem; 35 (41, 53) sts each instep and sole.

toe

RND 1: *K1, ssk, knit to 3 sts before m, k2tog, k1; rep from *—4 sts dec'd.

RND 2: Knit.

Rep the last 2 rnds 10 (12, 16) times, then work Rnd 1 once more—22 (26, 34) sts rem.

Arrange sts so that 11 (13, 17) sts for each instep and sole are on separate needles and graft them together using Kitchener st (see Glossary).

finishing

Block to measurements. Weave in loose ends.

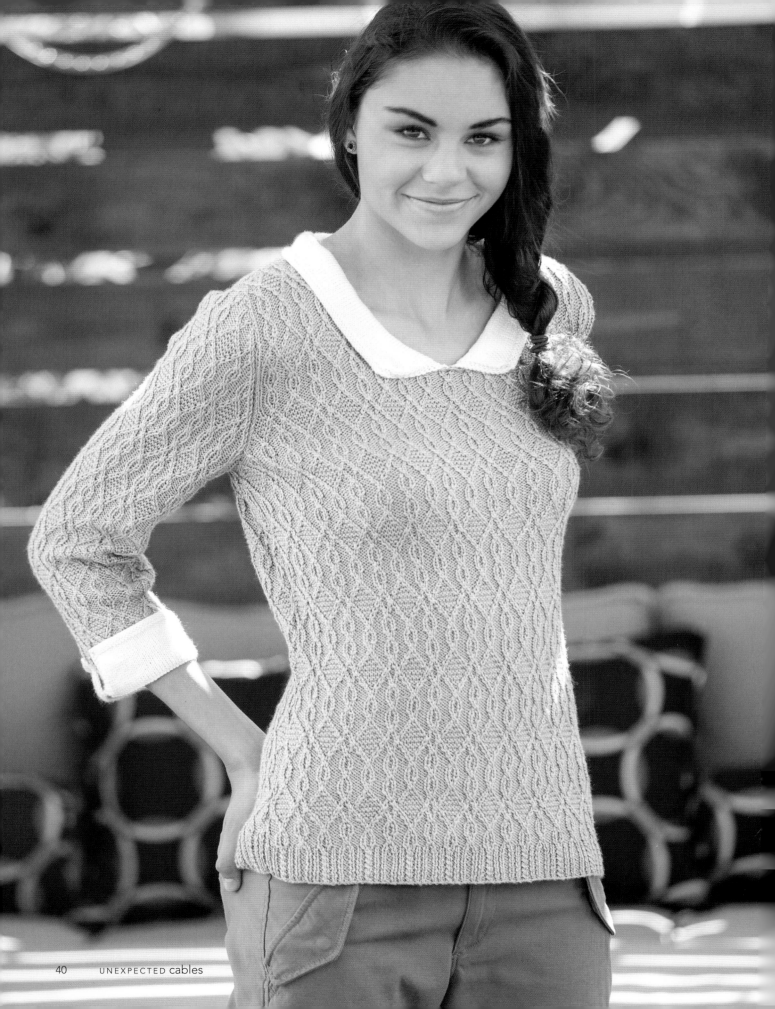

cocalico pullover

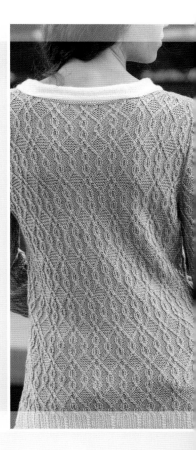

THIS SWEET PULLOVER features allover cables refined by using a silky lightweight yarn. Set-in three-quarter-length sleeves with contrasting cuffs match the cheeky Peter Pan collar keeping the look young and fresh.

FINISHED SIZE
Bust Circumference: About 30½ (33½, 36½, 39½, 42½, 45½, 48½)" (77.5 [85, 92.5, 100.5, 108, 115.5, 123] cm).

Length: About 23¾ (24¼, 24¾, 25½, 25¾, 26¼, 27)" (60.5 [61.5, 63, 65, 65.5, 66.5, 68.5] cm).

Sweater shown measures 36½" (92.5 cm).

YARN
Sport weight (#2 Fine).

Shown here: Mirasol Yarn Nuna (40% silk, 40% wool, 20% bamboo; 191 yd [175 m]/50 g): #24 delicate lilac (MC), 8 (9, 9, 10, 11, 12, 13) skeins; #12 seashell (CC), 1 skein.

NEEDLES
Body and Sleeves: Size U.S. 4 (3.5 mm): 24" (60 cm) circular (cir).

Collar and Cuffs: Size U.S. 3 (3.25 mm): 16" (40 cm) cir and set of double-pointed (dpn).

Adjust needle size if necessary to obtain the correct gauge.

NOTIONS
Markers (m); cable needle (cn); st holder or waste yarn; tapestry needle.

GAUGE
32 sts and 38½ rows = 4" (10 cm) in Cable chart on larger needle.

stitch guide

1/1 RC: Sl 1 st to cn and hold in back, k1, k1 from cn.

1/1 LC: Sl 1 st to cn and hold in front, k1, k1 from cn.

1/1 RPC: Sl 1 st to cn and hold in back, k1, p1 from cn.

1/1 LPC: Sl 1 st to cn and hold in front, p1, k1 from cn.

Notes: Circular needle is used on body and sleeves to accommodate large number of sts. Do not join; work back and forth in rows.

Maintain first and last st of each row in St st (knit on RS, purl on WS) for ease when seaming.

When working shaping, work cables as established unless you are unable to complete a cross with all sts. If this is not possible because of the current st count, work sts as they appear (knit the knit sts and purl the purl sts) instead.

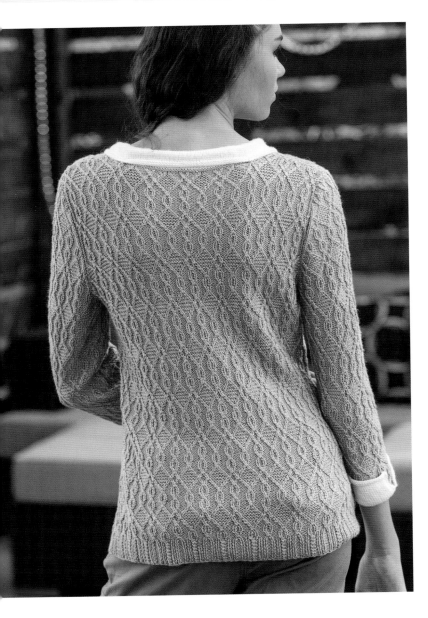

back

With MC and larger needle, CO 122 (134, 146, 158, 170, 182, 194) sts. Do not join; work back and forth in rows.

Work Ribbing chart for 1½" (3.8 cm), ending after a WS row.

Work Rows 1–10 of Cable chart.

SHAPE WAIST

Cont working in Cable chart while working as foll:

DEC ROW: (RS) K1, ssk, work in patt to last 3 sts, k2tog, k1—2 sts dec'd.

[Work 11 rows even, then rep dec row] 1 (1, 3, 3, 4, 4, 4) time(s)—118 (130, 138, 150, 160, 172, 184) sts rem.

[Work 9 rows even, then rep dec row] 4 (4, 2, 2, 1, 1, 1) time(s)—110 (122, 134, 146, 158, 170, 182) sts.

Work even in patt until piece meas 9¼ (9¼, 9½, 9½, 9¾, 9¾, 9¾)" (23.5 [23.5, 24, 24, 25, 25, 25] cm) from CO edge, ending after a WS row.

INC ROW: (RS) K1, m1R (see Glossary), work in patt to last st, m1L (see Glossary), k1—2 sts inc'd.

Sizes 33½ (36½, 39½, 45½, 48½)" only:

Work 13 rows even, then rep inc row—126 (138, 150, 174, 186) sts rem.

All Sizes:

[Work 11 rows even, then rep inc row] 5 (4, 4, 4, 5, 4, 4) times—122 (134, 146, 158, 170, 182, 194) sts.

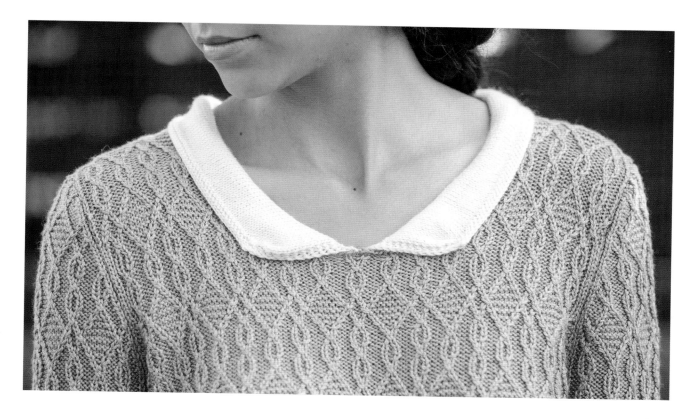

Work even in patt until piece meas 16¾ (17, 17¼, 17¼, 17¼, 17½, 17½)" (42.5 [43, 44, 44, 44, 44.5, 44.5] cm) from CO edge, ending after a WS row.

SHAPE ARMHOLES

BO 3 (3, 3, 4, 4, 5, 5) sts at the beg of the next 2 rows, BO 3 sts at the beg of the next 2 (4, 4, 4, 6, 8, 8) rows, BO 2 sts at the beg of the next 2 (2, 2, 4, 6, 6, 8) rows, then BO 1 st at the beg of the next 2 (6, 16, 18, 18, 18, 24) rows—104 (106, 108, 112, 114, 118, 120) sts rem.

Work even in patt until armholes meas 7 (7¼, 7½, 8¼, 8½, 8¾, 9½)" (18 [18.5, 19, 21, 21.5, 22, 24] cm), ending after a WS row.

SEPARATE SHOULDERS

NEXT ROW: (RS) Work 28 (28, 28, 28, 28, 30, 30) sts in patt, then place them onto a st holder or waste yarn for right shoulder, BO 48 (50, 52, 56, 58, 58, 60) sts, work in patt to end—28 (28, 28, 28, 28, 30, 30) sts rem for left shoulder.

Shape Left Shoulder

Shape left shoulder using short-rows (see Glossary) as foll:

NEXT ROW: (WS) Work even to neck edge, turn.

SHORT-ROW 1: (RS) Work in patt to last 7 sts, wrap next st and turn so WS is facing; work in patt to end of row.

SHORT-ROW 2: Work in patt to last 14 sts, wrap next st and turn so WS is facing; work in patt to end of row.

SHORT-ROW 3: Work in patt to last 21 sts, wrap next st and turn so WS is facing; work in patt to end of row.

NEXT ROW: (RS) Work in patt, working wraps as you come to them.

BO all sts in patt.

Shape Right Shoulder

Return 28 (28, 28, 28, 28, 30, 30) held right shoulder sts to larger needle and join yarn preparing to work a WS row.

SHORT-ROW 1: (WS) Work in patt to last 7 sts, wrap next st and turn so RS is facing; work in patt to end of row.

SHORT-ROW 2: Work in patt to last 14 sts, wrap next st and turn so RS is facing; work in patt to end of row.

Cable

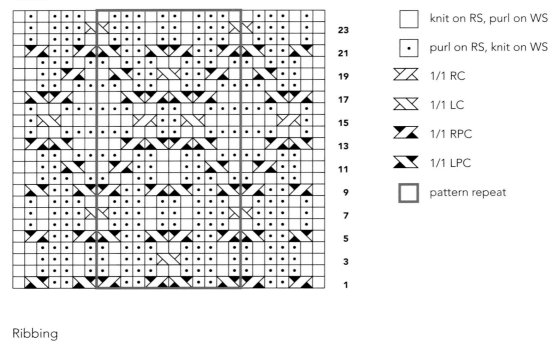

□	knit on RS, purl on WS
·	purl on RS, knit on WS
⤬	1/1 RC
⤬	1/1 LC
⤬	1/1 RPC
⤬	1/1 LPC
□	pattern repeat

Ribbing

SHORT-ROW 3: Work in patt to last 21 sts, wrap next st and turn so RS is facing; work in patt to end of row.

NEXT ROW: (WS) Work in patt, working wraps as you come to them.

BO all sts in patt.

front

Work as for back to armhole shaping—122 (134, 146, 158, 170, 182, 194) sts.

SHAPE ARMHOLES

BO 3 (3, 3, 4, 4, 5, 5) sts at the beg of the next 2 rows, BO 3 sts at the beg of the next 2 (4, 4, 4, 6, 8, 8) rows, BO 2 sts at the beg of the next 2 (2, 2, 4, 6, 6, 8) rows, then BO 1 st at the beg of the next 2 (6, 16, 18, 18, 18, 24) rows—104 (106, 108, 112, 114, 118, 120) sts rem.

Work even in patt for 20 (18, 10, 10, 12, 12, 8) rows, ending after a WS row.

Pm each side of center 16 (16, 18, 18, 20, 20, 20) sts for neck.

SHAPE NECK

NEXT ROW: (RS) Work in patt to neck marker, remove m, join second ball of yarn to work across both fronts at the same time, BO 16 (16, 18, 18, 20, 20, 20) sts, remove second m, work in patt to end of row—44 (45, 45, 47, 47, 49, 50) sts rem on each side.

Working each side at the same time with separate balls of yarn, BO 4 (4, 4, 4, 5, 5) sts at each neck edge once, BO 3 (3, 3, 4, 4, 4, 4) sts at each neck edge once, then BO 2 (2, 2, 3, 3, 3, 3) sts at each neck edge once—35 (36, 36, 36, 36, 37, 38) sts rem on each side

Work 1 WS row even.

DEC ROW: (RS) Work in patt to 3 sts before neck edge, k2tog, k1; on other side k1, ssk, work in patt to end—1 st dec'd each side.

Rep the last 2 rows 6 (7, 7, 7, 7, 6, 7) times—28 (28, 28, 28, 28, 30, 30) sts rem each side.

Work even as established until armhole measures 7 (7¼, 7½, 8¼, 8½, 8¾, 9½)" (18 [18.5, 19, 21, 21.5, 22, 24] cm) ending after a RS row.

Shape Right Shoulder

Shape right shoulder using short-rows as foll:

NEXT ROW: (WS) Work even to neck edge, turn.

SHORT-ROW 1: (RS) Work in patt to last 7 sts, wrap next st and turn so WS is facing; work in patt to end of row.

SHORT-ROW 2: Work in patt to last 14 sts, wrap next st and turn so WS is facing; work in patt to end of row.

SHORT-ROW 3: Work in patt to last 21 sts, wrap next st and turn so WS is facing; work in patt to end of row.

NEXT ROW: (RS) Work in patt, working wraps as you come to them.

BO right shoulder sts in patt.

Shape Left Shoulder

Shape left shoulder using short-rows as foll:

SHORT-ROW 1: (WS) Work in patt to last 7 sts, wrap next st and turn so RS is facing; work in patt to end of row.

SHORT-ROW 2: Work in patt to last 14 sts, wrap next st and turn so RS is facing; work in patt to end of row.

SHORT-ROW 3: Work in patt to last 21 sts, wrap next st and turn so RS is facing; work in patt to end of row.

NEXT ROW: (WS) Work in patt, working wraps as you come to them.

BO all sts in patt.

sleeves

With MC and larger needle, CO 74 (74, 86, 86, 98, 110, 110) sts. Do not join; work back and forth in rows.

SHAPE SLEEVE

Work Cable chart for 15 (11, 19, 9, 9, 9, 9) rows.

INC ROW: (RS) K1, m1L, work in patt to last st, m1R, k1—2 sts inc'd.

Rep the last 16 (12, 20, 10, 10, 10, 10) rows 1 (8, 5, 8, 0, 8, 0) time(s)—78 (92, 98, 104, 100, 128, 112) sts.

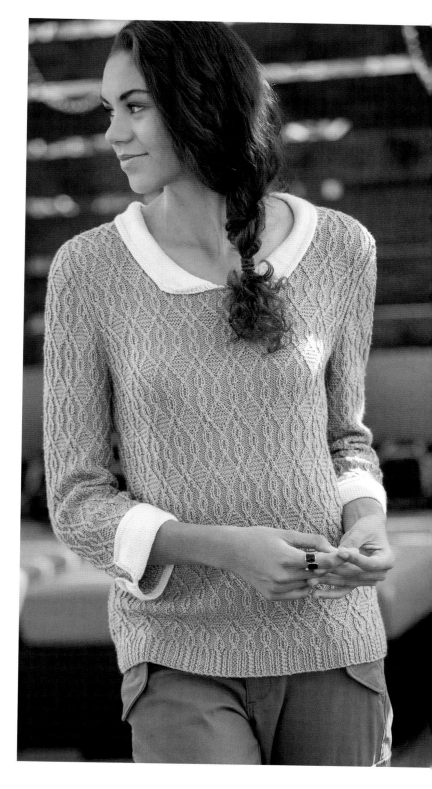

Sizes 30½ (33½, 39½, 42½, 45½, 48½)" only:
[Work in patt for 13 (9, 7, 7, 7, 7) rows, then rep inc row] 6 (1, 4, 14, 4, 14) time(s)—90 (94, 112, 128, 136, 140) sts.

All Sizes:
Work even in patt until piece meas 13 (13¼, 13½, 13¾, 13¾, 13¾, 13¾)" (33 [33.5, 34.5, 35, 35, 35, 35] cm) from CO edge, ending after a WS row.

SHAPE CAP
BO 3 (3, 3, 4, 4, 5, 5) sts at beg of next 2 rows—84 (88, 92, 104, 120, 126, 130) sts rem.

BO 3 sts at beg of next 2 (4, 4, 4, 6, 8, 8) rows—78 (76, 80, 92, 102, 102, 106) sts rem.

BO 2 sts at beg of next 2 (2, 2, 4, 6, 6, 8) rows—74 (72, 76, 84, 90, 90, 90) sts rem.

Sizes 30½ (33½, 36½, 48½)" only:
Work 4 (6, 4, 2) rows even, ending after a WS row.

Sizes 39½ (42½, 45½)" only:
BO 1 st at beg of next 44 (42, 40) rows—40 (48, 50) sts rem.

Sizes 30½ (33½, 36½, 42½, 45½, 48½)" only:
BO 1 (1, 1, 2, 2, 1) st(s) at beg of next 40 (36, 40, 2, 2, 44) rows—34 (36, 36, 44, 46, 46) sts rem.

All Sizes:
BO 2 sts at beg of next 4 rows, then BO 3 sts at the beg of the next 2 rows—20 (22, 22, 26, 30, 32, 32) sts rem.

BO all rem sts.

Make second sleeve the same as the first.

finishing

Block to measurements. Weave in ends. Seam sides, shoulders, and under sleeves. Set sleeves into armholes.

COLLAR
With WS facing, smaller cir needle and CC, beg in the center of the front neck, pick up and knit 164 (170, 190, 208, 214, 220, 236) sts evenly around. Do not join; work back and forth in rows.

ROW 1: (RS) Sl 1 purlwise with yarn in back (pwise wyb), k2, purl to last 3 sts, k3.

ROW 2: (WS) Sl 1 pwise with yarn in front (wyf), knit to end.

Rep last 2 rows until collar meas 1½" (3.8 cm) from pick-up row.

DEC ROW: (RS) Sl 1 pwise wyb, k2, sssk, knit to last 5 sts, k3tog, k3—4 sts dec'd.

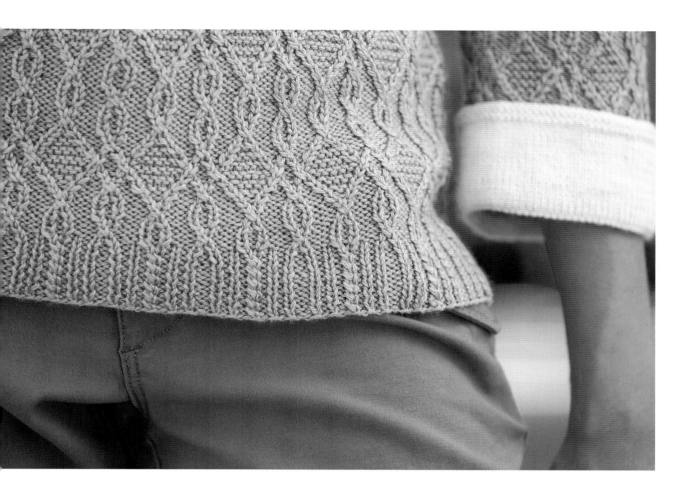

DEC ROW: (WS) Sl 1 pwise wyf, k2, p3tog, purl to last 5 sts, sssp, k3—4 sts dec'd.

Rep last 2 rows once more—148 (154, 174, 192, 198, 204, 220) sts rem.

NEXT ROW: (RS) Sl 1 pwise wyb, knit to end.

NEXT ROW: (WS) Sl 1 pwise wyf, knit to end.

Rep last 2 rows once more.

BO all sts.

Tack collar points to sweater front.

CUFFS

With WS facing, smaller dpn and CC, beg in the center of the sleeve (opposite from the seam), pick up and knit 74 (74, 86, 86, 98, 110, 110) sts evenly around (1 st in each CO st). Pm and join for knitting in the rnd. Knit 1 rnd with the WS facing, then turn so RS is facing.

Cont working back and forth in rows.

NEXT ROW: (RS) Sl 1 pwise wyf, purl to end.

NEXT ROW: (WS) Sl 1 pwise wyb, knit to end.

TURNING ROW: (RS) Sl 1 pwise wyf, knit to end.

ROW 1: (WS) Sl 1 pwise wyb, knit to end.

ROW 2: (RS) Sl 1 pwise wyf, k2, purl to last 3 sts, k3.

Rep the last 2 rows until cuff meas 1½" (3.8 cm) from turning row.

NEXT ROW: (WS) Sl 1 pwise wyb, knit to end.

NEXT ROW: (RS) Sl 1 pwise wyf, knit to end.

Rep the last 2 rows once more.

BO all sts.

Tack cuff points to sleeve.

Make second sleeve cuff the same as the first.

Block again if desired.

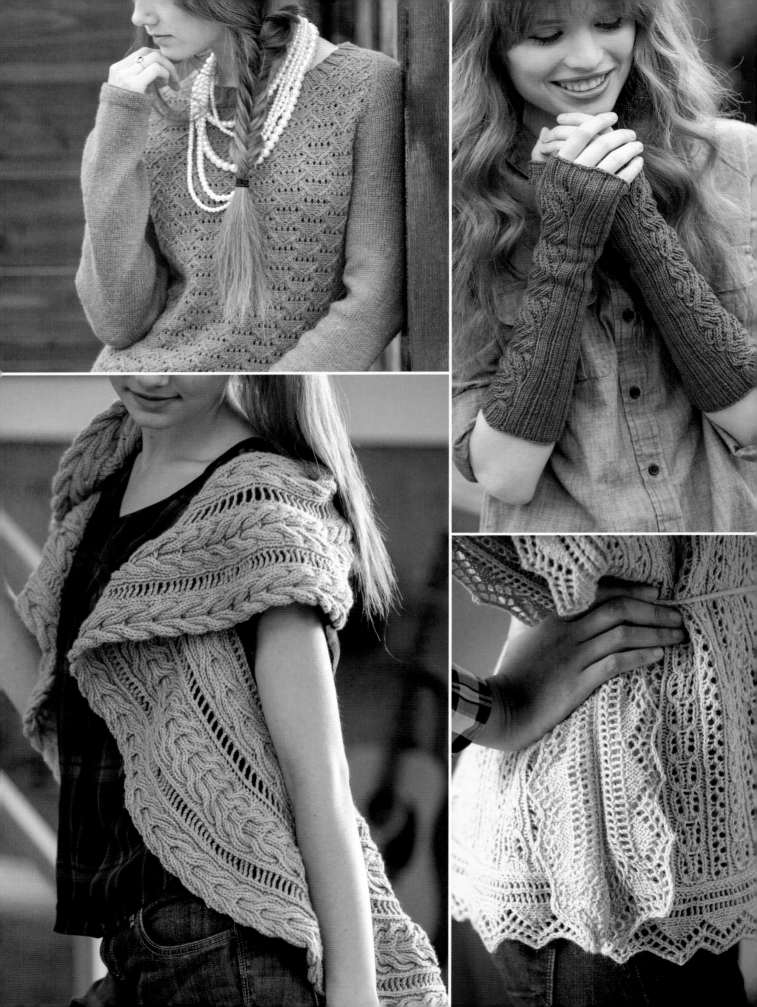

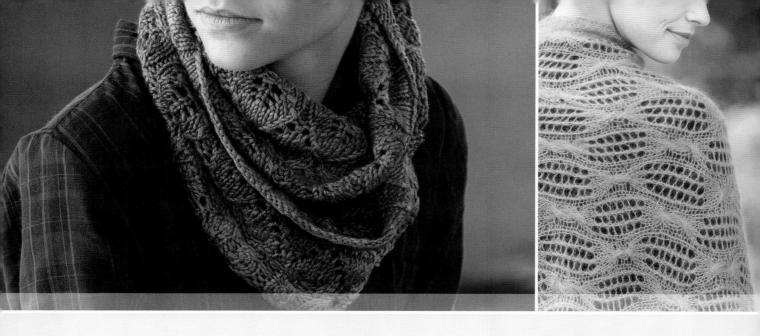

CHAPTER 2 | lace

CABLES AND LACE, TWO OF MY FAVORITE KNITTING TECHNIQUES, come together in this section to produce unexpectedly light and feminine accessories and garments. The six projects in this chapter feature lace that ranges from allover to a simple sprinkling of eyelets, as well as balances the openness of lace with the denseness of cabling.

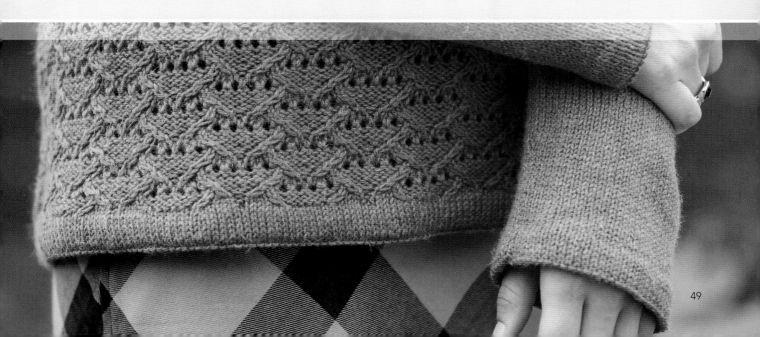

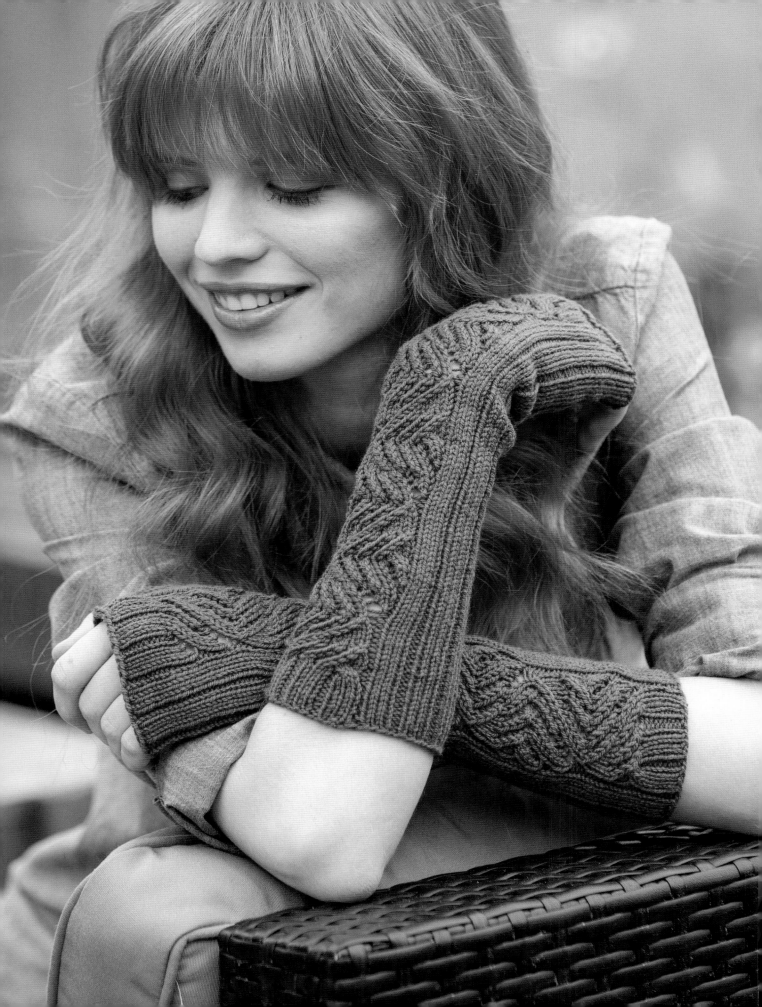

bainbridge armwarmers

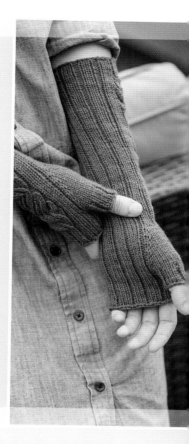

WORKED FROM THE TOP DOWN, these fun and functional armwarmers are easily adjustable. Make them short to keep just your wrists toasty, or make them even longer for full-length coverage. A sinuous cable and lace panel is worked down the fronts to the back of the hands. Ribbing and a gusset for the thumb give you a customized fit.

FINISHED SIZE

Arm Circumference: About 4¾ (5¼, 6)" (12 [13.5, 15] cm).

Will stretch to fit about 7 (8, 9½)" 18 [20.5, 24] cm) arm circumference.

Length: About 12½" (32 cm).

Armwarmers shown measure 5¼" (13.5 cm).

YARN

Sport weight (#2 Fine).

Shown here: Quince and Co. Chickadee (100% wool; 181 yd [166 m]/50 g): crocus, 2 skeins.

NEEDLES

Size U.S. 6 (4 mm): double-pointed (dpn).

Adjust needle size if necessary to obtain the correct gauge.

NOTIONS

Markers (m); cable needle (cn); tapestry needle.

GAUGE

35 sts and 37 rnds = 4" (10 cm) in k3, p1 ribbing, relaxed.

12 sts = 1½" (3.8 cm) in Cable chart.

stitch guide

2/2 RC: Sl 2 sts to cn and hold in back, k2, k2 from cn.

2/2 LC: Sl 2 sts to cn and hold in front, k2, k2 from cn.

K3, p1 Ribbing (multiple of 4 sts)

RND 1: *K3, p1; rep from *.

Rep Rnd 1 for patt.

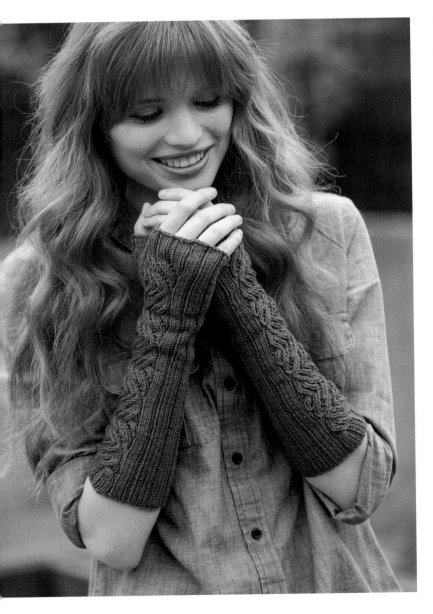

right armwarmer

CO 40 (44, 52) sts. Divide sts evenly over dpn. Place marker (pm) and join for knitting in the rnd, being careful not to twist sts.

CUFF

Work in k3, p1 ribbing until piece meas 1" (2.5 cm) from CO edge.

ARM

EST PATT: Work Rnd 1 of Cable chart over first 12 sts, then work in rib to end of rnd.

Cont working even as est, until Rnds 1–24 of Cable chart have been completed 3 times.

[Piece should meas about 8¾" (22 cm) to here.]

GUSSET

SET-UP RND: Work Cable chart over 12 sts, k3, p1, k1, pm, m1R (see Glossary), k1, m1L (see Glossary), pm, work in est rib to end of rnd—42 (46, 54) sts.

NEXT RND: Work as est to m, sl m, knit to next m, sl m, work in est rib to end of rnd.

INC RND: Work as est to m, sl m, m1R, knit to m, m1L, sl m, work in est rib to end of rnd—2 sts inc'd.

[Work 2 rnds even as est, then rep inc rnd] 4 (6, 6) more times—50 (58, 66) sts.

NEXT RND: Work as est to m, remove m, sl next 11 (15, 15) sts to st holder or waste yarn, remove m, use the backward loop method (see Glossary) to CO 1 st, work in est rib to end of rnd—40 (44, 52) sts rem.

Cont working as est until piece meas about 11½" (29 cm) from CO edge, ending after Rnd 24 of Cable chart.

Work k3, p1 ribbing for 1" (2.5 cm).

BO all sts loosely in rib.

THUMB

Divide 11 (15, 15) held sts over dpn and join yarn to work with RS facing.

NEXT RND: Work in rib as est for 11 (15, 15) sts, then pick up and knit 3 sts over CO—14 (18, 18) sts. Join for working in the rnd.

NEXT RND: Work in est rib for 10 (14, 14) sts, ssk, k1, k2tog—12 (16, 16) sts.

(*Note:* The last k2tog uses the last st of the rnd and the first st of the rnd.)

Pm for beg of rnd.

Work in rib as est for 1" (2.5 cm). BO all sts loosely in rib.

left armwarmer

Work as for right armwarmer until arm.

ARM
EST PATT: Work Rnd 13 of Cable chart over first 12 sts, then work in est rib to end of rnd.

Cont working even as est, until Rnds 13–24 of Cable chart are complete; work Rnds 1–24 twice, then work Rnds 1–12 once more.

[Piece should meas about 8¾" (22 cm) to here.]

GUSSET
SET-UP RND: Work as est to last 7 sts, pm, m1R, k1, m1L, pm, work in est rib to end of rnd.

NEXT RND: Work as est to m, sl m, knit to next m, sl m, work in est rib to end of rnd.

INC RND: Work as est to m, sl m, m1R, knit to m, m1L, sl m, work in est rib to end of rnd—2 sts inc'd.

[Work 2 rnds even as est, then rep inc rnd] 3 (5, 5) more times—50 (58, 66) sts.

NEXT RND: Work as est to m, remove m, sl next 11 (15, 15) sts to st holder or waste yarn, use the backward loop method to CO 1 st, work in est rib to end of rnd—40 (44, 52) sts rem.

Cont working as est until piece meas about 11½" (29 cm) from CO edge, ending after Rnd 12 of Cable chart.

Work k3, p1 ribbing for 1" (2.5 cm).

BO all sts loosely in rib.

THUMB
Work as for right armwarmer thumb.

finishing

Block to measurements. Weave in ends.

Cable

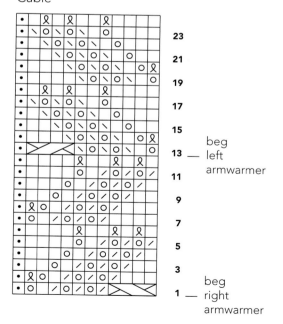

	knit
•	purl
o	yo
\	ssk
/	k2tog
ꝗ	k1tbl
⧅	2/2 RC
⧄	2/2 LC

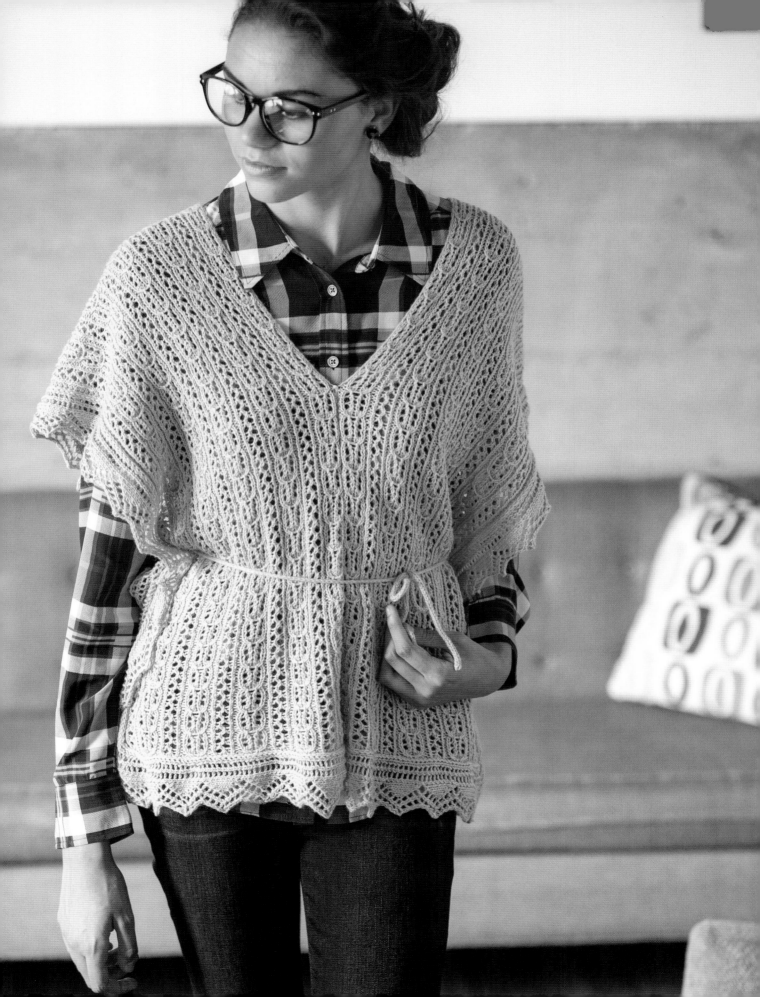

conoy tunic

A SIMPLE AND CASUAL PIECE, this tunic is created with just two rectangular panels. Delicate cables and sinuous lace are married into this relaxed garment. An applied lace edge doubles as decoration, and a side ruffle and a simple I-cord belt bring the look together. The drape and flow of this luxurious alpaca/cotton blend give this tunic graceful movement.

FINISHED SIZE
Bust Circumference: About 31 (39, 46, 54)" (78.5 [99, 117, 137] cm).

Length: About 22½ (23¾, 24¾, 25¼)" (57 [60.5, 63, 64] cm).

Sweater shown measures 39" (99 cm).

YARN
Sport weight (#2 Fine).

Shown here: Manos del Uruguay Serena (60% alpaca, 40% cotton; 170 yd [155 m]/50 g): curry, 5 (6, 7, 8) skeins.

NEEDLES
Size U.S. 5 (3.75 mm): straight and set of 2 double-pointed (dpn).

Adjust needle size if necessary to obtain the correct gauge.

NOTIONS
Crochet hook; markers (m); cable needle (cn); waste yarn; tapestry needle.

GAUGE
26 sts and 34 rows = 4" (10 cm) in Left and Right charts.

stitch guide

1/2 RC: Sl 2 sts to cn and hold in back, k1, k2 from cn.

1/2 LC: Sl 1 st to cn and hold in front, k2, k1 from cn.

Note: When working short-rows on edges, be careful to keep the st count accurate by working each yo with its corresponding dec, noting that on the RS rows between Rows 3–10 there is 1 additional yo to inc the total st count, and on RS rows between Rows 11–18 there is 1 additional dec to dec the total st count.

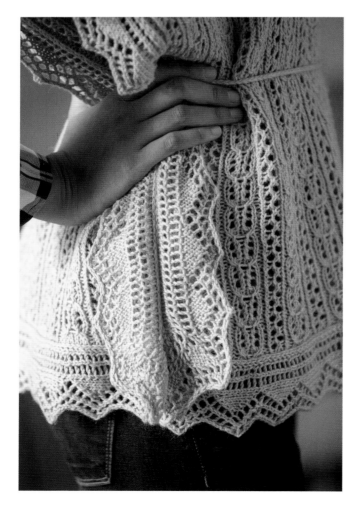

right panel

Use the crochet provisional method (see Glossary) to CO 51 (63, 75, 87) sts.

Work Rows 1–8 of the Right chart 43 (46, 48, 49) times, then work Rows 1–3 once more.

RIGHT EDGE

With RS facing, k51 (63, 75, 87) sts, rotate work 90 degrees clockwise and pick up and knit 173 (185, 193, 197) sts along long edge of the panel (1 st in every other row), carefully remove waste yarn from provisional CO and place 51 (63, 75, 87) sts onto empty needle, then knit across—275 (311, 343, 371) sts.

With WS facing, use the cable method (see Glossary) to CO 1 st, place marker (pm), then CO 10 more sts for edge.

EST PATT: (WS) Work Right Edge chart to m, sl m, p2tog joining 1 st from edge with the picked-up sts from the panel, turn.

NEXT ROW: (RS) Sl 1 pwise wyb, sl m, work Right Edge chart to end.

Cont working as est, and *at the same time,* at each corner, work short-rows (see Glossary) as foll:

*__SHORT-ROW 1: (WS)__ Work in patt to 3 sts before m, wrap next st and turn so RS is facing; work in patt to end of row.

SHORT-ROW 2: Work in patt to 7 sts before m, wrap next st and turn so RS is facing; work in patt to end of row.

NEXT ROW: (WS) Work in patt to m, working wraps together with their sts as they appear, sl m, with right needle pick up the st used in the previous p2tog and place it on the left needle, purl it together with the last edge st to join.

NEXT ROW: (RS) Sl 1 pwise wyb, sl m, work in patt to end.

Rep from * once more.

Once you finish joining all panel sts with the edge sts, end after a RS row—only the number of edge sts rem as needed for the chart, plus 1 st after the m.

BO rem sts.

left panel

Use the crochet provisional method to CO 51 (63, 75, 87) sts.

Work Rows 1–8 of the Left chart 43 (46, 48, 49) times, then work Rows 1–3 once more.

LEFT EDGE

With WS facing, rotate the work 90 degrees counterclockwise and pick up and purl 173 (185, 193, 197) sts along the long edge of the panel (1 st in every other row), carefully remove waste yarn from provisional CO and place 51 (63, 75, 87) sts onto

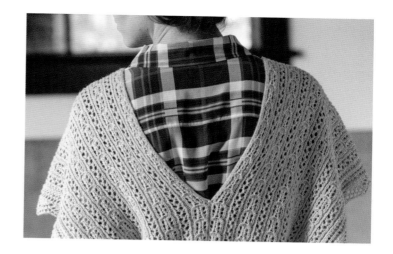

Right Edge

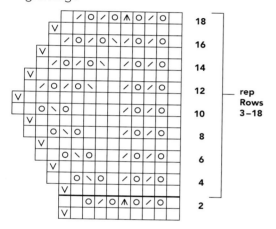

Left Edge

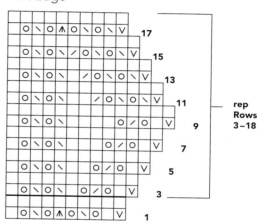

Left

Right

	knit on RS, purl on WS
•	purl on RS, knit on WS
ℛ	k1tbl on RS, p1tbl on WS
o	yo
＼	ssk
／	k2tog
V	sl pwise wyb on RS, wyf on WS
⋀	s2kp
⤬	1/2 RC
⤫	1/2 LC
	pattern repeat

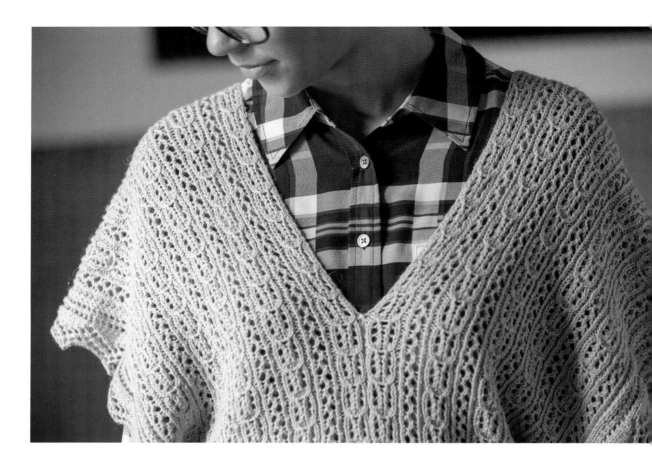

empty needle, then purl across—275 (311, 343, 371) sts.

With RS facing, use the cable method to CO 1 st, pm, then CO 10 more sts for edge.

EST PATT: (RS) Work the Left Edge chart to m, sl m, ssk joining 1 st from edge with the picked-up sts from the panel, turn.

NEXT ROW: (WS) Sl 1 pwise wyf, sl m, work Left Edge chart to end.

Cont working as est, and *at the same time,* at each corner, work short-rows as foll:

***SHORT-ROW 1: (RS)** Work in patt to 3 sts before m, wrap next st and turn so WS is facing; work in patt to end of row.

SHORT-ROW 2: Work in patt to 7 sts before m, wrap next st and turn so WS is facing; work in patt to end of row.

NEXT ROW: (RS) Work in patt to m, working wrap

together with their sts as they appear, sl m, with right needle pick up the st used in the previous ssk and place it on the left needle, ssk it together with the last edge st to join.

NEXT ROW: (WS) Sl 1 pwise wyf, sl m, work in patt to end.

Rep from * once more.

Once you finish joining all panel sts with the edge sts, end after a RS row—only the number of edge sts rem as needed for the chart, plus 1 st after the m.

BO rem sts.

belt

With dpn, CO 3 sts.

Work I-cord (see Glossary) until belt meas 57 (65, 73, 81)" (145 [165, 185.5, 206] cm) from CO edge.

BO all sts.

finishing

Block to measurements.

Use the mattress st (see Glossary) to sew the long edges of the left and right panels and edgings together for 14¼ (15, 15¾, 15¾)" (36 [38, 40, 40] cm) at each end leaving an opening in the center for the neck (see assembly schematic).

With RS facing, use a crochet hook to sl sts (see Glossary) to seam the first and last 8½ (8¾, 9¼, 9¼)" (21.5 [22, 23.5, 23.5] cm) of the left panel together (do not join edgings), leaving a hole for the arm (see assembly schematic). Rep for right panel.

Thread belt through sides at waist.

Weave in ends. Block again if desired.

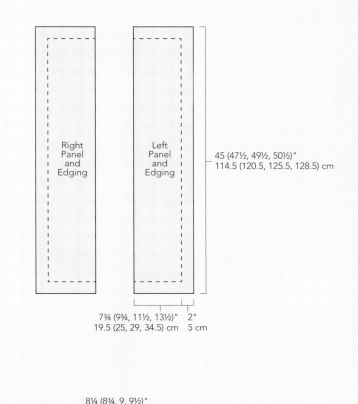

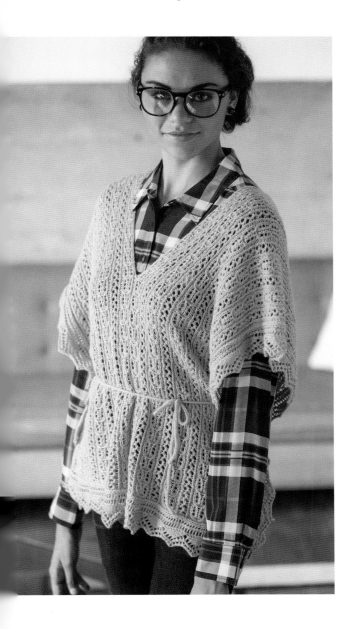

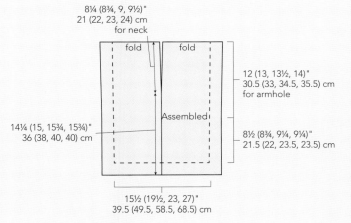

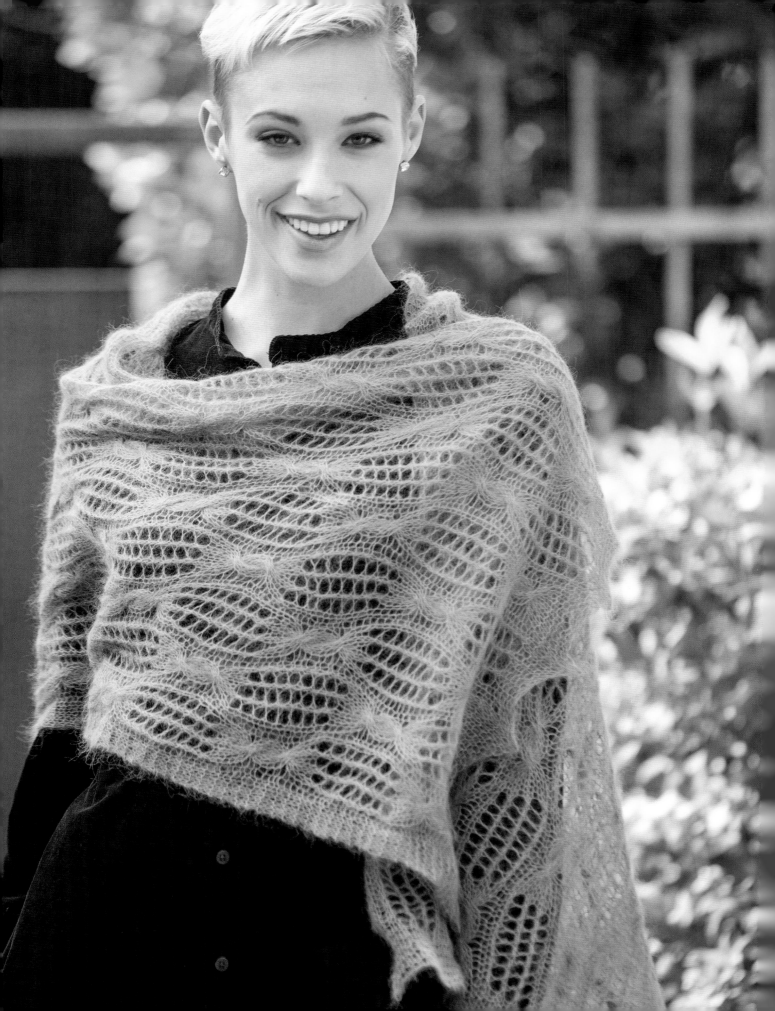

ronks stole

THIS ELEGANT STOLE COMBINES CABLES AND LACE with a diaphanous yarn to create a lighter-than-air wrap. The brushed Suri alpaca blooms to create a halo of warmth. Wear it over the shoulders to take off the chill on a cool summer evening.

FINISHED SIZE

Width: About 20¼" (51.5 cm).

Length: About 61" (155 cm).

YARN

Lace weight (#0 Lace).

Shown here: The Alpaca Yarn Company Halo (78% brushed Suri alpaca, 22% nylon; 514 yd [470 m]/50 g): #7422 paradise, 2 skeins.

NEEDLES

Size U.S. 8 (5 mm): straight.

Adjust needle size if necessary to obtain the correct gauge.

NOTIONS

2 cable needles (cn); tapestry needle.

GAUGE

18 sts and 21 rows = 4" (10 cm) in Lace and Cable chart.

stitch guide

3/1/3 LC: Sl 3 sts to first cn and hold in front, sl 1 st to second cn and hold in back, k3; k1 from second cn, k3 from first cn.

3/1/3 RC: Sl 3 sts to first cn and hold in back, sl 1 st to second cn and hold in back, k3; k1 from second cn, k3 from first cn.

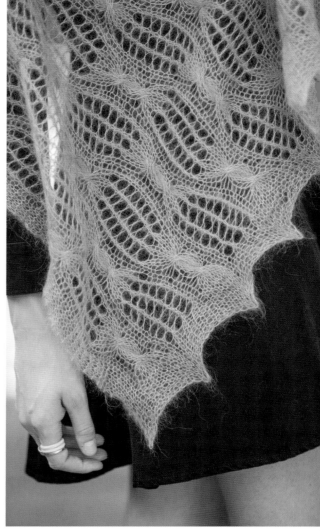

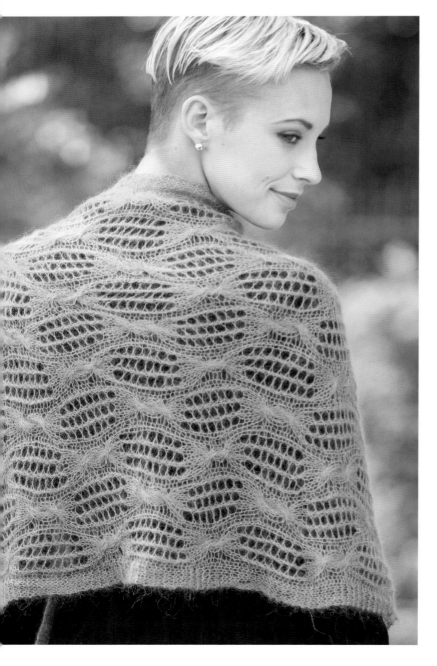

stole

CO 91 sts loosely.

Knit 10 rows.

Work Rows 1–32 of Lace and Cable chart 9 times, then work Rows 1–16 once more.

Knit 10 rows.

BO all sts loosely.

finishing

Block to measurements. Weave in ends.

using multiple cable needles

Occasionally a more complex cable will call for more than one cable needle. This facilitates the reordering of more than one group of stitches.

The cables used in the Ronks stole are worked using two cable needles.

3/1/3 LC

STEP 1: Slip 3 stitches to the first cable needle and hold in front.

STEP 2: Slip 1 stitch to the second cable needle and hold in back.

STEP 3: Knit 3 stitches.

STEP 4: Knit the stitch from the second cable needle.

STEP 5: Knit the 3 stitches from the first cable needle.

3/1/3 RC

STEP 1: Slip 3 stitches to the first cable needle and hold in back.

STEP 2: Slip 1 stitch to the second cable needle and also hold in back.

STEP 3: Knit 3 stitches.

STEP 4: Knit the stitch from the second cable needle.

STEP 5: Knit the 3 stitches from the first cable needle.

This creates a cable crossing where the central stitch remains stationary while the three stitches on either side cross around it.

Lace and Cable

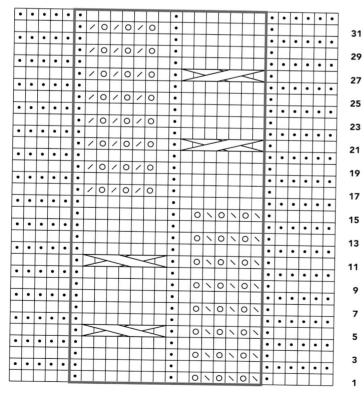

☐	knit on RS, purl on WS	
•	purl on RS, knit on WS	
o	yo	
\	ssk	
/	k2tog	
⧓	3/1/3 RC	
⧓	3/1/3 LC	
☐	pattern repeat	

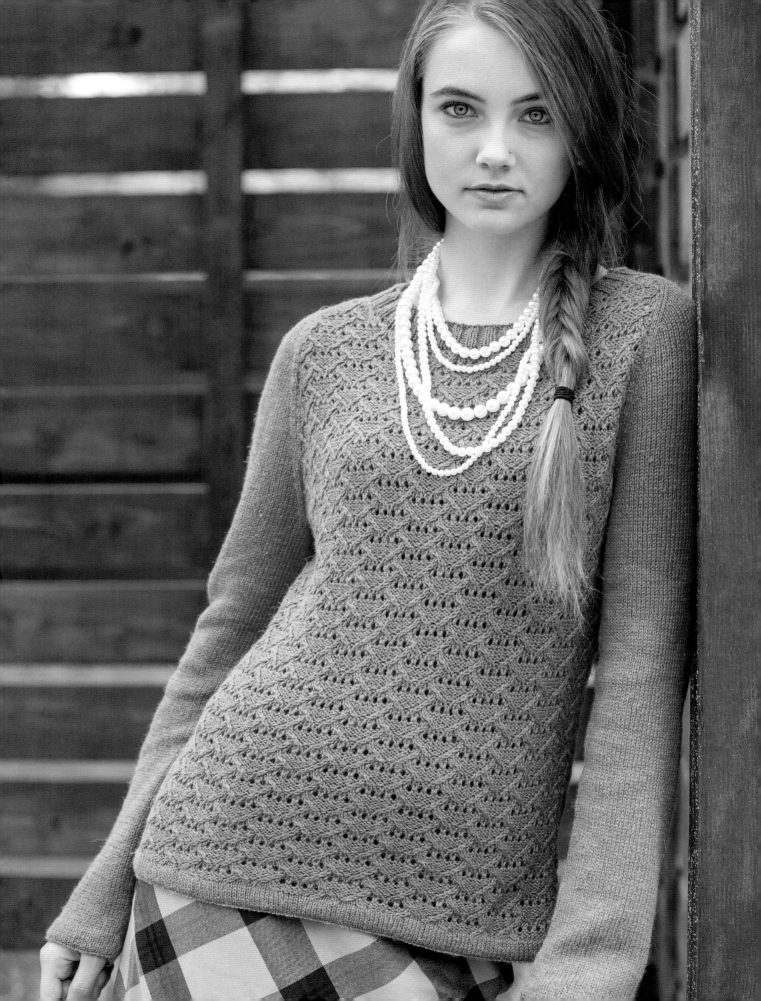

talmage pullover

WORKED IN PIECES FROM THE BOTTOM UP, this sport-inspired raglan is made feminine with an allover cabled lace pattern. The solid plain sleeves are reminiscent of the classic baseball tee. Turned hems and a simple ribbed collar keep things clean and simple.

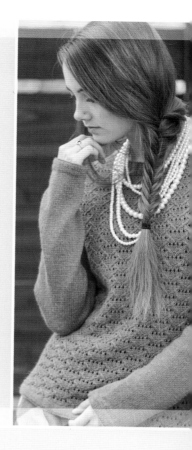

FINISHED SIZE
Bust Circumference: About 30 (35, 40, 45, 50, 55)" (76 [89, 101.5, 114.5, 127, 139.5] cm).

Length: About 25¼ (26¾, 27½, 27¾, 29¼, 30)" (64 [68, 70, 70.5, 74.5, 76] cm).

Sweater shown measures 35" (89 cm).

YARN
DK weight (#3 Light).

Shown here: Classic Elite Yarns Soft Linen (35% wool, 35% linen, 30% alpaca; 137 yd [125 m]/50 g): #2225 smokey rose, 10 (11, 13, 15, 17, 19) skeins.

NEEDLES
Body and Sleeves: Size U.S. 5 (3.75 mm): 24" (60 cm) circular (cir) and straight.

Collar: Size U.S. 4 (3.5 mm): 16" (40 cm) cir.

Adjust needle size if necessary to obtain the correct gauge.

NOTIONS
Markers (m); cable needle (cn); tapestry needle.

GAUGE
28 sts and 33 rows = 4" (10 cm) in St st with larger needles.

29 sts and 33 rows = 4" (10 cm) in Cable and Lace chart with larger needles.

stitch guide

1/2 RPC: Sl 2 sts to cn and hold in back, k1, p2 from cn.

1/2 LPC: Sl 1 st to cn and hold in front, p2, k1 from cn.

Notes: Circular needle is used on back and front to accommodate large number of sts. Do not join; work back and forth in rows.

When working shaping, be sure to maintain proper st count by pairing each patterned yo with its corresponding decrease. If this is not possible because of the current st count, work in St st instead.

back

HEM

With larger cir needle, CO 109 (127, 145, 163, 181, 199) sts. Do not join; work back and forth in rows.

Beg with a WS row, work in St st (knit on RS, purl on WS) for 6 rows, ending after a RS row.

TURNING ROW: (WS) Knit.

Work in St st for 7 rows, ending after a WS row.

BEGIN CABLE AND LACE

Work Cable and Lace chart for 16 (10, 8, 6, 14, 10) rows, ending after a WS row.

SHAPE WAIST

DEC ROW: (RS) K1, ssk, work in patt to last 3 sts, k2tog, k1—2 sts dec'd.

[Work 0 (9, 7, 5, 13, 9) rows even in patt, then rep dec row] 0 (4, 3, 7, 1, 2) time(s)—107 (117, 137, 147, 177, 193) sts rem.

[Work 13 (0, 5, 3, 11, 7) rows even in patt, then rep dec row] 2 (0, 3, 1, 2, 3) time(s)—103 (117, 131, 145, 173, 187) sts rem.

Work 21 (13, 9, 7, 15, 11) rows even in patt, ending after a WS row.

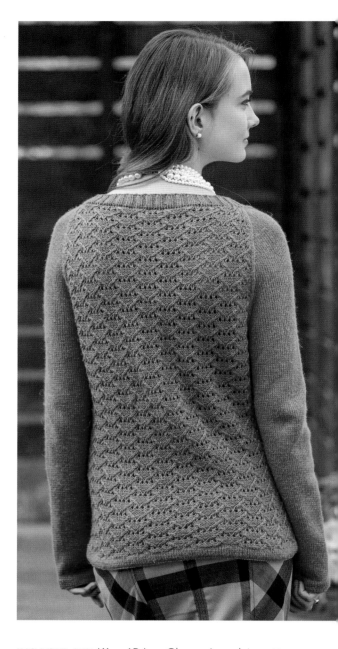

INC ROW: (RS) K1, m1R (see Glossary), work in patt to last st, m1L (see Glossary), k1—2 sts inc'd.

Rep the last 22 (14, 10, 8, 16, 12) rows 1 (1, 3, 2, 3, 1) more time(s)—107 (121, 139, 151, 181, 191) sts.

[Work 19 (11, 7, 5, 0, 9) rows even in patt, then rep inc row] 1 (3, 3, 6, 0, 4) time(s)—109 (127, 145, 163, 181, 199) sts.

Work even in patt until piece meas 15¼ (16, 16, 15¾, 16¼, 16½)" (38.5 [40.5, 40.5, 40, 41.5, 42] cm) from turning row of hem, ending after a WS row.

SHAPE RAGLAN

BO 5 (6, 7, 8, 9, 10) sts at beg of next 2 rows—99 (115, 131, 147, 163, 179) sts rem.

DEC ROW: (RS) K1, ssk, work in patt to last 3 sts, k2tog, k1—2 sts dec'd.

[Work 5 (3, 3, 3, 3, 1) row(s) even in patt, then rep dec row] 2 (17, 13, 8, 5, 50) times—93 (79, 103, 129, 151, 77) sts rem.

[Work 3 (1, 1, 1, 1, 0) row(s) even in patt, then rep dec row] 16 (7, 17, 29, 38, 0) times—61 (65, 69, 71, 75, 77) sts rem.

BO rem sts loosely.

front

Work as for back to raglan shaping—109 (127, 145, 163, 181, 199) sts.

(*Note:* Raglan and neck shaping happen at the same time. Read the next sections all the way through before proceeding.)

Cable and Lace

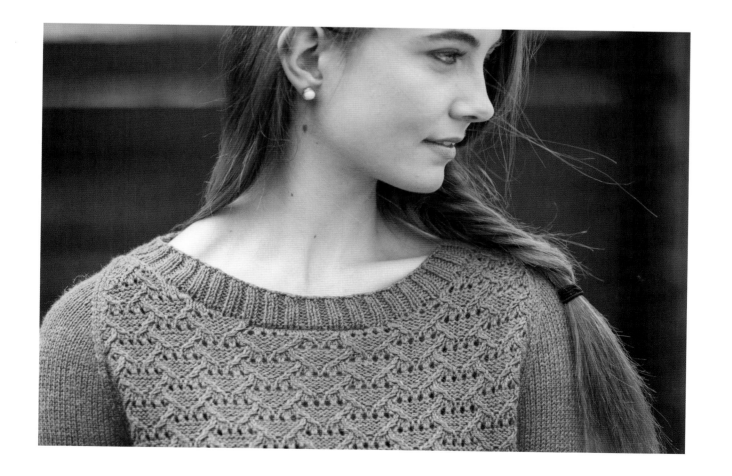

	knit on RS, purl on WS
•	purl on RS, knit on WS
↘	p2tog
o	yo
⧄	1/2 RPC
⧅	1/2 LPC
	pattern repeat

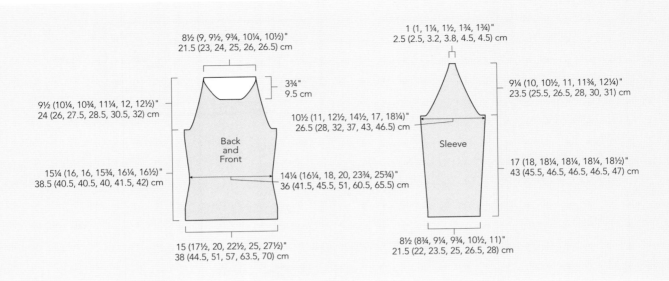

8½ (9, 9½, 9¾, 10¼, 10½)"
21.5 (23, 24, 25, 26, 26.5) cm

3¾"
9.5 cm

9½ (10¼, 10¾, 11¼, 12, 12½)"
24 (26, 27.5, 28.5, 30.5, 32) cm

10½ (11, 12½, 14½, 17, 18¼)"
26.5 (28, 32, 37, 43, 46.5) cm

Back and Front

15¼ (16, 16, 15¾, 16¼, 16½)"
38.5 (40.5, 40.5, 40, 41.5, 42) cm

14¼ (16¼, 18, 20, 23¾, 25¾)"
36 (41.5, 45.5, 51, 60.5, 65.5) cm

15 (17½, 20, 22½, 25, 27½)"
38 (44.5, 51, 57, 63.5, 70) cm

1 (1, 1¼, 1½, 1¾, 1¾)"
2.5 (2.5, 3.2, 3.8, 4.5, 4.5) cm

9¼ (10, 10½, 11, 11¾, 12¼)"
23.5 (25.5, 26.5, 28, 30, 31) cm

Sleeve

17 (18, 18¼, 18¼, 18¼, 18½)"
43 (45.5, 46.5, 46.5, 46.5, 47) cm

8½ (8¾, 9¼, 9¾, 10½, 11)"
21.5 (22, 23.5, 25, 26.5, 28) cm

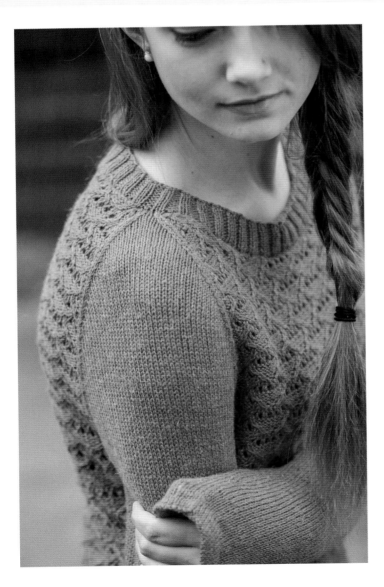

SHAPE RAGLAN

Work as for back raglan shaping, and *at the same time*, when raglan meas 5¾ (6½, 7, 7½, 8¼, 8¾)" (14.5 [16.5, 18, 19, 21, 22] cm), end after a WS row.

SHAPE NECK

Pm on each side of center 21 (23, 23, 25, 25, 27) sts for neck.

Cont working raglan shaping as est, while working neck shaping as foll:

NEXT ROW: (RS) Work in patt to the marked sts, join a second ball of yarn, BO 21 (23, 23, 25, 25, 27) center sts removing markers, work in patt to end.

Working both sides at the same time, at each neck edge, BO 4 sts once, BO 3 sts 1 (1, 2, 2, 2, 2) time(s), BO 2 sts 2 (3, 3, 3, 5, 5) times, then BO 1 st 9 (8, 7, 7, 5, 5) times.

No sts should rem after raglan and neck shaping are completed.

sleeves

HEM

With straight needles, CO 61 (63, 67, 71, 77, 79) sts.

Beg with a WS row, work in St st for 6 rows, ending after a RS row.

TURNING ROW: (WS) Knit.

Work in St st for 7 more rows, ending after a WS row.

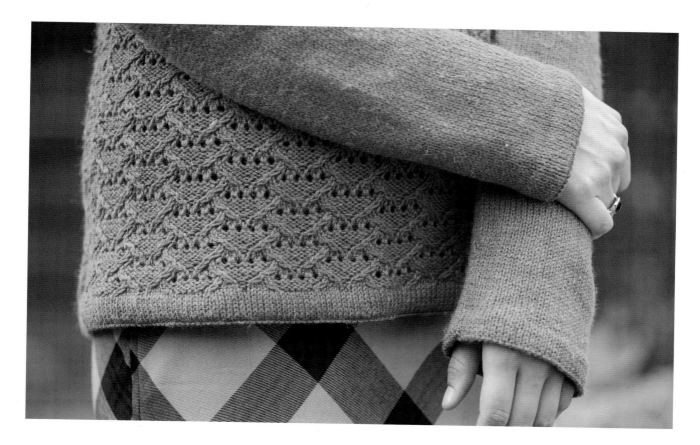

SHAPE SLEEVE

Work even in St st for 17 (17, 11, 9, 7, 5) rows, ending after a WS row.

INC ROW: (RS) K1, m1R, knit to last st, m1L, k1—2 sts inc'd.

Rep the last 18 (18, 12, 10, 8, 6) rows 1 (5, 10, 2, 1, 17) more time(s)—65 (75, 89, 77, 81, 115) sts.

[Work 15 (15, 9, 7, 5, 3) rows even in St st, then rep inc row] 6 (2, 1, 14, 21, 9) time(s)—77 (79, 91, 105, 123, 133) sts.

Work even in St st until piece meas 17 (18, 18¼, 18¼, 18¼, 18½)" (43 [45.5, 46.5, 46.5, 46.5, 47] cm) from turning row of hem, ending after a WS row.

SHAPE RAGLAN

BO 5 (6, 7, 8, 9, 10) sts at beg of next 2 rows—67 (67, 77, 89, 105, 113) sts rem.

DEC ROW: (RS) K1, ssk, knit to last 3 sts, k2tog, k1—2 sts dec'd.

[Work 3 rows even, then rep dec row] 9 (12, 10, 7, 3, 1) time(s)—47 (41, 55, 73, 97, 109) sts rem.

[Work 1 row even, then rep dec row] 20 (17, 23, 31, 42, 48) times—7 (7, 9, 11, 13, 13) sts rem.

BO rem sts.

Make second sleeve the same as the first.

finishing

Fold hems at turning rows and sew to inside of body and sleeves.

Block to measurements.

Sew side, sleeve, and raglan seams.

COLLAR

With smaller cir needle and RS facing, beg at right back neck, pick up and knit 144 (152, 164, 172, 184, 188) sts evenly around the neck opening. Pm and join for working in the rnd.

Work k2, p2 ribbing for 1" (2.5 cm).

BO all sts in patt.

Weave in ends. Block again if desired.

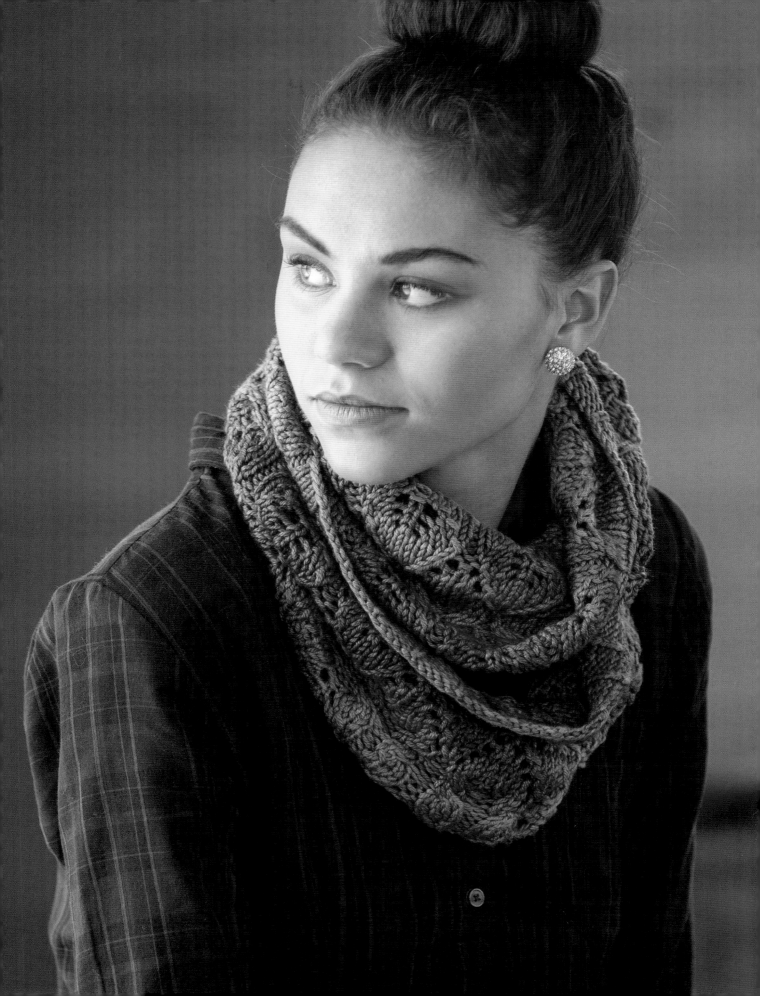

safe harbor cowl

WRAP YOURSELF IN SUPERSOFT MERINO AND SILK with this lovely cowl. Cables and lace form delicate leaves that surround your neck in warmth. Worked seamlessly in the round, this cowl is a quick and fun project for both beginning lace and cable knitters.

FINISHED SIZE

Circumference: About 47" (119.5 cm).

Height: About 8¾" (22 cm).

YARN

Worsted weight (#4 Medium).

Shown here: SweetGeorgia Merino Silk Aran (50% merino, 50% silk; 185 yd [169 m]/100 g): jade, 2 skeins.

NEEDLES

Ribbing: Size U.S. 7 (4.5 mm): 32" (80 cm) circular (cir).

Body: Size U.S. 8 (5 mm): 32" (80 cm) cir.

Adjust needle size if necessary to obtain the correct gauge.

NOTIONS

Marker (m); cable needle (cn); tapestry needle.

GAUGE

17 sts and 26 rnds = 4" (10 cm) in Cable chart with larger needles.

stitch guide

2/2 RC: Sl 2 sts to cn and hold in back, k2, k2 from cn.

2/2 LC: Sl 2 sts to cn and hold in front, k2, k2 from cn.

K4, p1 Ribbing (multiple of 5 sts)

RND 1: *P1, k4; rep from *.

Rep Rnd 1 for patt.

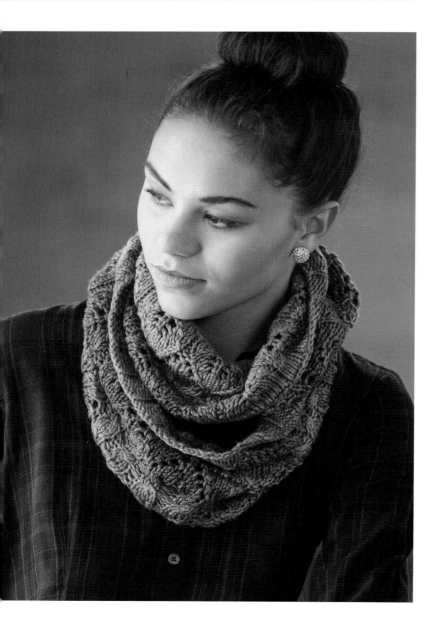

cowl

RIBBING

With smaller needle, CO 200 sts. Place marker (pm) and join for working in the rnd, being careful not to twist sts.

Work k4, p1 ribbing until piece meas 1" (2.5 cm) from CO edge.

BODY

Change to larger needles.

Work Rnds 1–22 of Cable chart twice.

RIBBING

Change to smaller needles.

Work k4, p1 ribbing for 1" (2.5 cm).

BO all sts in pattern.

finishing

Block to measurements. Weave in ends.

Cable

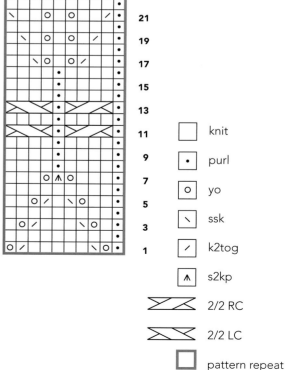

knit								
• purl								
○ yo								
\ ssk								
/ k2tog								
⋀ s2kp								
2/2 RC								
2/2 LC								
pattern repeat								

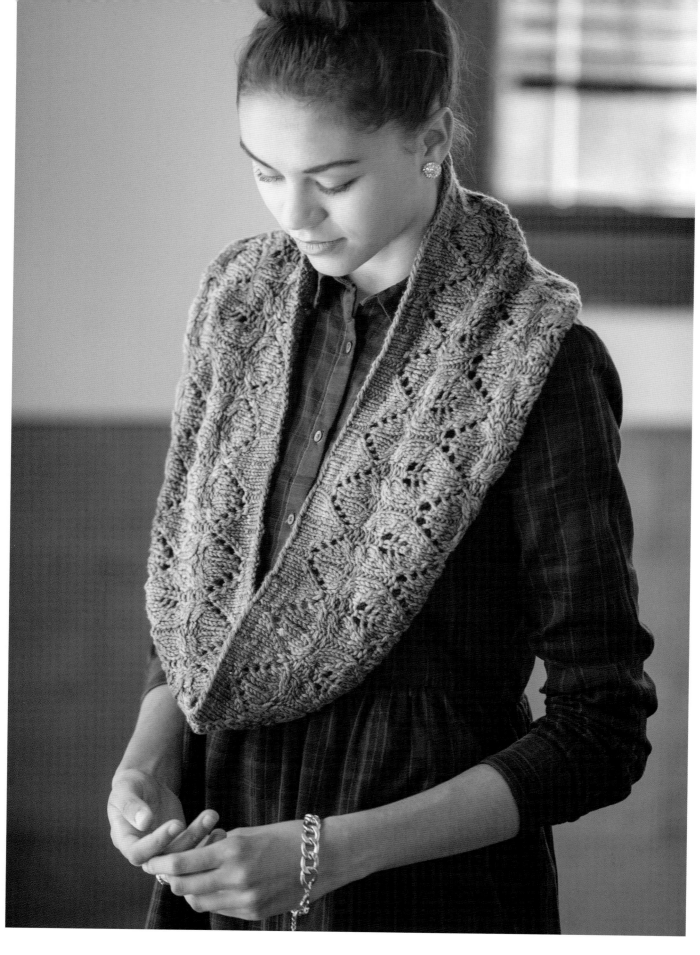

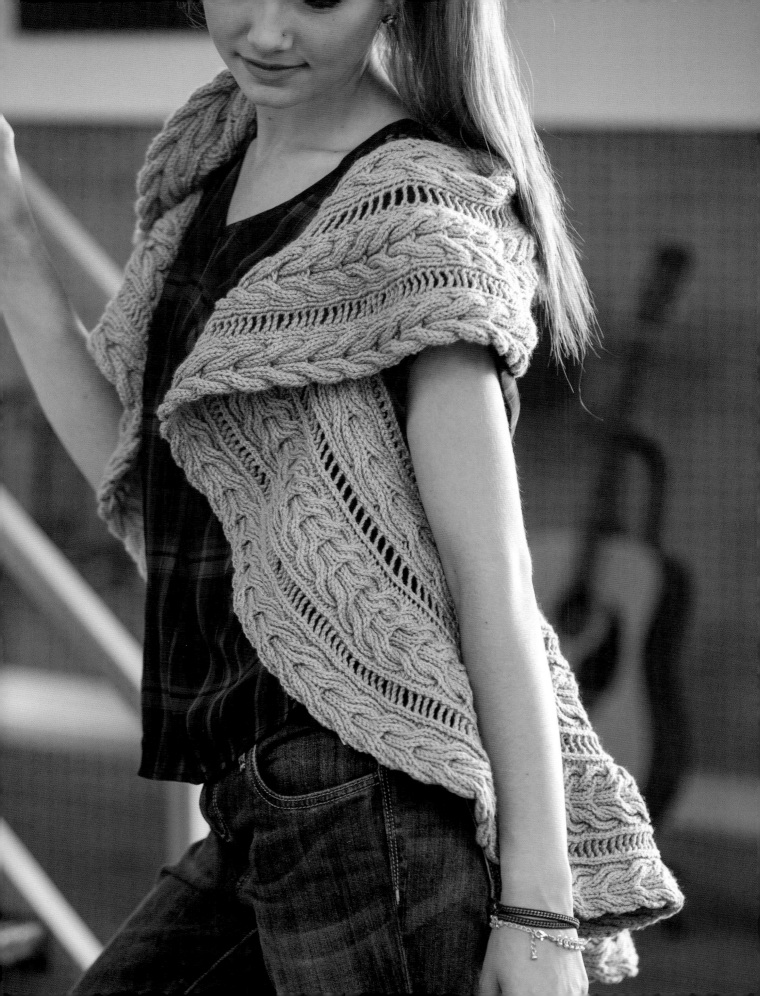

stevens vest

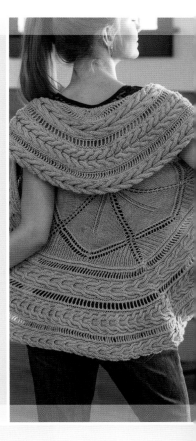

CIRCLE SWEATERS FLATTER ALL BODY TYPES, and Stevens is no exception. This circle vest begins in the center with a shawl cast-on, which grows into a large flower medallion. Its edge features a reversible cable so there is no wrong side when the collar is folded over.

FINISHED SIZE

Back Width: About 16¾ (17¼, 18, 18¼, 19, 19¾)" (42.5 [44, 45.5, 46.5, 48.5, 50] cm).

Vest shown measures 16¾" (42.5 cm).

YARN

Worsted weight (#4 Medium).

Shown here: Swans Island Natural Colors Merino Worsted (100% merino; 250 yd [229 m]/100 g): vintage lilac, 7 (8, 9, 10, 11, 12) skeins.

NEEDLES

Size U.S. 8 (5 mm): set of double-pointed (dpn) and 24" (60 cm), 40" (100 cm), and 60" (150 cm) circulars (cir).

Adjust needle size if necessary to obtain the correct gauge.

NOTIONS

Marker (m); cable needle (cn); tapestry needle.

GAUGE

22 sts and 24 rnds = 4" (10 cm) in St st.

22 sts = 3¼" (8.5 cm) in Cable chart.

stitch guide

4/4 RC: Sl 4 sts to cn and hold in back, (k1, p2, k1), (k1, p2, k1) from cn.

4/4 LC: Sl 4 sts to cn and hold in front, (k1, p2, k1), (k1, p2, k1) from cn.

medallion

Using Emily Ocker's method (see Glossary) and dpn, CO 6 sts. Pm for beg of rnd and join for working in the rnd.

Work Medallion chart for 50 (52, 54, 55, 57, 59) rnds, changing to longer cir needles when sts no longer fit comfortably on dpn or shorter cir—288 (300, 312, 324, 366, 348) sts.

PLACE ARMHOLES

Work next rnd in k1, p1 rib as est for 67 (69, 71, 73, 77, 79) sts, BO 39 (41, 44, 47, 48, 51) sts for right armhole, work 77 (80, 83, 84, 87, 89) sts in k1, p1 rib as est, BO 39 (41, 44, 47, 48, 51) sts for left armhole, work 66 (69, 70, 73, 76, 78) sts in k1, p1 rib as est to end.

Beg of rnd is at center of lower body—67 (69, 71, 73, 77, 79) sts rem for lower right body, 77 (80, 83, 85, 87, 89) sts rem for upper body, and 66 (69, 70, 73, 76, 78) sts rem for lower left body.

cable edge

With RS of medallion facing, use the cable method (see Glossary) to CO 1 st, pm, then CO 66 (66, 88, 88, 110, 110) more sts.

SHORT-ROWS OVER MEDALLION

Work in short-rows (see Glossary) and join cable edge to medallion as foll:

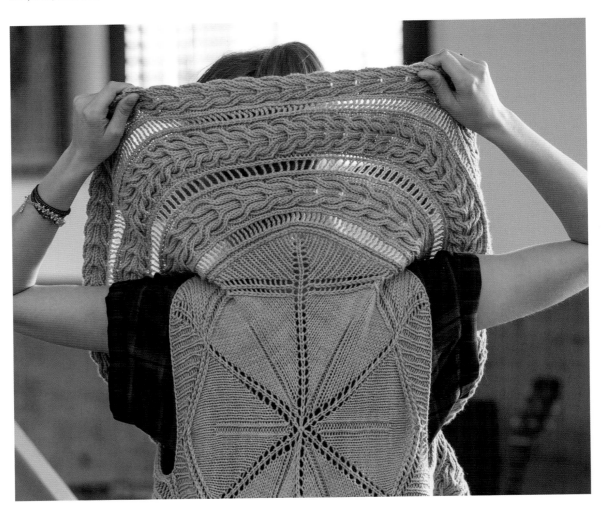

Medallion

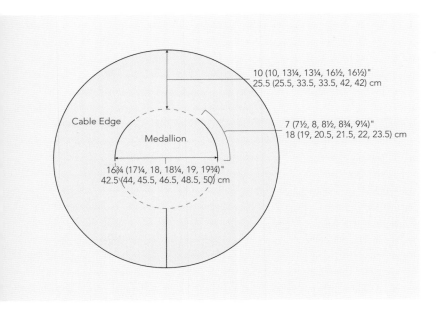

Cable Edge

Medallion

10 (10, 13¼, 13¼, 16½, 16½)"
25.5 (25.5, 33.5, 33.5, 42, 42) cm

7 (7½, 8, 8½, 8¾, 9¼)"
18 (19, 20.5, 21.5, 22, 23.5) cm

16¾ (17¼, 18, 18¼, 19, 19¾)"
42.5 (44, 45.5, 46.5, 48.5, 50) cm

ROW 1: (RS) Work the Cable chart to m, sl m, ssk to join cable edge to medallion, turn.

ROW 2: P1, sl m, work the Cable chart to end.

ROW 3: (SHORT-ROW) Work 44 sts of the Cable chart, wrap next st and turn so WS is facing, work the Cable chart to end of row.

Rep the last 3 rows until the last st of lower right body has been decreased, working the wrapped sts together with the sts they wrap as you come to them—67 (67, 89, 89, 111, 111) sts for cable edge; 77 (80, 84, 85, 87, 89) upper body sts, 66 (69, 70, 73, 76, 78) lower left body sts rem.

SHORT-ROWS OVER ARMHOLE

ROW 1: (RS) Work the Cable chart to m, sl m, k1, turn.

Cable

(chart with rows labeled 1, 3, 5, 7)

☐	knit on RS, purl on WS
•	purl on RS, knit on WS
⅄	k1tbl
O	yo
╱	k2tog
╲	ssk
⋀	s2kp
𐤀	s2k3p
⤬	4/4 RC
⤬	4/4 LC
▨	no stitch
☐	pattern repeat

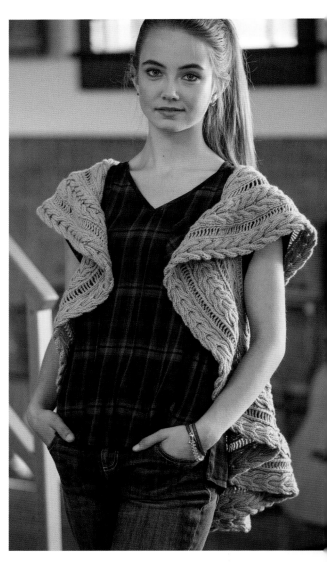

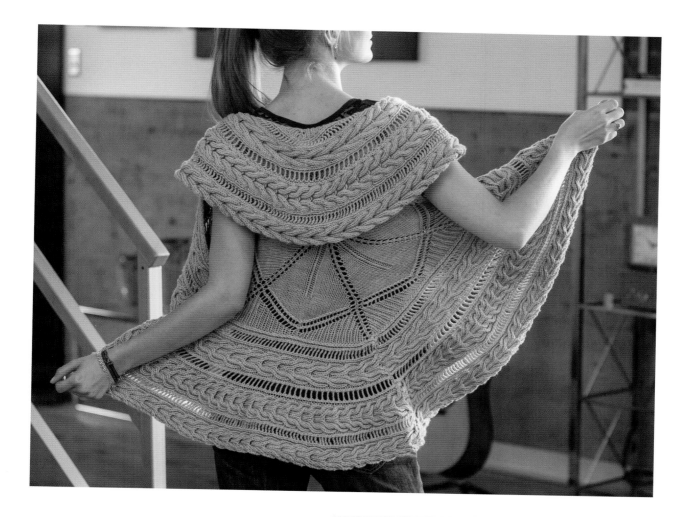

ROW 2: P1, sl m, work the Cable chart to end.

ROW 3: (SHORT-ROW) Work 44 sts in the Cable chart, wrap next st and turn so WS is facing, work the Cable chart to end of row.

Rep the last 3 rows 38 (40, 43, 46, 47, 50) more times, working the wrapped sts together with the sts they wrap as you come to them.

Work short-rows over medallion along upper body sts, work short-rows over armhole, then work short-rows over medallion over rem lower left body sts—67 (67, 89, 89, 111, 111) sts rem.

BO all sts.

finishing

Block to measurements. Weave in ends. Seam CO and BO of cable edge together.

making reversible cables

Cabling, while beautiful, is typically only shown on one side of the fabric. This works for most applications, however, occasionally you want to see cabling on both sides.

The cable is only viewable in the knit stitches while the purl stitches hide the crossing. To combat this, the easiest fix is to work the cable in rib. This way knit stitches are on both sides of the fabric and so we can see the crossing on both sides as well.

The cables on the outer rim of Stevens utilize these ribbed cables so when folded over at the collar, there is no wrong side.

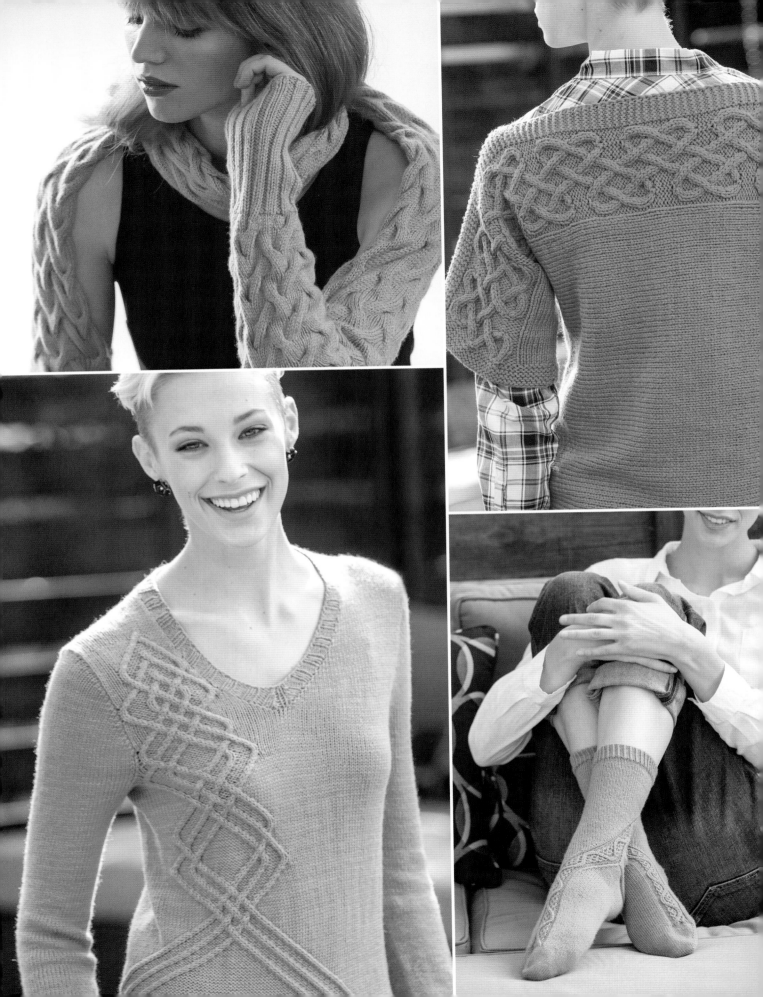

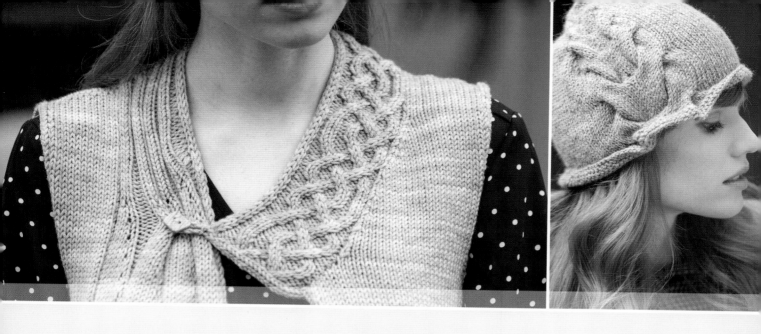

CHAPTER 3 | abstract

MODERN AND EDGY, the projects in this chapter all feature cables on the canvas of unexpected construction. Worked sideways, asymmetrically, or from the top down, the garments and accessories in this section make for exciting knitting while keeping the focus on the cable. Bright colors alongside gritty neutrals lend an urban feeling to these projects; abstract construction techniques keep the knitting fresh.

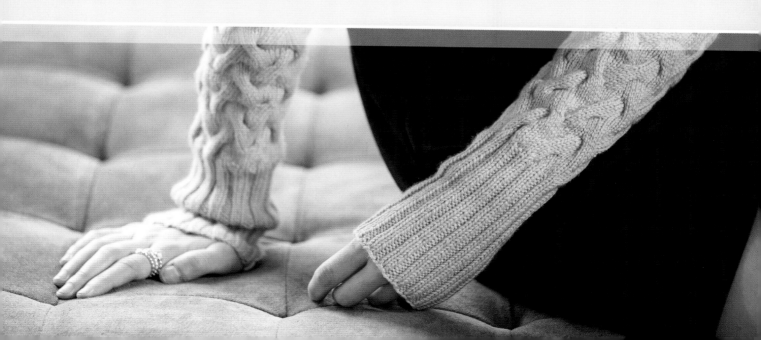

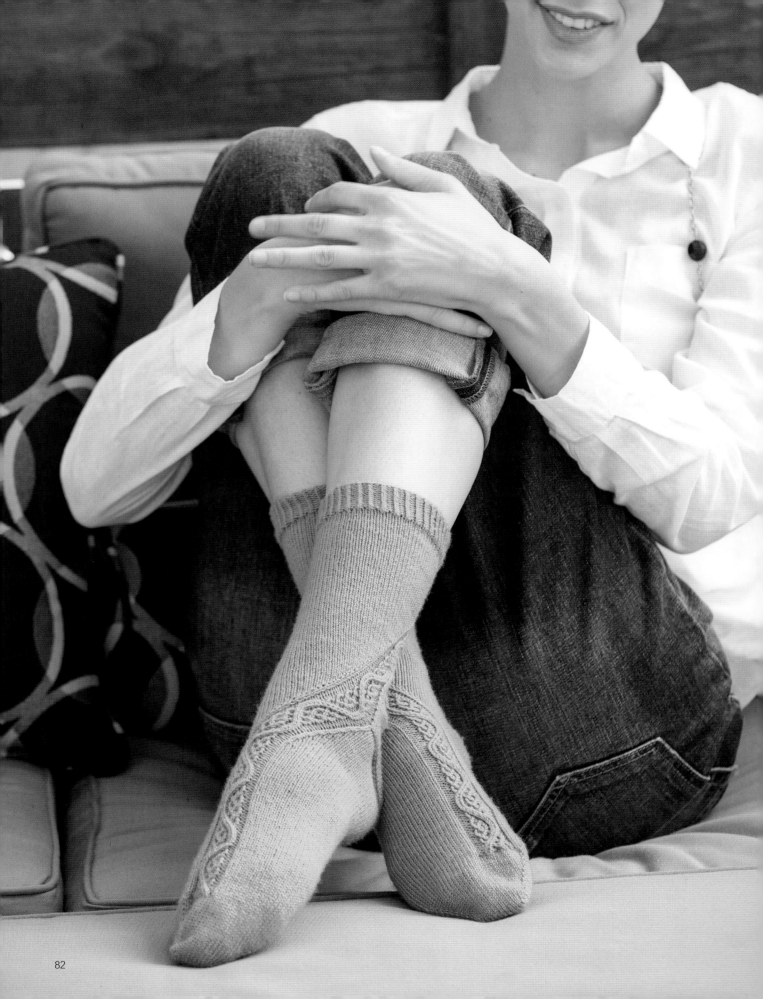

drumore socks

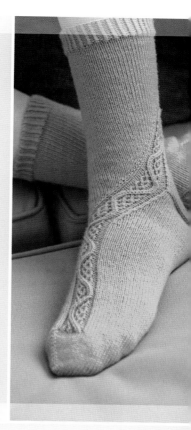

WORKED TOE UP, THESE SOCKS START SIMPLY ENOUGH. However, an unusual gusset forces the cable panel into a swirl that continues around the leg. A traditional heel flap ensures a good fit. It's topped off with a twisted rib cuff.

FINISHED SIZE

Leg Circumference: About 7¼ (8)" (18.5 [20.5] cm).

Socks shown measure 7¼" (18.5 cm).

YARN

Fingering weight (#1 Super Fine).

Shown here: Shibui Knits Staccato (70% merino, 30% silk; 191 yd [175 m]/50 g): #2026 brass, 2 skeins.

NEEDLES

Size U.S. 1 (2.25 mm): double-pointed (dpn).

Adjust needle size if necessary to obtain the correct gauge.

NOTIONS

Markers (m); cable needle (cn); tapestry needle.

GAUGE

37 sts and 54 rnds = 4" (10 cm) in St st. 12 sts = ¾" (2 cm) in Cable chart.

stitch guide

RT: Sl 1 st to cn and hold in back, k1tbl, k1tbl from cn.

LT: Sl 1 st to cn and hold in front, k1tbl, k1tbl from cn.

RTP: Sl 1 st to cn and hold in back, k1tbl, p1 from cn.

LTP: Sl 1 st to cn and hold in front, p1, k1tbl from cn.

2/1 RT: Sl 1 st to cn and hold in back, k2tbl, k1tbl from cn.

2/1 LT: Sl 2 sts to cn and hold in front, k1tbl, k2tbl from cn.

2/1 RTP: Sl 1 st to cn and hold in back, k2tbl, p1 from cn.

2/1 LTP: Sl 2 sts to cn and hold in front, p1, k2tbl from cn.

Twisted Rib (multiple of 2 sts)

RND 1: *K1tbl, p1tbl; rep from *.

Rep Rnd 1 for patt.

Note: It is suggested to use different-colored markers for the beg of rnd, side of foot, Cable chart, and gusset to easily tell them apart.

right sock

TOE
Using Judy's Magic Cast-On (see Glossary), CO 24 (28) sts. Place marker (pm) and join for working in the rnd, being careful not to twist sts.

Knit 1 rnd.

SET-UP RND: *K1, m1 (see Glossary), k10 (12), m1, k1, pm for side of foot; rep from * once—28 (32) sts.

Knit 1 rnd.

INC RND: *K1, m1, knit to 1 st before m, m1, k1, sl m; rep from * once—4 sts inc'd.

Rep the last 2 rnds 10 (11) more times—72 (80) sts.

Knit 1 rnd, removing side of foot m.

FOOT
EST PATT: K21 (25), pm for cable, beg with Row 1, work 12 sts in Cable chart, pm for cable, knit to end of rnd.

Cont working even as est until piece meas 3" (7.5 cm) less than desired total length.

GUSSET
SET-UP RND: Knit to 2 sts before cable m, k2tog, sl m, work Cable chart to next cable m, sl m, k1, pm for

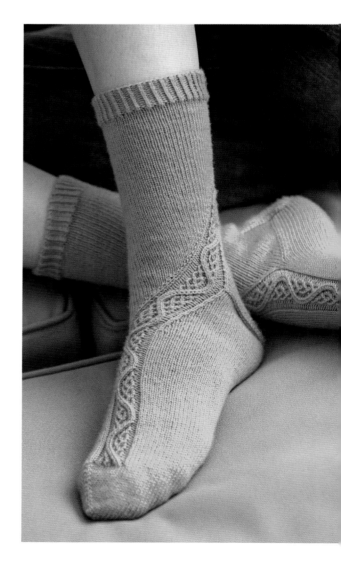

gusset, m1R (see Glossary), k1, m1L (see Glossary), pm for gusset, knit to end of rnd—73 (81) sts total; 20 (24) sts rem between beg of rnd and cable m, 3 sts between gusset markers.

Work 1 rnd even in patt as est.

INC RND 1: Work in patt to first gusset m, sl m, m1R, knit to next gusset m, m1L, sl m, knit to end of rnd—2 sts inc'd between gusset markers.

Work 1 rnd even in patt as est.

INC RND 2: Work in patt to 2 sts before cable m, k2tog, sl m, work in patt to first gusset m, sl m, m1R, knit to next gusset m, m1L, sl m, knit to end of rnd—1 st dec'd between beg of rnd and cable m, 2 sts inc'd between gusset markers.

Work 1 rnd even in patt as est.

Rep last 4 rnds 6 more times, then work Inc rnd 1 once more—96 (104) sts total; 13 (17) sts rem between beg of rnd and cable m, 33 sts between gusset markers.

NEXT RND: Remove beg of rnd m, k12 (11), pm for new beg of rnd, work 35 (41) sts in patt removing gusset markers, but leaving cable markers, pm for end of instep—35 (41) instep sts; 61 (63) sole sts rem.

TURN HEEL

Work back and forth in short-rows (see Glossary) over the sole sts as foll:

SHORT-ROW 1: (RS) K41 (43), k1f&b, k1, wrap next st and turn so WS is facing; p24 (26), p1f&b, p1, wrap next st and turn so RS is facing—63 (65) sole sts.

SHORT-ROW 2: K22 (24), k1f&b, k1, wrap next st and turn so WS is facing; p20 (22), p1f&b, p1, wrap next st and turn so RS is facing—65 (67) sole sts.

SHORT-ROW 3: K18 (20), k1f&b, k1, wrap next st and turn so WS is facing; p16 (18), p1f&b, p1, wrap next st and turn so RS is facing—67 (69) sole sts.

SHORT-ROW 4: K14 (16), k1f&b, k1, wrap next st and turn so WS is facing; p12 (14), p1f&b, p1, wrap next st and turn so RS is facing—69 (71) sole sts.

NEXT ROW: (RS) Knit to end of rnd, working wraps together with their sts as you come to them.

HEEL FLAP

Shape heel flap with short-rows as foll:

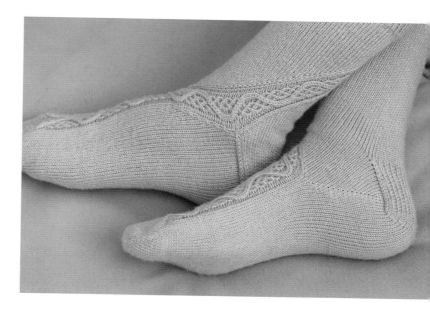

SET-UP ROW: (RS) Work 35 (41) instep sts in patt, sl m, k52 (54), working wraps together with their sts as you come to them, ssk, turn (do NOT wrap)—68 (70) sole sts rem.

SHORT-ROW 1: (WS) Sl 1 st purlwise with yarn in front (pwise wyf), p34 (36), p2tog, turn (do NOT wrap)—1 st dec'd.

SHORT-ROW 2: (RS) *Sl 1 st pwise with yarn in back (wyb), k1; rep from * 17 (18) times, sl 1 st pwise wyb, ssk, turn (do NOT wrap)—1 st dec'd.

Cable

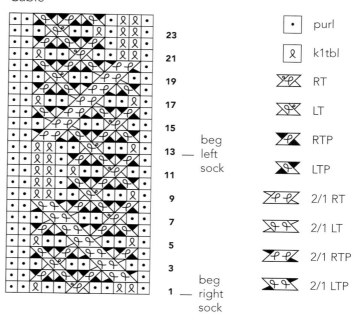

	Symbol	Name
	•	purl
	Q	k1tbl
		RT
		LT
		RTP
		LTP
		2/1 RT
		2/1 LT
		2/1 RTP
		2/1 LTP

beg left sock

beg right sock

Rep the last 2 rows 14 more times, then work Short-row 1 once more—72 (80) sts total rem; 35 (41) instep sts and 37 (39) sole sts.

NEXT ROW: (RS) Sl 1 st pwise wyb, knit to end of rnd. Remove instep m.

LEG
BIAS RND: Work in patt to 2 sts before cable m, k2tog, sl m, work Cable chart to next cable m, sl m, k1, m1L, knit to end of rnd.

Rep bias rnd every other rnd until leg meas 1" (2.5 cm) less than total desired height, moving beg of rnd m to just before the k2tog as needed.

CUFF
Work in twisted rib for 1" (2.5 cm). BO all sts loosely in patt.

left sock

TOE
Work same as for right sock—72 (80) sts.

FOOT
EST PATT: K3, pm for cable, beg with Row 13, work 12 sts in Cable chart, pm for cable, knit to end of rnd.

Cont working even as est until piece meas 3" (7.5 cm) less than desired total length.

GUSSET
SET-UP RND: K1, pm for gusset, m1R, k1, m1L, pm for gusset, k1, sl m, work Cable chart to next cable m, sl m, ssk, knit to end of rnd—73 (81) sts total; 3 sts between gusset markers; 56 (64) sts between cable m and end of rnd.

Work 1 rnd even in patt as est.

INC RND 1: K1, sl m, m1R, knit to m, m1L, sl m, k1, sl m, work Cable chart to next cable m, sl m, knit to end of rnd—2 sts inc'd between gusset markers.

Work 1 rnd even in patt as est.

INC RND 2: K1, sl m, m1R, knit to m, m1L, sl m, k1, sl m, work Cable chart to next cable m, sl m, ssk, knit to end of rnd—1 st dec'd between cable m and end of rnd, 2 sts inc'd between gusset markers.

Work 1 rnd even in patt as est.

Rep last 4 rnds 6 more times, then work Inc rnd 1 once more—96 (104) sts total; 33 sts rem between gusset markers, 49 (57) sts rem between cable m and end of rnd.

NEXT RND: Remove beg of rnd m, k13 removing gusset m, pm for new beg of rnd, work 35 (41) sts in patt removing gusset m, but leaving chart markers, pm for end of instep—35 (41) instep sts; 61 (63) sole sts.

TURN HEEL AND HEEL FLAP
Work same as for right sock.

LEG
BIAS RND: Work in patt to 1 st before cable m, m1R, k1, sl m, work Cable chart to next cable m, sl m, ssk, knit to end of rnd.

Rep bias rnd every other rnd until leg meas 1" (2.5 cm) less than total desired height, moving beg of rnd m to just after the ssk as needed.

CUFF
Work same as for right sock.

finishing

Block to measurements if desired. Weave in loose ends.

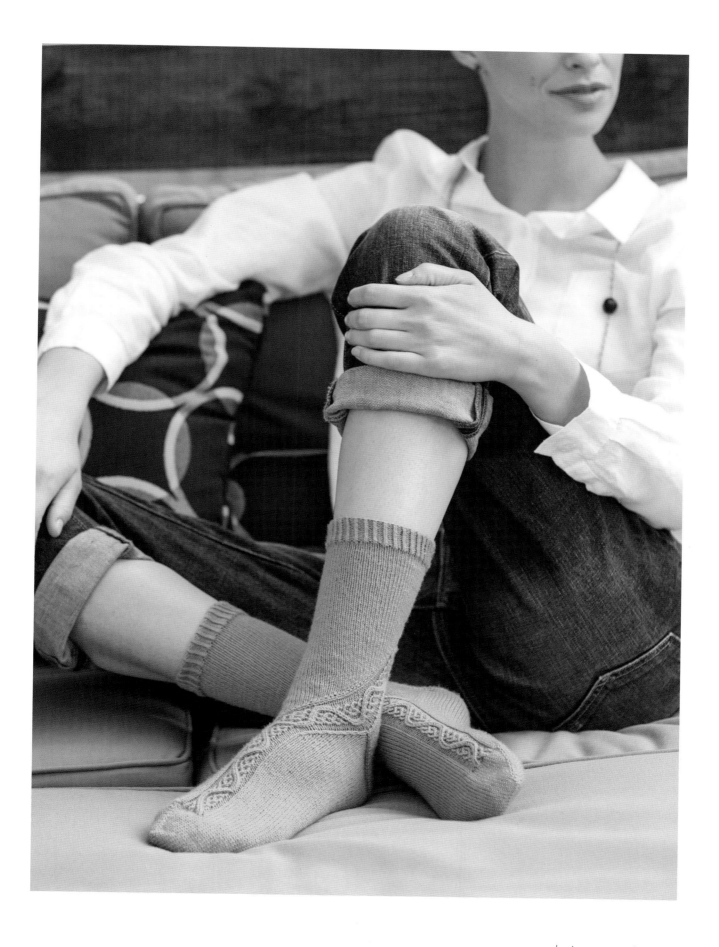

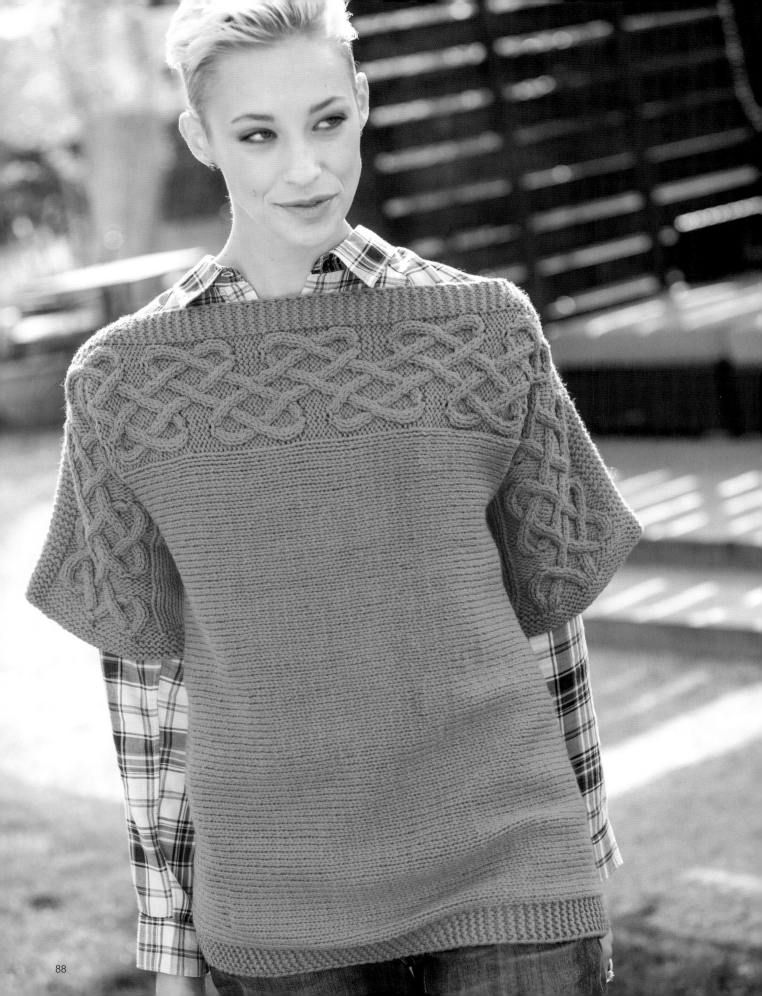

kissel hill dolman

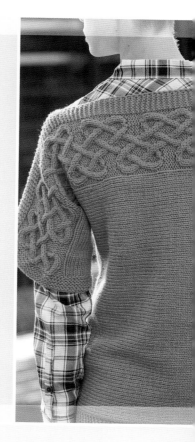

A COMPLEX CLOSED CABLED PANEL TAKES CENTER STAGE on this casual pullover. The simple dolman shape and garter stitch edges complement the design without taking focus away from the intricate cable work. Knit side to side in just two T-shaped pieces, this sweater is a fast project with minimal finishing.

FINISHED SIZE

Bust Circumference: About 34½ (38½, 42, 46, 50, 54)" (87.5 [98, 106.5, 117, 127, 137] cm).

Length: About 25¼ (25¼, 26¾, 28, 28, 30)" (64 [64, 68, 71, 71, 76] cm).

Sweater shown measures 38½" (98 cm).

YARN

Worsted weight (#4 Medium).

Shown here: Quince and Co. Osprey (100% wool; 170 yd [155 m]/100 g): nasturtium, 7 (7, 8, 9, 10, 11) skeins.

NEEDLES

Size U.S. 10 (6 mm): 24" (60 cm) circular (cir).

Adjust needle size if necessary to obtain the correct gauge.

NOTIONS

Markers (m); cable needle (cn); tapestry needle.

GAUGE

16½ sts and 25 rows = 4" (10 cm) in St st.

24 sts = 4½" (11.5 cm) in Cable chart (see Notes).

stitch guide

2/1 RPC: Sl 1 st to cn and hold in back, k2, p1 from cn.

2/1 LPC: Sl 2 sts to cn and hold in front, p1, k2 from cn.

2/2 RC: Sl 2 sts to cn and hold in back, k2, k2 from cn.

2/2 LC: Sl 2 sts to cn and hold in front, k2, k2 from cn.

2/2 RPC: Sl 2 sts to cn and hold in back, k2, p2 from cn.

2/2 LPC: Sl 2 sts to cn and hold in front, p2, k2 from cn.

DEC 4: Sl 3 sts purlwise with yarn in back (pwise wyb), then pass the first 2 slipped sts over the third slipped st and return the rem st to the left needle, pass the second and third st on the left needle over the first, then k1—4 sts dec'd.

Notes: The st count in the Cable chart is 24 sts on Rows 1–2, 10–14, and 22–24, and 18 sts on Rows 3–9 and 15–21. The st counts throughout the pattern reflect the st count used on the row of the Cable chart where the st counts are given.

Circular needle is used to accommodate large number of sts. Do not join; work back and forth in rows.

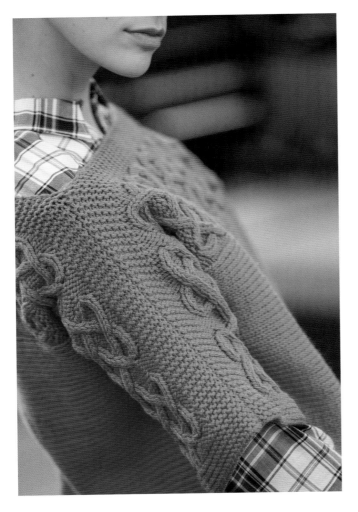

front

SLEEVE

CO 39 (39, 39, 44, 44, 49) sts. Do not join; work back and forth in rows.

Knit 8 rows.

EST PATT: (RS) Work 8 (8, 8, 13, 13, 18) sts in St st (knit on RS, purl on WS), place marker (pm), work Cable chart, pm, work 7 sts in Gtr st (knit every row).

Cont working as est until Rows 1–24 of Cable chart have been completed 2 times, and then work 6 (0, 6, 12, 18, 12) more rows, ending after a WS row—43 (39, 43, 44, 48, 49) sts.

Piece meas about 9¾ (8¾, 9¾, 10½, 11½, 10½)" (25 [22, 25, 26.5, 29, 26.5] cm) to here.

body

With RS facing, use the cable method (see Glossary) to CO 72 (72, 78, 78, 78, 82) sts—115 (111, 121, 122, 126, 131) sts. Do not turn.

EST PATT: (RS) Work 7 sts in Gtr st, pm, work to m in St st, sl m, work Cable chart to next m, sl m, work 7 sts in Gtr st.

knit on RS, purl on WS		□
purl on RS, knit on WS		•
M1		M
(k1, p1, k1) all in the same st		V
Dec 4		Ŝ
2/1 RPC		
2/1 LPC		
2/2 RC		
2/2 LC		
2/2 RPC		
2/2 LPC		
no stitch		

Cable

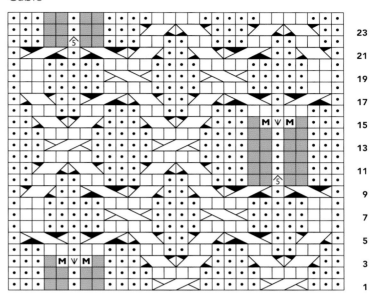

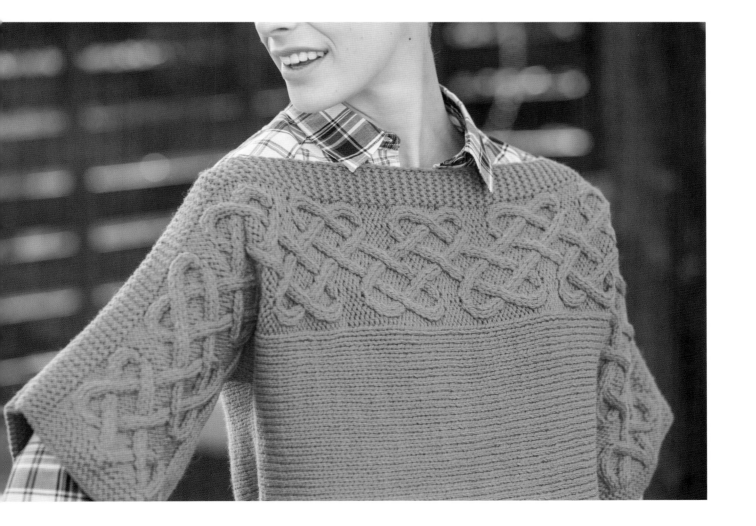

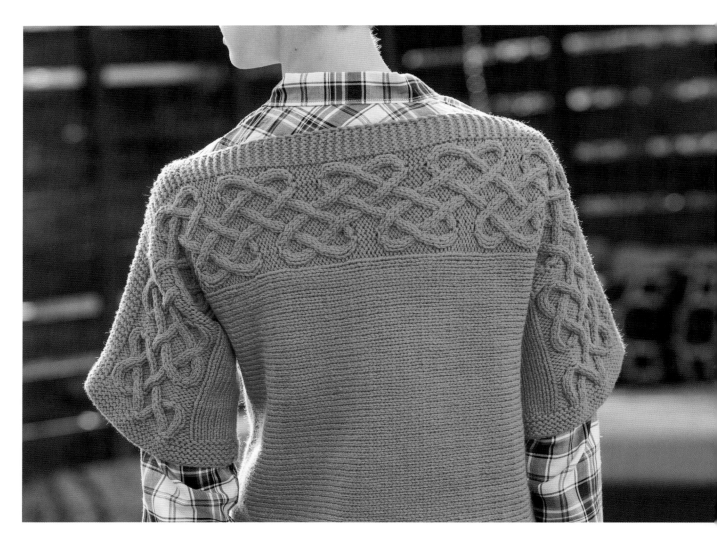

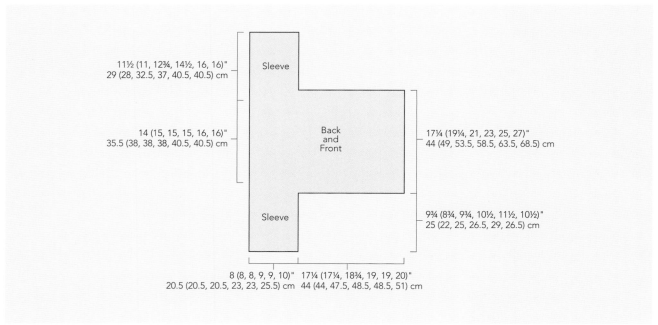

11½ (11, 12¾, 14½, 16, 16)"
29 (28, 32.5, 37, 40.5, 40.5) cm

Sleeve

Back
and
Front

17¼ (19¼, 21, 23, 25, 27)"
44 (49, 53.5, 58.5, 63.5, 68.5) cm

14 (15, 15, 15, 16, 16)"
35.5 (38, 38, 38, 40.5, 40.5) cm

Sleeve

9¾ (8¾, 9¾, 10½, 11½, 10½)"
25 (22, 25, 26.5, 29, 26.5) cm

8 (8, 8, 9, 9, 10)"
20.5 (20.5, 20.5, 23, 23, 25.5) cm

17¼ (17¼, 18¾, 19, 19, 20)"
44 (44, 47.5, 48.5, 48.5, 51) cm

making closed cables

Some of the most interesting cable patterns appear to spring from nowhere in the fabric, twist around in knots, and then disappear again. These are called closed, or pretzel, cables. Closed cables are especially useful when creating shapes like circles or cables that run sideways.

Kissel Hill uses closed cables across the yoke in both the front and back. To create this magical effect, we start with a dramatic increase in stitches.

Now we have extra stitches to work our cable pattern. At the end, to close the cable we work an equally dramatic decrease in stitches.

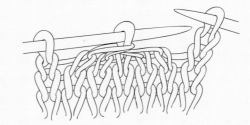

increase stitches

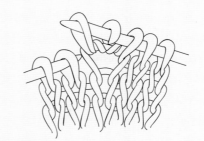

decrease stitches

Cont working as est until piece meas about 17¼ (19¼, 21, 23, 25, 27)" (44 [49, 53.5, 58.5, 63.5, 68.5] cm) from body CO, ending after WS Row 18 (24, 18, 12, 6, 12) of Cable chart—115 (111, 121, 122, 126, 131) sts.

sleeve

NEXT ROW: (RS) BO 72 (72, 78, 78, 78, 82) sts, knit to m, sl m, work Row 19 (1, 19, 13, 7, 13) of Cable chart to next m, sl m, knit to end—43 (39, 43, 44, 48, 49) sts rem.

Cont working as est until piece meas about 8¾ (7¾, 8¾, 9½, 10½, 9½)" (22 [19.5, 22, 24, 26.5, 24] cm) from BO, ending after WS Row 24 of Cable chart—39 (39, 39, 44, 44, 49) sts; 9 (9, 10, 11, 12, 12) total reps of Cable chart have been worked.

Knit 8 rows.

BO all sts.

back

Work same as for front.

finishing

Block to measurements.

Sew under sleeves and sides. Sew upper sleeves leaving a hole for the neck about 14 (15, 15, 15, 16, 16)" (35.5 [38, 38, 38, 40.5, 40.5] cm) wide.

Weave in ends.

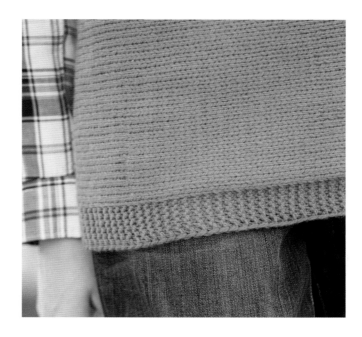

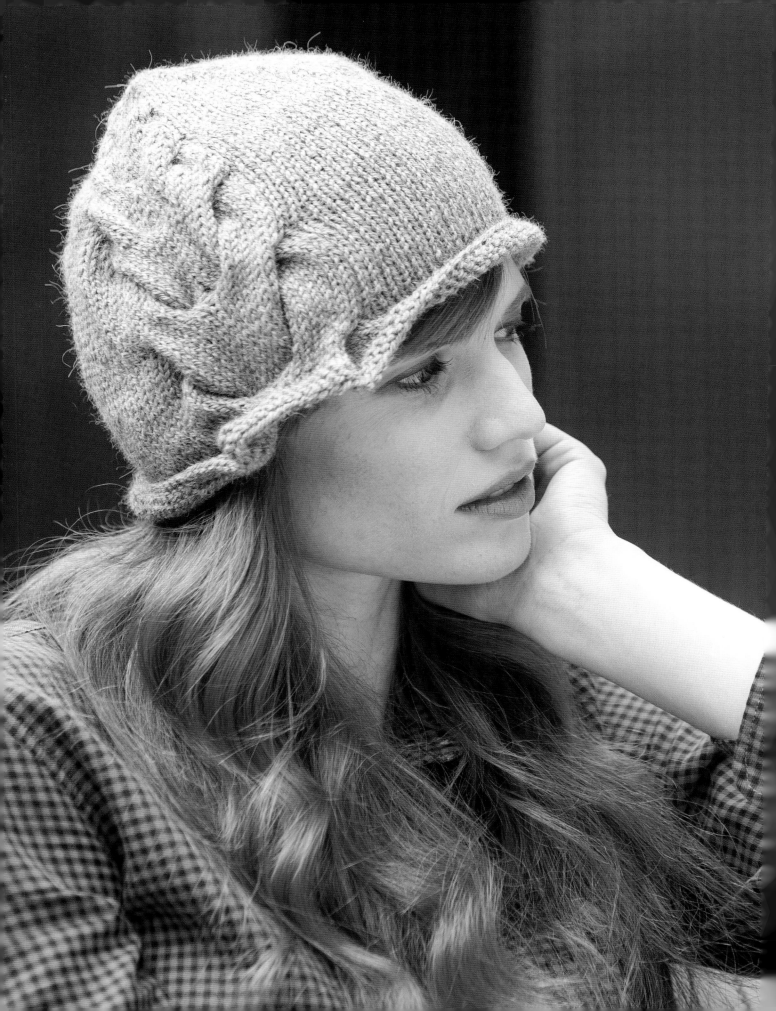

refton cloche

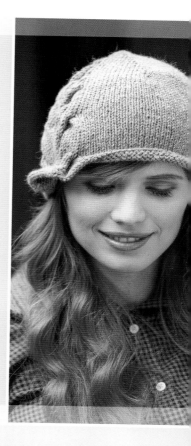

THIS CLEVER CLOCHE USES THE DRAWING-IN OF LARGE CABLES to create a cute ruffle on one side. Diminishing cables then travel up the side of the head to the crown. Without the conventional ribbed brim, this cloche has a vintage flare that's also gentle on your hair. Say good-bye to hat head with this stylish cap!

FINISHED SIZE

Circumference: About 19½" (49.5 cm).

YARN

Worsted weight (#4 Medium).

Shown here: Classic Elite Yarns MountainTop Vista (50% alpaca, 50% wool; 100 yd [91 m]/50 g): #6006 wolf, 2 skeins.

NEEDLES

Size U.S. 7 (4.5 mm): 16" (40 cm) circular (cir) and set of double-pointed (dpn).

Adjust needle size if necessary to obtain the correct gauge.

NOTIONS

Markers (m); cable needle (cn); tapestry needle.

GAUGE

21½ sts and 30 rnds = 4" (10 cm) in St st.

stitch guide

8/8 LC: Sl 8 sts to cn, hold in front, k8, k8 from cn.

8/8 RC: Sl 8 sts to cn, hold in back, k8, k8 from cn.

7/7 LC: Sl 7 sts to cn, hold in front, k7, k7 from cn.

7/7 RC: Sl 7 sts to cn, hold in back, k7, k7 from cn.

6/6 LC: Sl 6 sts to cn, hold in front, k6, k6 from cn.

6/6 RC: Sl 6 sts to cn, hold in back, k6, k6 from cn.

4/4 LC: Sl 4 sts to cn, hold in front, k4, k4 from cn.

4/4 RC: Sl 4 sts to cn, hold in back, k4, k4 from cn.

2/2 LC: Sl 2 sts to cn, hold in front, k2, k2 from cn.

2/2 RC: Sl 2 sts to cn, hold in back, k2, k2 from cn.

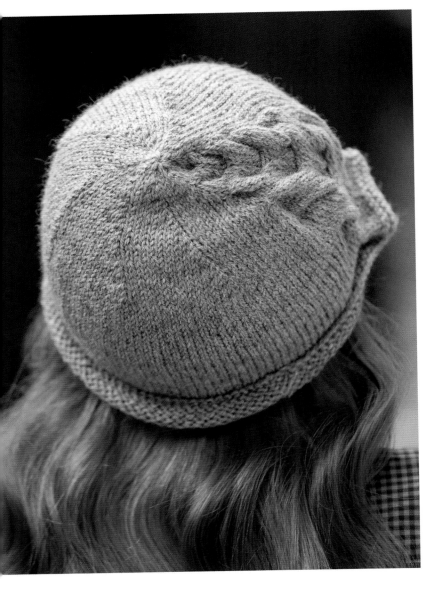

brim

CO 121 sts. Place marker (pm) and join for working in the rnd, being careful not to twist sts.

Purl 1 rnd.

Knit 1 rnd.

Purl 1 rnd.

Knit 6 rnds.

Remove m, k74, pm for new beg of rnd.

16-ST CABLE RND: 8/8 RC, 8/8 LC, knit to end.

Knit 15 rnds.

Rep 16-st cable rnd.

Knit 11 rnds.

14-ST CABLE RND: K2, 7/7 RC, 7/7 LC, knit to end of rnd.

Knit 1 rnd.

crown

SET-UP RND: K1, *k13, k2tog, pm; rep from *—113 sts rem.

Knit 1 rnd.

DEC RND: K1, *knit to 2 sts before m, k2tog, sl m; rep from *—8 sts dec'd.

Rep the last 2 rnds 2 times—89 sts rem.

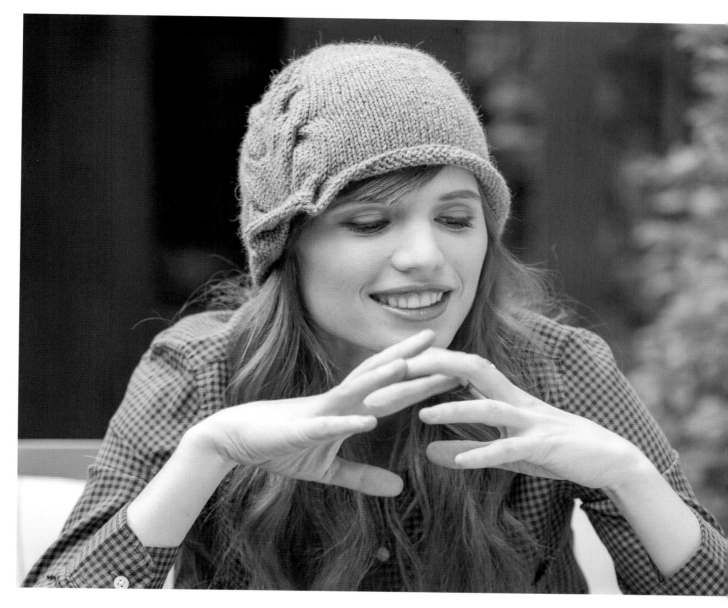

12-ST CABLE RND: 6/6 RC, sl m, 6/6 LC replacing m before the last st of cable, knit to end of rnd.

(*Note:* There should be 12 sts between the beg of rnd m and the first m, then 11 sts between all the foll markers.)

[Knit 1 rnd, work dec rnd] 4 times—57 sts.

8-ST CABLE RND: 4/4 RC, sl m, 4/4 LC replacing m before the last st of cable, knit to end of rnd.

(*Note:* There should be 8 sts between the beg of rnd m and the first m, then 7 sts between all the foll markers.)

[Knit 1 rnd, work dec rnd] 3 times—33 sts.

4-ST CABLE RND: K1, 2/2 RC, sl m, 2/2 LC, sl m, knit to end of rnd.

Work dec rnd 3 more times—9 sts.

Remove markers. Break yarn leaving 7" (18 cm) tail. With tapestry needle, thread tail through rem sts and pull tightly. Secure tail to the inside of the hat.

finishing

Block to measurements. Weave in loose ends.

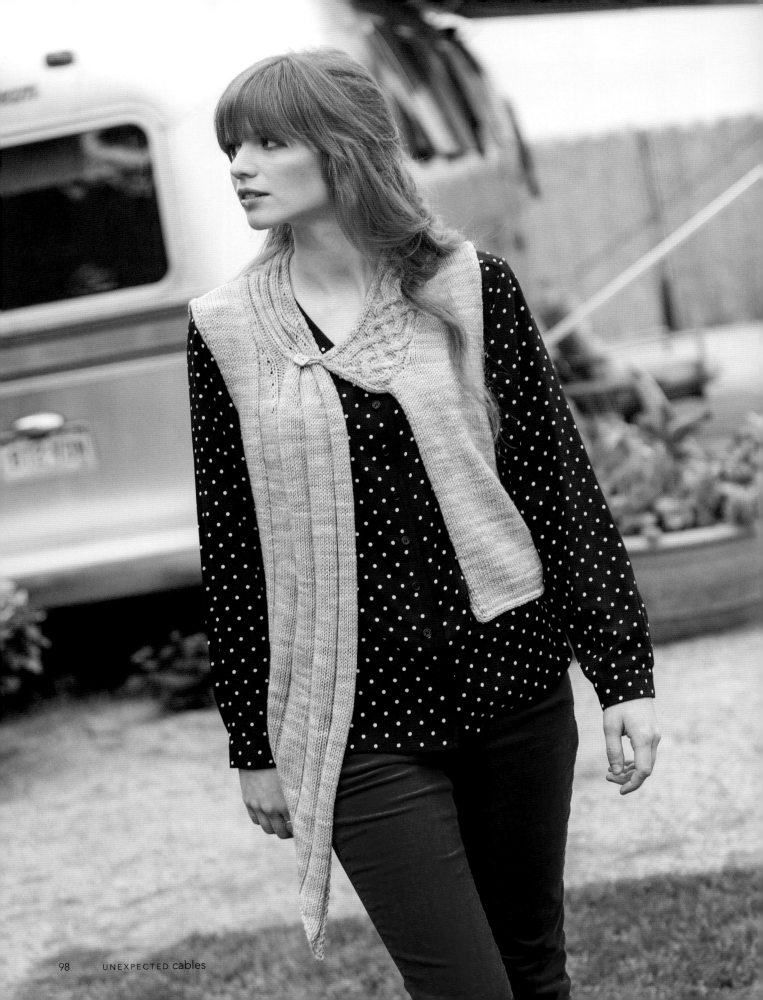

holtwood vest

ASYMMETRICAL AND MODERN, this vest features a cabled collar that flares into a wide ribbed panel. The body is worked seamlessly from the bottom up in simple stockinette. All edges are finished cleanly with applied I-cord, and a single button closes the front.

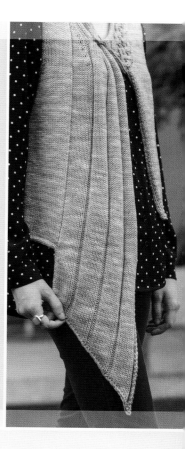

FINISHED SIZE
Bust Circumference: About 35 (39, 43, 47¼, 51¼, 55½)" (89 [99, 109, 120, 130, 141] cm).

Length: About 18½ (19¼, 19¾, 20, 20½, 21)" (47 [49, 50, 51, 52, 53.5] cm).

Vest shown measures 39" (99 cm).

YARN
Worsted weight (#4 Medium).

Shown here: Baah! Shasta (100% merino; 200 yd [183 m]/100 g): sage, 4 (4, 5, 5, 6, 6) skeins.

NEEDLES
Size U.S. 8 (5 mm): set of 2 double-pointed (dpn) and 24" (60 cm) circular (cir).

Adjust needle size if necessary to obtain the correct gauge.

NOTIONS
Crochet hook; waste yarn; cable needle (cn); st holder or waste yarn; tapestry needle; one 5/8" (1.5 cm) button.

GAUGE
19½ sts and 30 rows = 4" (10 cm) in St st.

20 sts = 2½" (6.5 cm) and 27 rows = 4" (10 cm) in Cable chart.

stitch guide

2/1 RPC: Sl 1 st to cn and hold in back, k2, p1 from cn.

2/1 LPC: Sl 2 sts to cn and hold in front, p1, k2 from cn.

2/2 RC: Sl 2 sts to cn and hold in back, k2, k2 from cn.

2/2 LC: Sl 2 sts to cn and hold in front, k2, k2 from cn.

2/2 RPC: Sl 2 sts to cn and hold in back, k2, p2 from cn.

2/2 LPC: Sl 2 sts to cn and hold in front, p2, k2 from cn.

Notes: Circular needle is used to accommodate large number of sts. Do not join; work back and forth in rows.

The collar is worked with a slipped st I-cord for the cable and ribbing sections. This creates a natural curve to the panel. After the collar comes around to the right front, a regular I-cord edging is used.

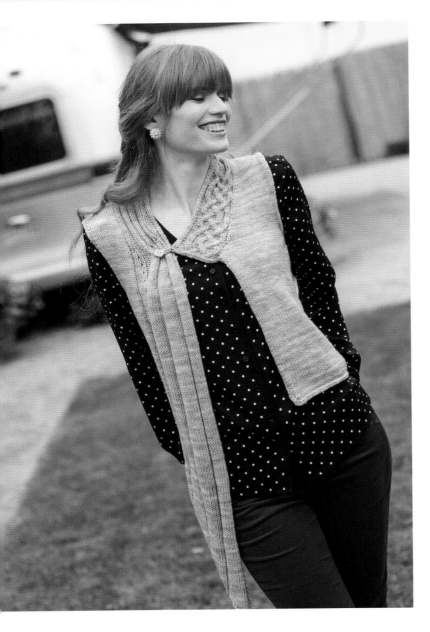

body

Use cir needle and a crochet provisional cast-on (see Glossary) to CO 145 (163, 182, 201, 221, 240) sts. Do not join; work back and forth in rows.

Work in St st until piece meas 11½ (11¾, 11¾, 11½, 11¾, 11¾)" (29 [30, 30, 29, 30, 30] cm) from CO edge, ending after a RS row.

DIVIDE FRONTS AND BACK

NEXT ROW: (WS) P39 (43, 49, 53, 59, 63) sts for left front then place them onto st holder or waste yarn, p85 (95, 105, 115, 125, 135) sts for back then place them onto a separate st holder or waste yarn, purl rem 21 (25, 28, 33, 37, 42) sts for right front. Cont working on right front sts only.

right front

Knit 1 WS row.

SHAPE ARMHOLE

BO 3 (3, 4, 4, 5, 5) sts at the beg of the next WS row,

BO 3 sts at the beg of the next 0 (1, 1, 2, 3, 3) WS row(s),

BO 2 sts at the beg of the next 1 (1, 2, 2, 3, 3) WS row(s), then

BO 1 st at the beg of the next 2 (3, 4, 5, 3, 6) WS rows—14 (14, 13, 14, 14, 16) sts rem.

Work even in St st until armhole meas 7 (7½, 8, 8½, 8¾, 9¼)" (18 [19, 20.5, 21.5, 22, 23.5] cm), ending after a WS row.

Transition

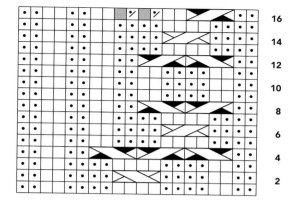

Cable

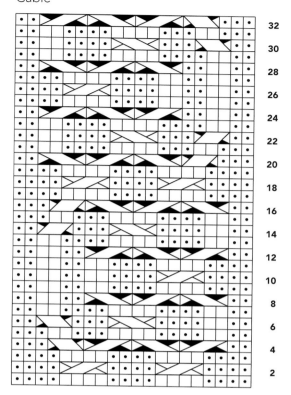

	knit on RS, purl on WS
•	purl on RS, knit on WS
✓	p2tog
▨	no stitch
⬡	2/1 RPC
⬡	2/1 LPC
⬡	2/2 RC
⬡	2/2 LC
⬡	2/2 RPC
⬡	2/2 LPC

SHAPE SHOULDER

Shape shoulder using short-rows (see Glossary) as foll:

SHORT-ROW 1: (RS) Knit to last 4 sts, wrap next st and turn so WS is facing; purl to end.

SHORT-ROW 2: Knit to 4 sts before last wrap, wrap next st and turn so WS is facing; purl to end.

Rep Short-row 2 once more.

NEXT ROW: (RS) Knit, working all wraps together with their sts as you come to them.

Place shoulder sts onto st holder or waste yarn. Break yarn.

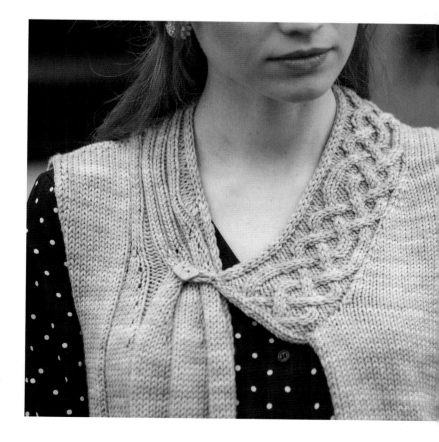

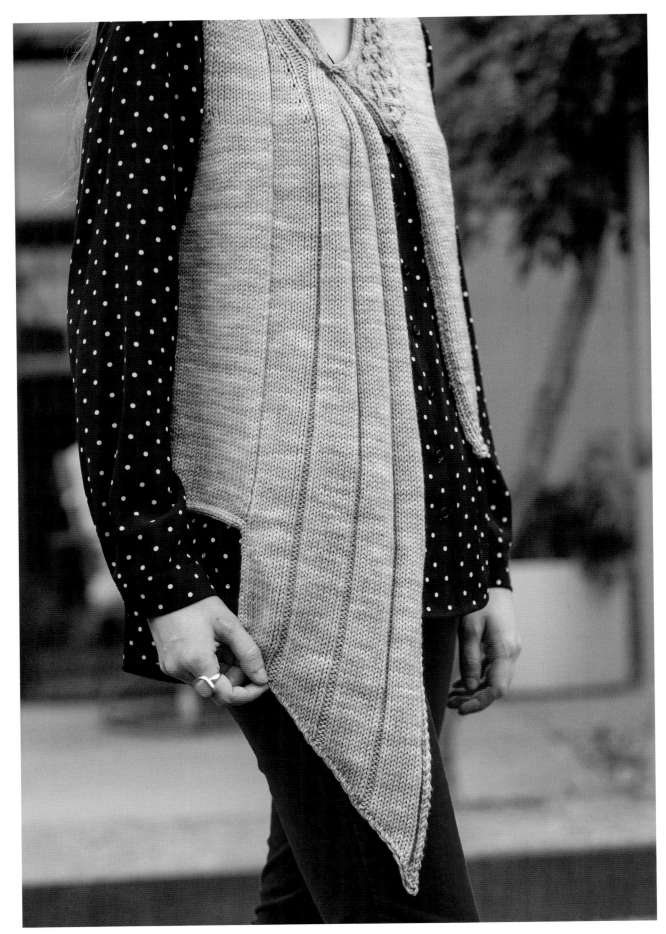

left front

Return 39 (43, 49, 53, 59, 63) held left front sts to needle and join yarn preparing to work a RS row.

SHAPE ARMHOLE

BO 3 (3, 4, 4, 5, 5) sts at the beg of the next row, BO 3 sts at the beg of the next 0 (1, 1, 2, 3, 3) RS row(s), BO 2 sts at the beg of the next 1 (1, 2, 2, 3, 3) RS row(s), then BO 1 st at the beg of the next 2 (3, 4, 5, 3, 6) RS rows—32 (32, 34, 34, 36, 37) sts rem.

SHAPE NECK

BO 4 (4, 4, 5, 5, 5) sts at beg of next WS row, BO 2 (2, 3, 3, 3, 3) sts at beg of next WS row, BO 1 st at beg of every 4th row 7 (6, 4, 6, 5, 4) times, then BO 1 st at beg of every WS row 5 (6, 10, 6, 9, 9) times—14 (14, 13, 14, 14, 16) sts.

Work even in St st until armhole meas 7 (7½, 8, 8½, 8¾, 9¼)" (18 [19, 20.5, 21.5, 22, 23.5] cm), ending with a RS row.

SHAPE SHOULDER

Shape shoulder using short-rows as foll:

SHORT-ROW 1: (WS) Purl to last 4 sts, wrap next st and turn so RS is facing; knit to end.

SHORT-ROW 2: Purl to 4 sts before last wrap, wrap next st and turn so RS is facing; knit to end of row.

Rep Short-row 2 once more.

NEXT ROW: (WS) Purl working all wraps together with their sts as you come to them.

Place shoulder sts on waste yarn or st holder. Break yarn.

back

Return 85 (95, 105, 115, 125, 135) held back sts to needle and join yarn preparing to work a RS row.

SHAPE ARMHOLE

BO 3 (3, 4, 4, 5, 5) sts at beg of next 2 rows, BO 3 sts at beg of next 0 (2, 2, 4, 6, 6) rows, BO 2 sts at beg of next 2 (2, 4, 4, 6, 6) rows, then BO 1 st at beg of next 4 (6, 8, 10, 6, 12) rows—71 (73, 75, 77, 79, 83) sts rem.

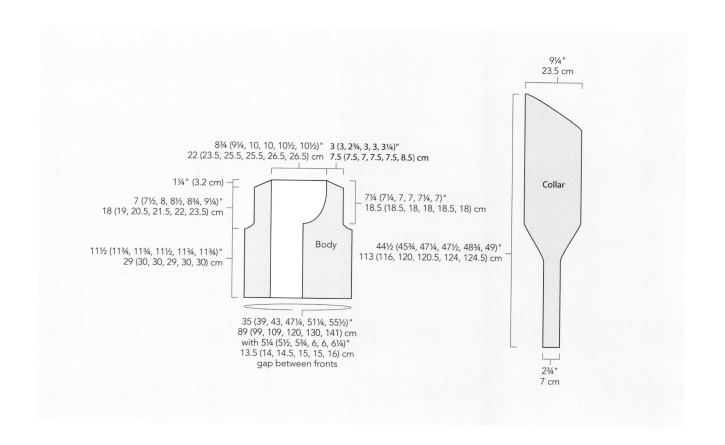

8¾ (9¼, 10, 10, 10½, 10½)"
22 (23.5, 25.5, 25.5, 26.5, 26.5) cm

3 (3, 2¾, 3, 3, 3¼)"
7.5 (7.5, 7, 7.5, 7.5, 8.5) cm

1¼" (3.2 cm)

7 (7½, 8, 8½, 8¾, 9¼)"
18 (19, 20.5, 21.5, 22, 23.5) cm

7¼ (7¼, 7, 7, 7¼, 7)"
18.5 (18.5, 18, 18, 18.5, 18) cm

Body

11½ (11¾, 11¾, 11½, 11¾, 11¾)"
29 (30, 30, 29, 30, 30) cm

44½ (45¾, 47¼, 47½, 48¾, 49)"
113 (116, 120, 120.5, 124, 124.5) cm

35 (39, 43, 47¼, 51¼, 55½)"
89 (99, 109, 120, 130, 141) cm
with 5¼ (5½, 5¾, 6, 6, 6¼)"
13.5 (14, 14.5, 15, 15, 16) cm
gap between fronts

9¼"
23.5 cm

Collar

2¾"
7 cm

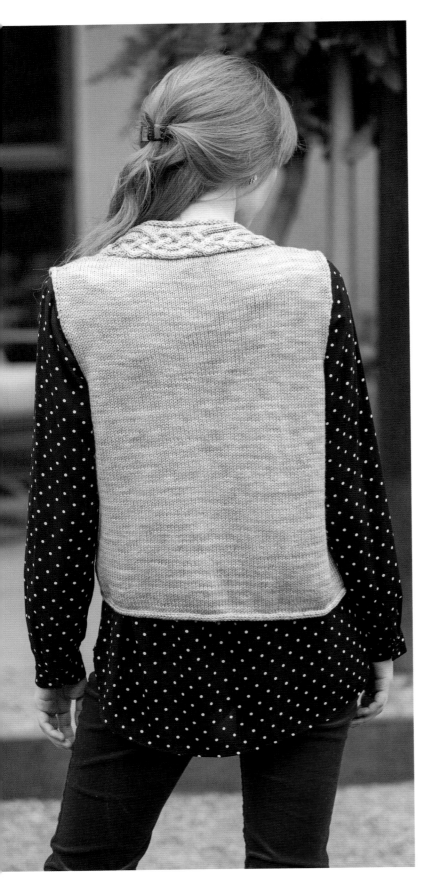

Work even in St st until armholes meas 7 (7½, 8, 8½, 8¾, 9¼)" (18 [19, 20.5, 21.5, 22, 23.5] cm), ending after a WS row.

SHAPE SHOULDERS
Shape shoulders using short-rows as foll:

SHORT-ROW 1: (RS) Knit to last 4 sts, wrap next st and turn so WS is facing; purl to last 4 sts, wrap next st and turn so RS is facing.

SHORT-ROW 2: Knit to 4 sts before last wrap, wrap next st and turn so WS is facing; purl to 4 sts before last wrap, wrap next st and turn so RS is facing.

Rep Short-row 2 once more.

NEXT ROW: (RS) K14 (14, 13, 14, 14, 16) sts working the wraps together with their sts, BO 43 (45, 49, 49, 51, 51) sts for neck, then knit the rem 14 (14, 13, 14, 14, 16) sts working the wraps together with their sts.

Place rem sts onto st holders or waste yarn for shoulders.

collar

CO 23 sts.

CABLE PANEL
EST PATT: (WS) K3, pm, work Cable chart to end.

NEXT ROW: (RS) Work Cable chart to m, sl m, sl 3 sts purlwise with yarn in front (pwise wyf).

Cont working as est, until Rows 1–32 of Cable chart have been worked 3 (3, 3, 4, 4, 4) times.

Then work Rows 1–16 of Transition chart, keeping 3 sts at left edge in slipped I-cord as est—21 sts rem.

Piece meas about 16½ (16½, 16½, 21¼, 21¼, 21¼)" (42 [42, 42, 54, 54, 54] cm) to here.

RIBBED PANEL
EST RIBBING: (WS) K3, sl m, [k2, p2] 4 times, k2.

NEXT ROW: (RS) [P2, k2] 4 times, p2, sl m, sl 3 sts pwise wyf.

Cont working in ribbing as est for 3" (7.5 cm), ending after a WS row.

SHAPE RIGHT FRONT COLLAR
SET-UP ROW: (RS) [P2, k2, pm] 4 times, p2, sl m, sl 3 sts pwise wyf.

NEXT ROW: K3, sl these 3 sts back to left needle and k3 again, work to end in ribbing as est.

INC ROW: (RS) [P2, knit to 1 st before m, m1, k1, sl m] 4 times, p2, sl 3 sts pwise wyf—4 sts inc'd.

Work 3 rows even as est.

Rep the last 4 rows 5 more times—45 sts.

Piece meas about 20¼ (20¼, 20¼, 25, 25, 25)" (51.5 [51.5, 51.5, 63.5, 63.5, 63.5] cm) to here.

Work even as est for 18½ (19¾, 21¼, 16¾, 18, 18¼)" (47 [50, 54, 42.5, 45.5, 46.5] cm), ending after a WS row.

SHAPE LOWER POINT
DEC ROW: (RS) P1, k2tog or p2tog keeping in patt, work to end in patt as est—1 st dec'd.

Work 1 WS row even as est.

Rep the last 2 rows 42 more times—2 sts rem.

Piece meas about 44½ (45¾, 47¼, 47½, 48¾, 49)" (113 [116, 120, 120.5, 124, 124.5] cm) to here.

BO rem sts.

finishing

With RS's facing, use the three-needle method (see Glossary) to join shoulder sts together.

Block to measurements. Weave in ends.

Seam collar to body, beg with Cable chart at left front neck edge, working around the back, and then down the right front.

I-CORD EDGES
With dpn, CO 3 sts.

Starting at the top point of left front collar and working down the left front, *k2, sl 1 knitwise with yarn in back (kwise wyb), pick up and knit 1 st from edge, and ssk using the slipped st and the edge st, sl 3 sts back to left needle; rep from * all the way down the left front, around the bottom of the vest using provisional sts as your picked-up sts, then down the right side of the front ribbed panel.

BO all sts. Weave in ends.

ARMBANDS
Starting at the underarm of each armhole, work as for I-cord edges working around the armhole. Weave in ends.

BUTTONHOLE
Using a crochet hook, and starting at the top point of left front collar, ch 8 sts, fasten off. Attach end to fabric to create a loop. Weave in ends.

Sew a button on the ribbed panel where you want to attach the left front. Block again if desired.

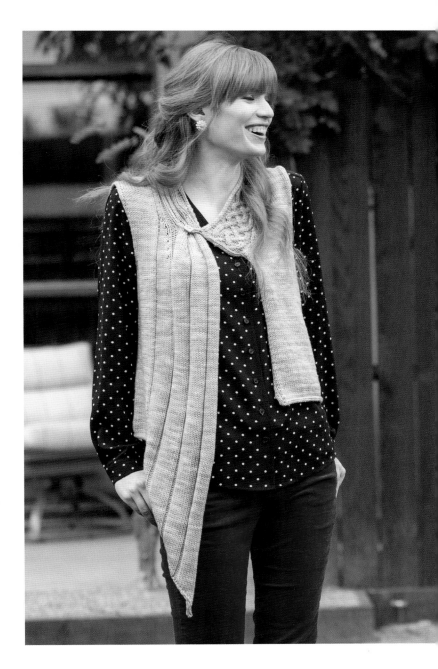

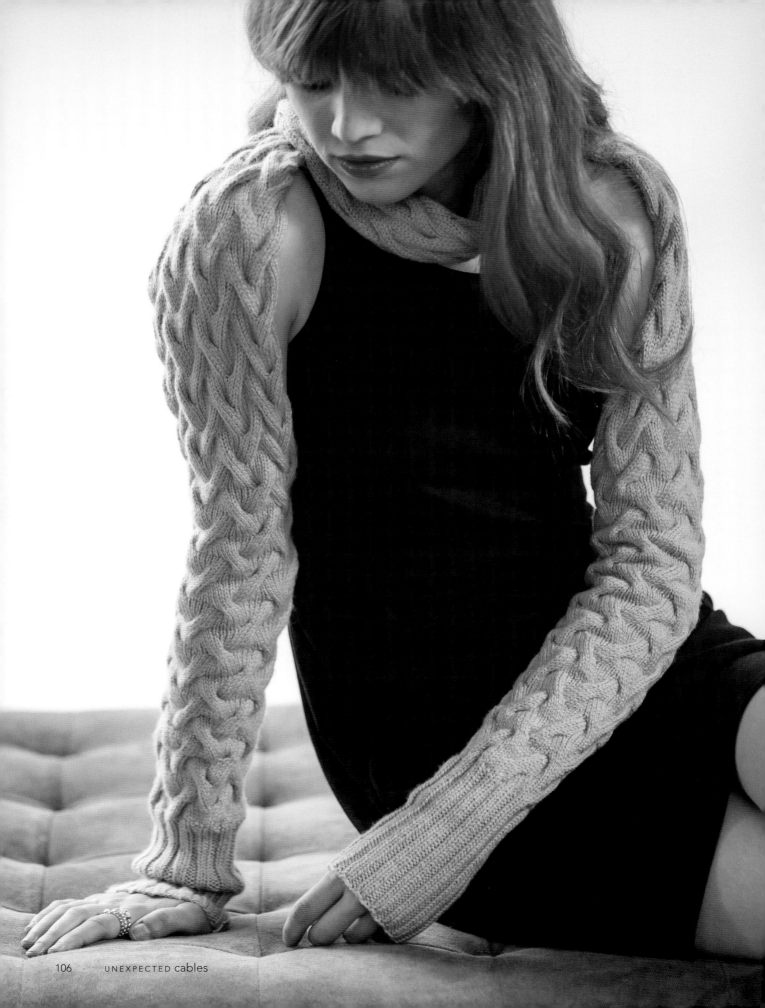

UNEXPECTED cables

fulton shrug

IT'S A SHRUG AND A SCARF IN ONE! This versatile piece is modern and fun. Worn up one arm, around the neck, and down the other, this accessory will keep your arms, shoulders, and neck warm during the coldest months. Wear over a close-fitting top as a statement piece or tucked under your coat for an extra layer of comfort.

FINISHED SIZE

Upper Arm Circumference: About 8 (9¼, 10¾, 12)" (20.5 [23.5, 27.5, 30.5] cm).

Length: About 85 (89¾, 93½, 96¾)" (216 [228, 237.5, 246] cm).

Shrug shown measures 8" (20.5 cm).

YARN

Sport weight (#2 Fine).

Shown here: Stitch Sprouts Yellowstone (80% wool, 20% silk; 285 yd [261 m]/100 g): old faithful, 4 (5, 5, 6) skeins.

NEEDLES

Size U.S. 6 (4 mm): double-pointed (dpn) and straight.

Adjust needle size if necessary to obtain the correct gauge.

NOTIONS

Marker (m); cable needle (cn); tapestry needle.

GAUGE

36 sts and 37 rows/rnds = 4" (10 cm) in Cable charts.

stitch guide

4/4 RC: Sl 4 sts to cn and hold in back, k4, k4 from cn.

4/4 LC: Sl 4 sts to cn and hold in front, k4, k4 from cn.

END-4/4 LC: Sl 4 sts to cn and hold in front, remove beg of rnd m, k4, replace beg of rnd m, k4 from cn.

K2, p2 Ribbing (multiple of 4 sts)
RND 1: *K2, p2; rep from *.

Rep Rnd 1 for patt.

Notes: To make a more traditional shrug, work the wrap section shorter.

The fit around the arms is intended to be snug to help hold the shrug in place.

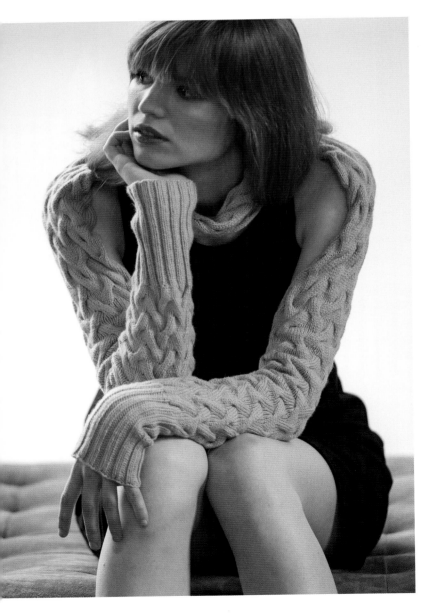

right sleeve

With dpn, CO 56 (64, 76, 84) sts. Place marker (pm) and join for working in the rnd, being careful not to twist sts.

Work in k2, p2 ribbing until piece meas 5½ (5¾, 6, 6¼)" (14 [14.5, 15, 16] cm) from CO edge.

INC RND: K0 (4, 6, 0), *m1 (see Glossary), k3, m1, k4 (3, 4, 4); rep from *—72 (84, 96, 108) sts.

Knit 5 rnds even.

Work Cable chart in the rnd until sleeve meas about 17½ (18½, 18¾, 19)" (44.5 [47, 47.5, 48.5] cm) from CO edge, ending after Rnd 1 or 9.

Turn so WS is facing, and cont working back and forth in rows.

wrap

(*Note:* Remove beg of rnd m and change to straight needles when comfortable to do so.)

Beg with WS Row 2 or 10, work Cable chart back and forth in rows until wrap meas about 50 (52¾, 56, 58¾)" (127 [134, 142, 149] cm) from end of sleeve, ending after WS Row 8 or 16.

left sleeve

Divide sts evenly on dpn, pm for beg of rnd and join for working in the rnd.

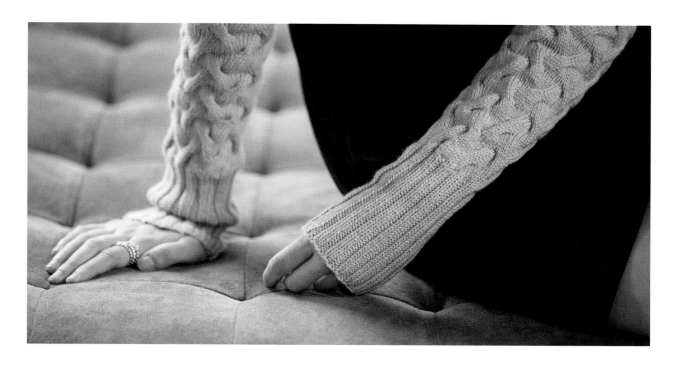

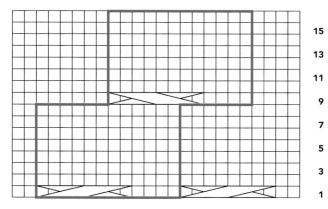

		knit on RS, purl on WS
v		sl 1 pwise wyb
		4/4 RC
		4/4 LC
		end-4/4 LC
		no stitch
		pattern repeat

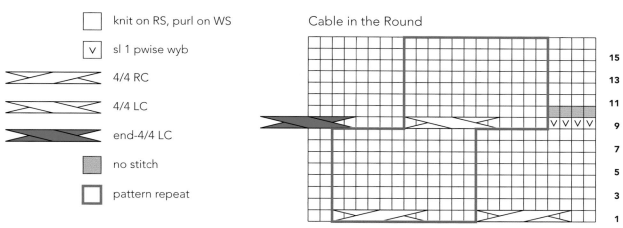

Beg with Rnd 1 or 9, work Cable chart in the rnd until sleeve meas 11¼ (12¼, 12¼, 12¼)" (28.5 [31, 31, 31] cm) from wrap, ending after Rnd 1 or 9.

Knit 5 rnds even.

DEC RND: K0 (4, 6, 0), *k2tog, k2, k2tog, 3 (2, 3, 3); rep from *—56 (64, 76, 84) sts rem.

Work in k2, p2 ribbing for 5½ (5¾, 6, 6¼)" (14 [14.5, 15, 16] cm) from dec rnd.

BO all sts in pattern.

finishing

Block to measurements. Weave in loose ends.

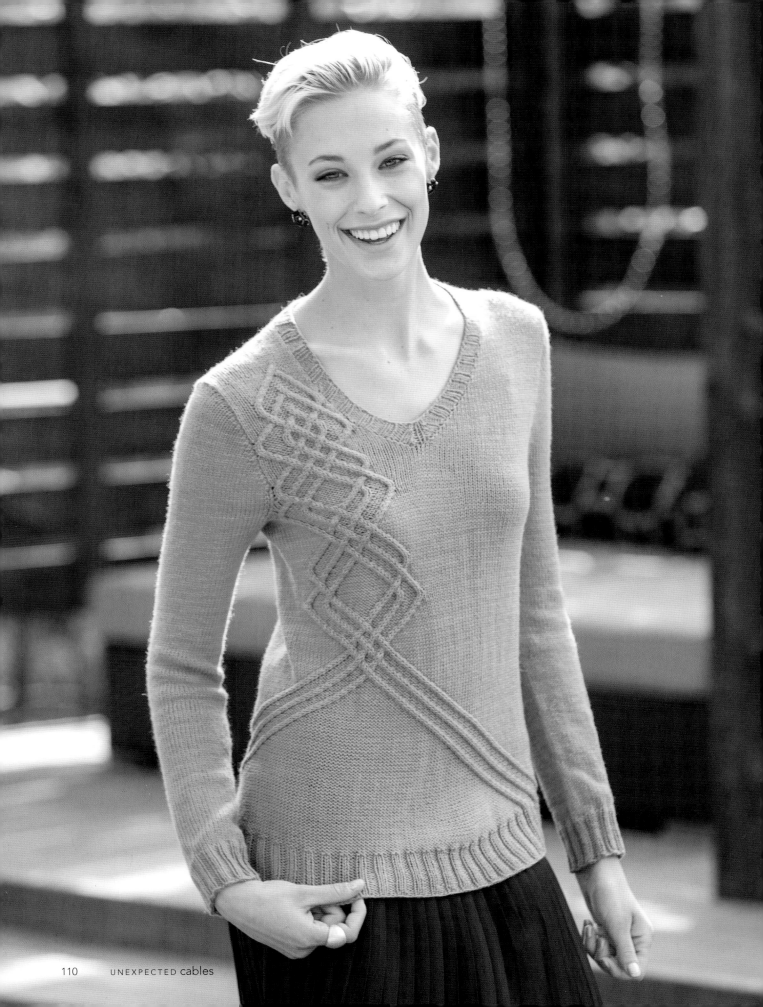

penryn pullover

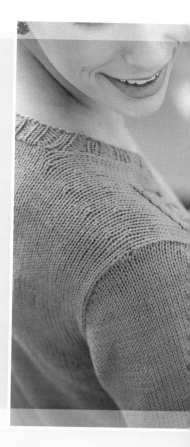

ON THIS FUNKY PULLOVER a cable blooms and grows from the right shoulder. As it grows down the sweater it also grows in width, exploding into an asymmetrical patch of reverse stockinette.

FINISHED SIZE

Bust Circumference: About 32 (36, 40, 44, 48, 52, 56)" (81.5 [91.5, 101.5, 112, 122, 132, 142] cm).

Length: About 23 (24, 24½, 25, 25½, 26, 26¼)" (58.5 [61, 62, 63.5, 65, 66, 66.5] cm).

Sweater shown measures 32" (81.5 cm).

YARN

DK weight (#3 Light).

Shown here: Swans Island Organic Washable Merino DK (100% merino; 140 yd [128 m]/50 g): pesto, 10 (11, 12, 13, 14, 15, 17) skeins.

NEEDLES

Size U.S. 6 (4 mm): set of double-pointed (dpn), and 24" (60 cm) circular (cir).

Adjust needle size if necessary to obtain the correct gauge.

NOTIONS

Crochet hook; waste yarn; removable st markers (m); st holders or waste yarn; cable needle (cn); tapestry needle.

GAUGE

24 sts and 34 rows = 4" (10 cm) in St st.

52 sts = 6" (15 cm) in Cable chart, measured over Rows 87–91.

stitch guide

2/2 RC: Sl 2 sts to cn and hold in back, k2, k2 from cn.

2/2 LC: Sl 2 sts to cn and hold in front, k2, k2 from cn.

2/2 RPC: Sl 2 sts to cn and hold in back, k2, p2 from cn.

2/2 LPC: Sl 2 sts to cn and hold in front, p2, k2 from cn.

K2, p2 Ribbing (multiple of 4 sts)

RND 1: *K2, p2; rep from *.

Rep Rnd 1 for patt.

Note: This pullover is worked seamlessly from the back, up over the shoulders, and then down in the round from the armholes. Set-in sleeves are picked up and worked top down using short-rows for sleeve cap shaping.

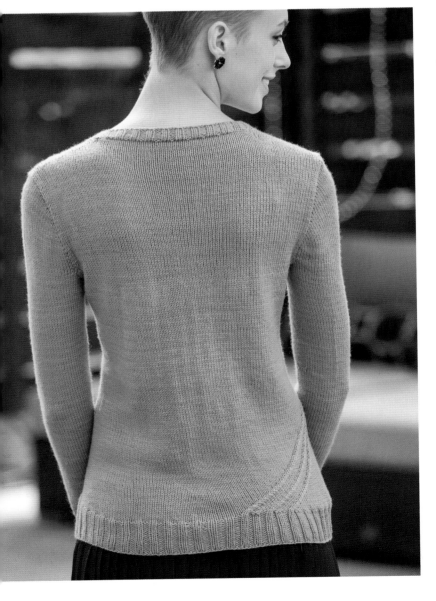

back

Use the crochet provisional method (see Glossary) to CO 102 (114, 126, 138, 150, 162, 174) sts onto cir needle. Do not join; work back and forth in rows.

Purl 1 row.

SHAPE ARMHOLES

Cont working in St st (knit on RS, purl on WS) while shaping as foll:

BO 3 (4, 4, 5, 5, 6, 7) sts at the beg of the next 2 rows, BO 3 sts at the beg of the next 2 (2, 4, 6, 6, 8, 8) rows, BO 2 sts at the beg of the next 2 (2, 4, 4, 6, 6, 8) rows, then BO 1 st at the beg of the next 2 (8, 8, 10, 16, 16, 18) rows—84 (88, 90, 92, 94, 98, 102) sts rem.

Work even in St st until armholes meas 7 (7½, 8, 8½, 8¾, 9¼, 9¼)" (18 [19, 20.5, 21.5, 22, 23.5, 23.5] cm), ending after a WS row.

SEPARATE SHOULDERS

Place markers (pm) on each side of center 40 (44, 46, 48, 46, 50, 54) sts for neck.

NEXT ROW: (RS) K22 (22, 22, 22, 24, 24, 24) to m, place these sts on st holder or waste yarn for right shoulder, BO 40 (44, 46, 48, 46, 50, 54) sts removing markers, knit to end—22 (22, 22, 22, 24, 24, 24) sts rem for left shoulder.

left back

SHAPE SHOULDER

Shape left shoulder using short-rows (see Glossary) as foll:

NEXT ROW: (WS) Purl to neck edge, turn.

SHORT-ROW 1: (RS) Knit to last 4 sts, wrap next st and turn so WS is facing; purl to end of row.

SHORT-ROW 2: Knit to last 8 sts, wrap next st and turn so WS is facing; purl to end of row.

SHORT-ROW 3: Knit to last 12 sts, wrap next st and turn so WS is facing; purl to end of row.

SHORT-ROW 4: Knit to last 16 sts, wrap next st and turn so WS is facing; purl to end of row.

NEXT ROW: (RS) Knit, working wraps as you come to them.

Purl 1 row. Place a removable m on the armhole edge between the last 2 rows to mark the top of the shoulder.

left front

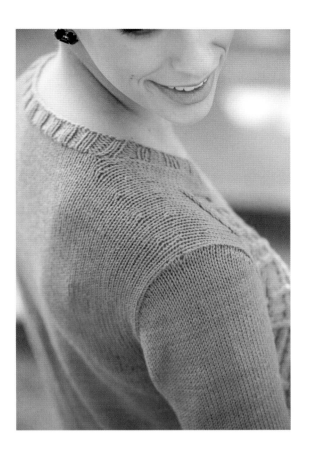

SHAPE SHOULDER

SHORT-ROW 1: (RS) K4, wrap next st and turn so WS is facing; purl to end of row.

SHORT-ROW 2: K8, working wrap as you come to it, wrap next st and turn so WS is facing; purl to end of row.

SHORT-ROW 3: K12, working wrap as you come to it, wrap next st and turn so WS is facing; purl to end of row.

SHORT-ROW 4: K16, working wrap as you come to it, wrap next st and turn so WS is facing; purl to end of row.

NEXT ROW: (RS) Knit, working wrap as you come to it.

Purl 1 WS row.

SHAPE NECK

INC ROW: (RS) K1, m1L (see Glossary), knit to end—1 st inc'd.

[Work 3 rows, then rep inc row] 8 (6, 5, 6, 7, 7, 5) times—31 (29, 28, 29, 32, 32, 30) sts.

[Work 1 row, then rep inc row] 9 (12, 14, 12, 7, 8, 10) times—40 (41, 42, 41, 39, 40, 40) sts.

SHAPE NECK AND ARMHOLE

Purl 1 WS row.

INC ROW: (RS) K1, m1L, knit to last st, m1R (see Glossary), k1—2 sts inc'd.

Rep the last 2 rows 0 (1, 1, 3, 6, 7, 9) more time(s)—42 (45, 46, 49, 53, 56, 60) sts.

Place sts on waste yarn or st holder, keeping yarn attached.

right back

Return 22 (22, 22, 22, 24, 24, 24) held right back sts to cir needle and join yarn preparing to work a WS row.

SHAPE SHOULDER

Shape right shoulder with short-rows as foll:

SHORT-ROW 1: (WS) Purl to last 4 sts, wrap next st and turn so RS is facing; knit to end of row.

Cable

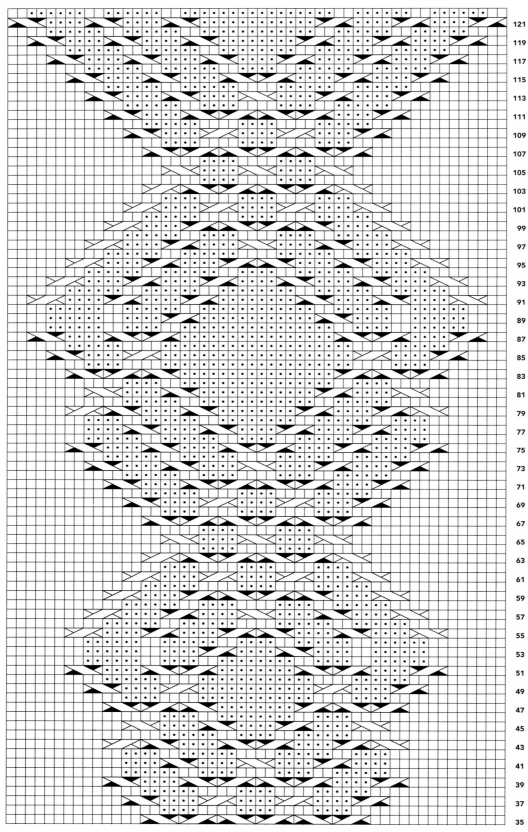

121
119
117
115
113
111
109
107
105
103
101
99
97
95
93
91
89
87
85
83
81
79
77
75
73
71
69
67
65
63
61
59
57
55
53
51
49
47
45
43
41
39
37
35

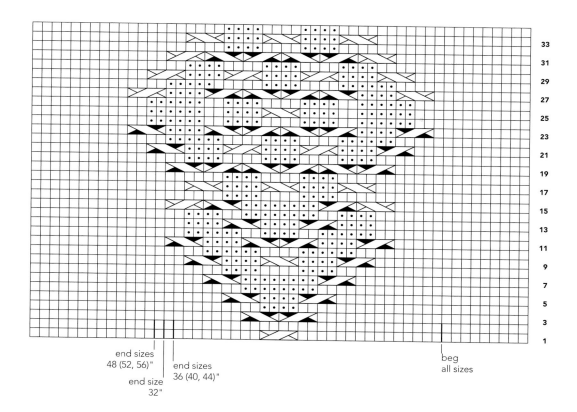

end sizes
48 (52, 56)"

end size
32"

end sizes
36 (40, 44)"

beg
all sizes

	33
	31
	29
	27
	25
	23
	21
	19
	17
	15
	13
	11
	9
	7
	5
	3
	1

SHORT-ROW 2: Purl to last 8 sts, wrap next st and turn so RS is facing; knit to end of row.

SHORT-ROW 3: Purl to last 12 sts, wrap next st and turn so RS is facing; knit to end of row.

SHORT-ROW 4: Purl to last 16 sts, wrap next st and turn so RS is facing; knit to end of row.

NEXT ROW: (WS) Purl, working wraps as you come to them.

KNIT 1 ROW. Place a removable m on the armhole edge between the last 2 rows to mark the top of the shoulder.

knit on RS, purl on WS

· purl on RS, knit on WS

2/2 RC

2/2 LC

2/2 RPC

2/2 LPC

right front

SHAPE SHOULDER

SHORT-ROW 1: (WS) P4, wrap next st and turn so RS is facing; knit to end of row.

SHORT-ROW 2: P8, working wrap as you come to it, wrap next st and turn so RS is facing; knit to end of row.

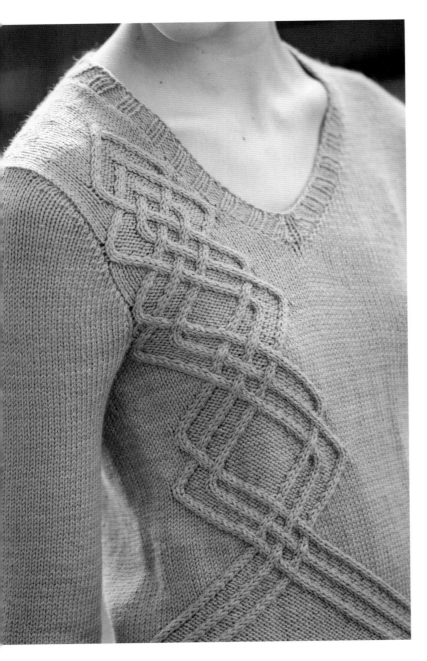

SHAPE NECK

INC ROW: (RS) Work in patt to last st, m1R, k1—1 st inc'd.

[Work 3 rows even, then rep inc row] 2 (1, 1, 1, 1, 1, 1) time(s)—29 (28, 28, 28, 30, 30, 30) sts.

Purl 1 WS row.

BEGIN CABLE CHART AND SHAPE NECK

NEXT ROW: (RS) Beg and end Cable chart where indicated on chart for your size.

Cont working neck shaping as foll, working inc'd sts into Cable chart as they become available, then work any additional sts in St st:

Work 1 WS row even, then rep inc row—30 (29, 29, 29, 31, 31, 31) sts.

[Work 3 rows even, then rep inc row] 5 (4, 3, 4, 5, 5, 3) times—35 (33, 32, 33, 36, 36, 34) sts.

[Work 1 row even, then rep inc row] 9 (12, 14, 12, 7, 8, 10) times—44 (45, 46, 45, 43, 44, 44) sts.

SHAPE NECK AND ARMHOLE

Purl 1 WS row.

INC ROW: (RS) K1, m1L, work in patt to last st, m1R (see Glossary), k1—2 sts inc'd.

Rep the last 2 rows 0 (1, 1, 3, 6, 7, 9) more time(s)—46 (49, 50, 53, 57, 60, 64) sts.

Keep sts on needle and break yarn.

front

JOIN LEFT AND RIGHT FRONT

Return 42 (45, 46, 49, 53, 56, 60) held left front sts to cir needle beside the right front sts. Cont using the yarn attached to the left front.

JOINING ROW: (WS) Purl to end of left front, then work in patt to end of right front—88 (94, 96, 102, 110, 116, 124) sts.

SHAPE ARMHOLES
Sizes 32 (36, 40, 44, 48, 52)" only:

INC ROW: (RS) K1, m1L, work in patt to last st, m1R, k1—2 sts inc'd.

Work 1 WS row even in patt.

SHORT-ROW 3: P12, working wrap as you come to it, wrap next st and turn so RS is facing; knit to end of row.

SHORT-ROW 4: P16, working wrap as you come to it, wrap next st and turn so RS is facing; knit to end of row.

NEXT ROW: (WS) Purl, working wrap as you come to it.

INC ROW: (RS) K2 (2, 2, 2, 4, 4, 4), *m1L, k5; rep from *—26 (26, 26, 26, 28, 28, 28) sts.

Rep the last 2 rows 0 (2, 2, 1, 1, 0) more time(s)—90 (100, 102, 106, 114, 118) sts.

All Sizes:
Use the backward loop method (see Glossary) to CO 2 sts at the end of the next 2 (2, 4, 4, 6, 6, 8) rows, CO 3 sts at the end of the next 2 (2, 4, 6, 6, 8, 8) rows, then CO 3 (4, 4, 5, 5, 6, 7) sts at the end of the next 2 rows—106 (118, 130, 142, 154, 166, 178) sts.

body

Carefully remove waste yarn from provisional cast-on sts and place 102 (114, 126, 138, 150, 162, 174) back sts onto cir needle beside front sts. Arrange sts on needle so tips of needle are where the yarn is attached (at the right underarm). Place marker (pm) for beg of rnd and join for working in the rnd, with RS facing —208 (232, 256, 280, 304, 328, 352) sts.

Cont working Cable chart as est until Rnd 122 is complete.

EST PATT: Knit to 2 sts before first cable, [2/2 RCP, p4] 3 times, purl to next cable, p2, 2/2 LCP, [p4, 2/2 LCP] 2 times, knit to end.

NEXT RND: Knit to next cable, [k2, p4] 3 times, purl to next cable, p2, k2, [p4, k2] 2 times, knit to end.

Rep the last 2 rnds 23 (29, 31, 33, 35, 37, 38) more times—112 (136, 144, 152, 160, 168, 172) purl sts between cables.

(*Note:* At some point the cable will meet the beg of rnd m. Shift the beg of rnd 2 sts to the right with each cable row to maintain patt.)

NEXT RND: [2/2 RCP, p4] 3 times, purl to next cable, p2, k2, [p4, k2] 2 times, knit to end—114 (138, 146, 154, 162, 170, 174) purl sts between cables.

Work in k2, p2 ribbing for 2" (5 cm).

BO all sts in patt.

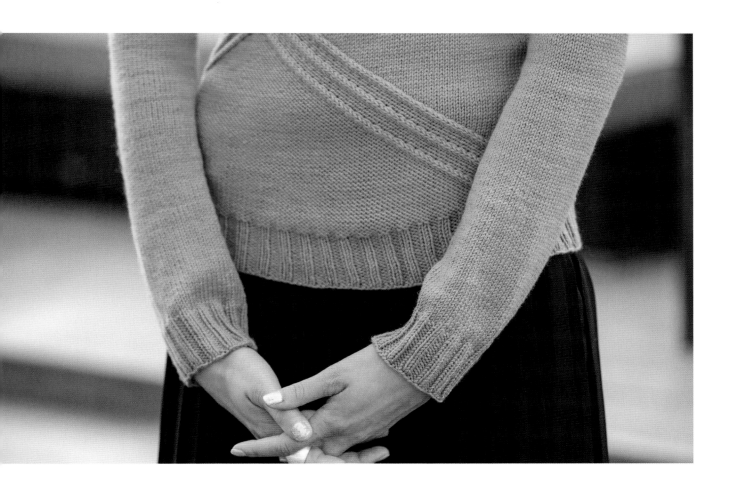

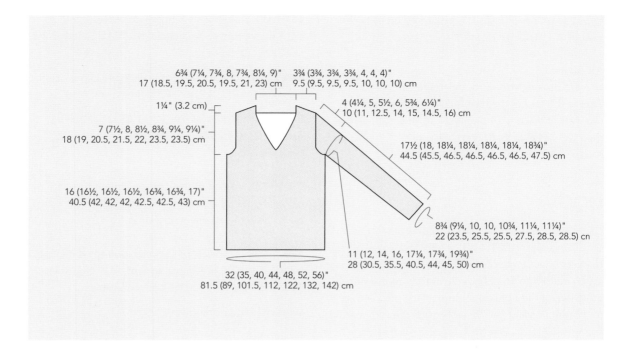

6¾ (7¼, 7¾, 8, 7¾, 8¼, 9)" 3¾ (3¾, 3¾, 3¾, 4, 4, 4)"
17 (18.5, 19.5, 20.5, 19.5, 21, 23) cm 9.5 (9.5, 9.5, 9.5, 10, 10, 10) cm

1¼" (3.2 cm)

4 (4¼, 5, 5½, 6, 5¾, 6¼)"
10 (11, 12.5, 14, 15, 14.5, 16) cm

7 (7½, 8, 8½, 8¾, 9¼, 9¼)"
18 (19, 20.5, 21.5, 22, 23.5, 23.5) cm

17½ (18, 18¼, 18¼, 18¼, 18¼, 18¾)"
44.5 (45.5, 46.5, 46.5, 46.5, 46.5, 47.5) cm

16 (16½, 16½, 16½, 16¾, 16¾, 17)"
40.5 (42, 42, 42, 42.5, 42.5, 43) cm

8¾ (9¼, 10, 10, 10¾, 11¼, 11¼)"
22 (23.5, 25.5, 25.5, 27.5, 28.5, 28.5) cn

11 (12, 14, 16, 17¼, 17¾, 19¾)"
28 (30.5, 35.5, 40.5, 44, 45, 50) cm

32 (35, 40, 44, 48, 52, 56)"
81.5 (89, 101.5, 112, 122, 132, 142) cm

sleeves

With RS facing, dpn, and beg at center of underarm, pick up and knit 33 (36, 42, 48, 52, 53, 59) sts to m at top of shoulder, pm, then pick up and knit another 33 (36, 42, 48, 52, 53, 59) sts evenly to the center of the underarm—66 (72, 84, 96, 104, 106, 118) sts. Pm and join for working in the rnd.

SLEEVE CAP

The sleeve cap is shaped using short-rows as foll:

SHORT-ROW 1: (RS) Knit to m at top of the shoulder, sl m, k8 (9, 10, 12, 13, 13, 14) sts, wrap next st and turn so WS is facing; p16 (18, 20, 24, 26, 26, 28) sts, wrap next st and turn so RS is facing—48 (52, 62, 70, 76, 78, 88) sts rem unwrapped at underarm.

SHORT-ROW 2: Knit to wrapped st, knit wrap together with its st, k2, wrap next st and turn so WS is facing; purl to wrapped st, purl wrap together with its st, p2, wrap next st and turn so RS is facing—42 (46, 56, 64, 70, 72, 82) sts rem unwrapped at underarm.

SHORT-ROW 3: Knit to wrapped st, knit wrap together with its st, k1, wrap next st and turn so WS is facing; purl to wrapped st, purl wrap together with its st, p1, wrap next st and turn so RS is facing—38 (42, 52, 60, 66, 68, 78) sts rem unwrapped at underarm.

SHORT-ROW 4: Knit to wrapped st, knit wrap together with its st, wrap next st and turn so WS is facing; purl to wrapped st, purl wrap together with its st, wrap next st and turn so RS is facing.

Rep the last short-row 11 (12, 13, 14, 15, 13, 15) more times—14 (16, 24, 30, 34, 40, 46) sts rem unwrapped at underarm.

Rep Short-row 3 one (1, 2, 2, 3, 3, 4) time(s)—10 (12, 16, 22, 22, 28, 30) sts rem unwrapped at underarm.

Rep Short-row 2 one (1, 2, 3, 3, 4, 4) time(s)—4 (6, 4, 4, 4, 4, 6) sts rem unwrapped at underarm.

NEXT ROW: (RS) Knit to the end of rnd, working wrapped sts together with their sts as you come to them. Cont working in the rnd.

SHAPE SLEEVE

Work even in St st (knit all sts, every rnd) until piece meas 1" (2.5 cm) from underarm.

DEC RND: K1, k2tog, knit to last 3 sts, ssk, k1—2 sts dec'd.

[Knit 17 (15, 11, 7, 7, 7, 5) rnds, then rep dec rnd] 5 (7, 4, 10, 4, 7, 16) times—54 (56, 74, 74, 94, 90, 84) sts rem.

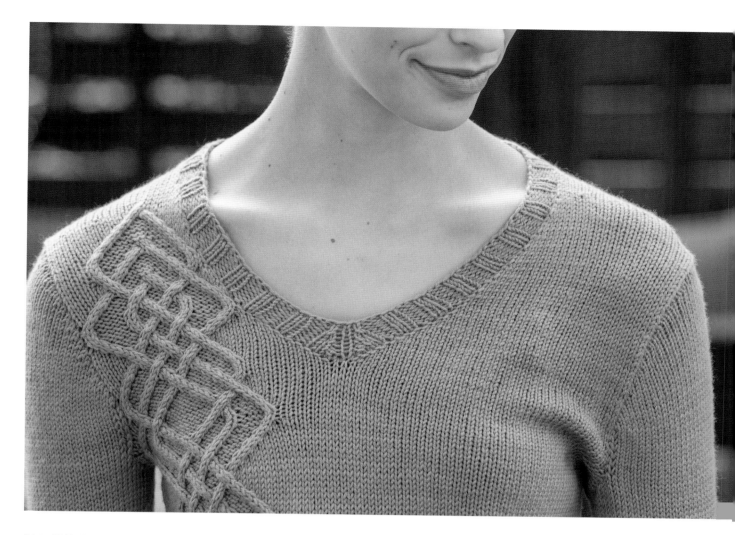

[Knit 15 (0, 9, 5, 5, 5, 3) rnds, then rep dec rnd] 1 (0, 7, 7, 15, 11, 8) time(s)—52 (56, 60, 60, 64, 68, 68) sts rem.

Cont working even in St st until piece meas 15½ (16, 16¼, 16¼, 16¼, 16¼, 16¾)" (39.5 [40.5, 41.5, 41.5, 41.5, 41.5, 42.5] cm) from underarm.

Work k2, p2 ribbing for 2" (5 cm).

BO all sts in patt.

Make second sleeve the same as the first.

finishing

Block piece to measurements.

COLLAR

With RS facing, cir needle, and beg at the front join of the neck, pick up and knit 163 (167, 171, 179, 175, 187, 191) sts evenly around neck edge. Pm and join for working in the rnd.

EST RIBBING: K1, *p2, k2; rep from * to last 2 sts, p2.

DEC RND 1: K1, ssp, work in patt to last 2 sts, p2tog—161 (165, 169, 177, 173, 185, 189) sts rem.

NEXT RND: K1, *p1, k2, p1; rep from *.

DEC RND 2: K1, k2tog, work in patt to last 2 sts, ssk—2 sts dec'd.

NEXT RND: K1, *k2, p2; rep from * to last 2 sts, k2.

Rep dec rnd 2—157 (161, 165, 173, 169, 181, 185) sts rem.

NEXT RND: *K2, p2; rep from * to last st, k1.

BO all sts in patt.

Weave in ends.

sources for yarn

*I dedicate this book to my
inspiration and my strength,
my mother.*

Acquisitions Editor Kerry Bogert
Editor Erica Smith
Technical Editor Kristen TenDyke
Photographer Joe Hancock
Hair and Makeup Kathy MacKay
Art Director Wendy Dunning
Cover and Interior Design Clare Finney
Production Designer Kerry Jackson

© 2015 Heather Zoppetti
Photographs © Joe Hancock

ISBN-13: 978-1-62033-851-3

Interweave
A division of F+W Media, Inc.
4868 Innovation Dr.
Fort Collins, CO 80525

interweave.com
Printed in Shenzhen, China

THE ALPACA YARN COMPANY
144 Roosevelt Ave., Bay #1
York, PA 17401
thealpacayarnco.com

BAAH!
baahyarn.com

CLASSIC ELITE YARNS
16 Esquire Rd. Unit 2
North Billerica, MA 01862
classiceliteyarns.com

CRABAPPLE YARNS
crabappleyarns.com

FAIRMOUNT FIBERS/ MANOS DEL URUGUAY
PO Box 2082
Philadelphia, PA 19103
fairmountfibers.com

IMPERIAL YARN
92462 Hinton Rd.
Maupin, OR 97037
imperialyarn.com

LORNA'S LACES
4229 N. Honore St.
Chicago, IL 60613
lornaslaces.net

MIRASOL YARN
mirasol.com.pe

QUINCE & CO
quinceandco.com

SHIBUI KNITS
1500 NW 18th Suite 110
Portland, OR 97209
shibuiknits.com

STITCH SPROUTS
stitchsprouts.com

SWANS ISLAND
231 Atlantic Hwy.
Northport, ME 04849
swansislandcompany.com

SWEET GEORGIA
110-408 East Kent Ave. S.
Vancouver, BC
Canada V5X 2X7
sweetgeorgiayarns.com

TANIS FIBER ARTS
tanisfiberarts.com

abbreviations

beg(s) begin(s); beginning

BO bind off

cir circular

cm centimeter(s)

cn cable needle

CO cast on

cont continue(s); continuing

dec(s)('d) decrease(s); decreasing; decreased

dpn double-pointed needles

est established

foll(s) follow(s); following

g gram(s)

inc(s)('d) increase(s); increasing; increase(d)

k knit

k1f&b knit into the front and back of same stitch

k2tog knit 2 stitches together

k3tog knit 3 stitches together

kwise knitwise, as if to knit

m marker(s)

mm millimeter(s)

m1 make one (increase)

p purl

p1f&b purl into front and back of same stitch

p2tog purl 2 stitches together

p3tog purl 3 stitches together

patt(s) pattern(s)

pm place marker

psso pass slipped stitch over

pwise purlwise; as if to purl

rem remain(s); remaining

rep repeat(s); repeating

rnd(s) round(s)

RS right side

s2kp slip 2 stitches, knit, pass slipped stitch over

s2k3p slip 2 stitches, knit 3, pass slipped stitch over

sl slip

sl st slip st (slip stitch purlwise unless otherwise indicated)

ssk slip, slip, knit (decrease)

ssp slip, slip, purl (decrease)

sssp slip, slip, slip purl (decrease)

st(s) stitch(es)

St st stockinette stitch

tbl through back loop

tog together

WS wrong side

wyb with yarn in back

wyf with yarn in front

yd yard(s)

yo yarnover

*repeat starting point

** repeat all between asterisks

() alternate measurements and/or

[] **work** as a group a specified number of times

glossary

CAST-ONS

Backward-Loop Cast-On

*Loop working yarn and place it on needle backward so that it doesn't unwind. Repeat from *.

Cable Cast-On

If there are no stitches on the needles, make a slip-knot of working yarn and place it on the needle, then use the knitted method to cast on one more stitch—two stitches on needle. Hold needle with working yarn in your left hand. *Insert right needle between the first two stitches on left needle (**Figure 1**), wrap yarn around needle as if to knit, draw yarn through (**Figure 2**), and place new loop on left needle (**Figure 3**) to form a new stitch. Repeat from * for the desired number of stitches, always working between the first two stitches on the left needle.

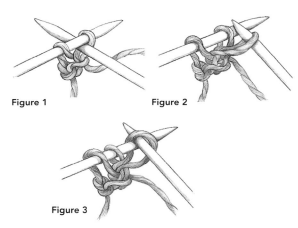

Figure 1 Figure 2

Figure 3

Emily Ocker Circular Beginning

This method for casting on for a circle in the round is invisible. Leaving a tail, make a large loop with the yarn. Hold the loop so that the crossing area of the loop is on the top and the tail is off to the left. With a double-pointed knitting needle, *reach inside the loop and pull the yarn coming from the ball through to make a stitch, then take the needle up over the top of the loop and yarn over; repeat from * until you have the desired number of stitches on the needle. Turn and knit one row. If you're casting on

an even number of stitches, the sequence ends with a yarnover, and it will be difficult to keep from losing the last stitch. To solve this, pick up 1 extra stitch from the inside and then work these last 2 stitches together on the first row to get back to an even number of stitches. Divide the stitches evenly onto four double-pointed needles.

Judy's Magic Cast-On

This amazingly simple cast-on is named for its founder, Judy Becker. It wraps the yarn around two parallel needles in such a way as to mimic a row of stockinette stitch between the two needles.

Leaving a 10" (25.5 cm) tail, drape the yarn over one needle, then hold a second needle parallel to and below the first and on top of the yarn tail (**Figure 1**).

Bring the tail to the back and the ball yarn to the front, then place the thumb and index finger of your left hand between the two strands so that the tail is over your index finger and the ball yarn is over your thumb (**Figure 2**). This forms the first stitch on the top needle.

*Continue to hold the two needles parallel and loop the finger yarn over the lower needle by bringing the lower needle over the top of the finger yarn (**Figure 3**), then bringing the finger yarn up from below the lower needle, over the top of this needle, then to the back between the two needles.

Point the needles downward, bring the bottom needle past the thumb yarn, then bring the thumb yarn to the front between the two needles and over the top needle (**Figure 4**).

Repeat from * until you have the desired number of stitches on each needle (**Figure 5**).

Remove both yarn ends from your left hand, rotate the needles like the hands of a clock so that the bottom needle is now on top and both strands of yarn are at the needle tip (**Figure 6**).

Using a third needle, knit half of the stitches from the top needle (**Figure 7**). There will now be the same number of stitches on two needles and twice that number of stitches on the bottom needle.

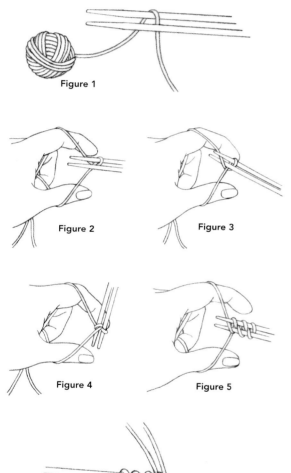

Figure 1

Figure 2

Figure 3

Figure 4

Figure 5

Figure 6

Figure 7

Provisional Cast-On

With waste yarn and crochet hook, make a loose crochet chain about four stitches more than you need to cast on. With knitting needle, working yarn, and beginning two stitches from end of chain, pick up and knit one stitch through the back loop of each crochet chain (**Figure 1**) for desired number of stitches. When you're ready to work in the opposite direction, pull out the crochet chain to expose live stitches (**Figure 2**).

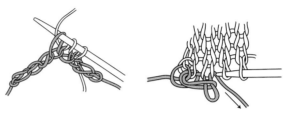

BIND-OFFS

Three-Needle Bind-Off

Place the stitches to be joined onto two separate needles and hold the needles parallel so that the right sides of knitting face together. Insert a third needle into the first stitch on each of two needles (**Figure 1**) and knit them together as one stitch (**Figure 2**), *knit the next stitch on each needle the same way, then use the left needle tip to lift the first stitch over the sec- ond and off the needle (**Figure 3**). Repeat from * until no stitches remain on first two needles. Cut yarn and pull tail through last stitch to secure.

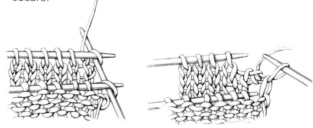

Figure 1

Figure 2

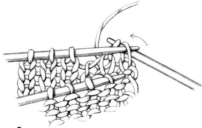

Figure 3

SEAMS

Slip St Crochet Seam

Make a slipknot and place it on a crochet hook. *Insert hook through both pieces of fabric one stitch in from selvedge (**Figure 1**), wrap yarn around hook to make a loop, pull this loop back through the fabric and through loop already on the hook (**Figure 2**). Repeat from *.

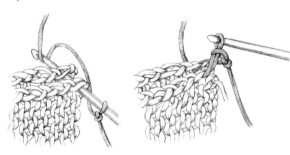

Figure 1 Figure 2

Mattress Stitch Seam

With RS of knitting facing, use threaded needle to pick up one bar between first two stitches on one piece (**Figure 1**), then corresponding bar plus the bar above it on other piece (**Figure 2**). *Pick up next two bars on first piece, then next two bars on other (**Figure 3**). Repeat from * to end of seam, finishing by picking up last bar (or pair of bars) at the top of first piece.

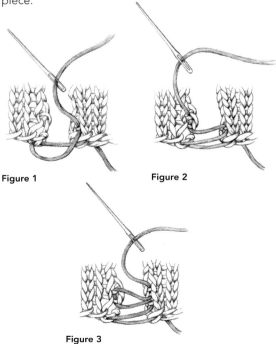

Figure 1 Figure 2

Figure 3

SHORT-ROWS

Knit Side

Work to the turning point, slip next stitch purlwise to right needle. Bring yarn to front (**Figure 1**). Slip same stitch back to left needle (**Figure 2**). Turn work and bring yarn in position for next stitch, wrapping the slipped stitch as you do so.

Note: Hide wraps on a knit stitch when right side of piece is worked as a knit stitch. Leave wrap if the purl stitch shows on the right side.

Hide wraps as follows: Knit stitch: On right side, work to just before wrapped stitch, insert right needle from front, under the wrap from bottom up, and then into wrapped stitch as usual. Knit them together, making sure the new stitch comes out under the wrap. Purl stitch: On wrong side, work to just before wrapped stitch. Insert right needle from back, under wrap from bottom up, and put on left needle. Purl lifted wrap and stitch together.

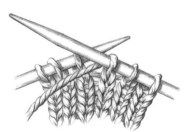

Figure 1

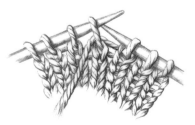

Figure 2

Purl Side

Work to the turning point, slip the next stitch purlwise to the right needle, bring the yarn to the back of the work (**Figure 1**), return the slipped stitch to the left needle, bring the yarn to the front between the needles (**Figure 2**), and turn the work so that the knit side is facing—one stitch has been wrapped and the yarn is correctly positioned to knit the next stitch. To hide the wrap on a subsequent purl row, work to the wrapped stitch, use the tip of the right needle to pick up the wrap from the back, place it on the left needle (**Figure 3**), then purl it together with the wrapped stitch.

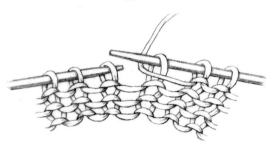

Figure 1

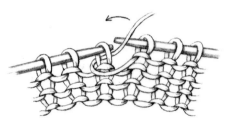

Figure 2

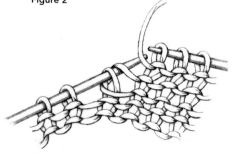

Figure 3

INCREASES

Left Slant (M1L) and Standard M1

With left needle tip, lift strand between needles from front to back (**Figure 1**). Knit lifted loop through the back (**Figure 2**).

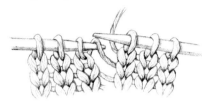

Figure 1

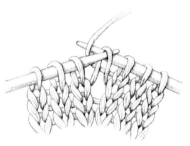

Figure 2

Right Slant (M1R)

With left needle tip, lift strand between needles from back to front (**Figure 1**). Knit lifted loop through the front (**Figure 2**).

You can work these increases purlwise (M1P) by purling the lifted strand instead of knitting it.

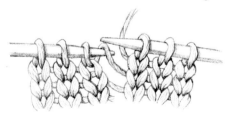

Figure 1

Figure 2

GRAFTING

Kitchener Stitch (St st Grafting)

STEP 1: Bring threaded needle through front stitch as if to purl and leave stitch on needle (**Figure 1**).

STEP 2: Bring threaded needle through back stitch as if to knit and leave stitch on needle (**Figure 2**).

STEP 3: Bring threaded needle through first front stitch as if to knit and slip this stitch off needle. Bring threaded needle through next front stitch as if to purl and leave stitch on needle (**Figure 3**).

STEP 4: Bring threaded needle through first back stitch as if to purl (as illustrated), slip this stitch off, bring needle through next back stitch as if to knit, leave this stitch on needle (**Figure 4**).

Repeat Steps 3 and 4 until no stitches remain on needles.

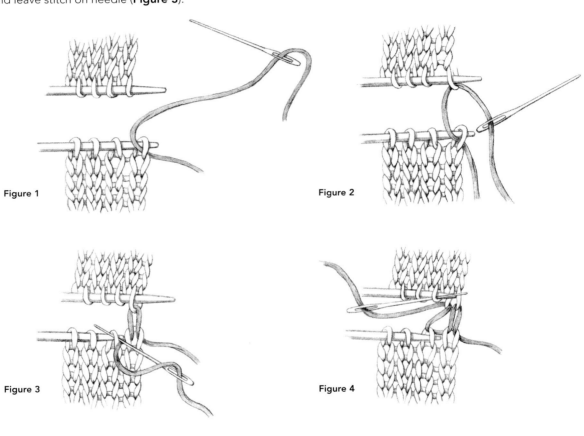

Figure 1

Figure 2

Figure 3

Figure 4

I-CORD

Using two double-pointed needles, cast on the desired number of stitches (usually three to five). *Without turning the needle, slide stitches to other end of needle, pull the yarn around the back, and knit the stitches as usual. Repeat from * for desired length.

index